RICHARD WOODS

RICHARD WOODS

Marco Livingstone and Gordon Burn

Ruskin School of Drawing and Fine Art, University of Oxford
Art Works in Wimbledon
Lund Humphries

Contents

Foreword

This book is the first monograph to be published on the remarkable work of Richard Woods. One of a younger generation of British artists whose sculptures and installations operate on the boundary between art, architecture and design, Woods displays a practical and intellectual interest in the way that large-scale printed graphics, almost clichéd in their extravagant simplicity, can intervene in and reactivate the social structures of urban space and the history of the built environment.

In 2005 Woods was given an opportunity to undertake commissions for New College in Oxford and a detached suburban house in London and suggested subjecting two very different buildings to the same super-sized, red brick treatment. The interest in and success of those installations convinced the Ruskin School of Drawing and Fine Art and Art Works in Wimbledon to collaborate on a publication recording not just *NewBUILD* and *RENOVATION*, but all of the artist's major works to date, and we are delighted that Lund Humphries has agreed to join us in this venture for the purposes of distribution.

In his introductory essay, the art historian and independent curator Marco Livingstone charts the development of Woods's sculptures and installations since his days as an art student in the mid-1980s, drawing on unpublished interviews with the artist and previously unseen documentation of earlier projects. Thereafter the book focuses on the building-based commissions completed since 2000, and many of these are further explored in extracts from an illuminating conversation between Woods and the writer and novelist Gordon Burn.

We should like to express our gratitude to Marco Livingstone and Gordon Burn for their thoughtful contributions to the publication, to Fraser Muggeridge studio for its lucid design, to Arts Council England and The Henry Moore Foundation, whose early commitment of funds made this publication and the projects in Oxford and Wimbledon practicable, and to Galleria S.A.L.E.S. for its additional support. Engaging with artists is invariably a rewarding experience, and our greatest debt is to Richard Woods himself. For his patience and unswerving good humour in the face of all our requests in connection with the production of this book, we extend our heartfelt thanks.

Paul Bonaventura
Senior Research Fellow in Fine Art Studies
Ruskin School of Drawing and Fine Art
University of Oxford

Martin Holman
Director
Art Works in Wimbledon

Re-make/Re-model: Playing with public perceptions[1]

Marco Livingstone

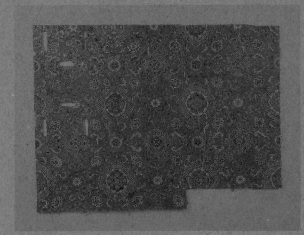

Renovated bathroom carpet no. 1, 1997

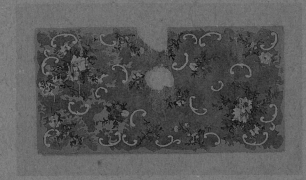

Renovated bathroom carpet no. 2, 1997

Richard Woods is really wily. Although his training was primarily as a sculptor, he does not think of his mature works as proper to that or any other distinct medium, preferring to discuss them in terms of their surfaces. His work crosses many boundaries and does not fit comfortably into any category. It is part painting, part printmaking, part sculpture. It has been referred to as installation art, and it could be described as conceptual. Woods declines to worry about these categories or about how his art relates to them, finding the issue unhelpful and irrelevant. He is loath to think even of his large room-based or building projects as installations, since he is concerned with resurfacing existing structures rather than with placing objects into space. While he prefers to sidestep the issue of how his use of paint on flat surfaces relates to the canon of painting, he does on occasion work with fragments that can be hung like paintings. If he has frequent recourse to printmaking procedures, notably when creating the modular elements of floors or walls, it is not out of any specific interest in these methods or in their histories, but just as a pragmatic solution to covering large surfaces quickly, simply and economically. His art constantly changes form as it dips in and out of the different languages.

There are connections between specific aspects of Woods's current practice and certain works by other artists. The painted floors made by an almost exact contemporary, the Scottish sculptor and installation artist Jim Lambie, come to mind in relation to Woods's colourfully printed floor pieces; but even in this case Woods is of the opinion that Lambie is more concerned with painting than he is. Yet Woods, too, is constantly devising ways of embellishing existing surfaces from the world we inhabit every day. Whatever structures he takes as his starting point – whether the floor of a domestic house, the walls of a gallery, the courtyard of a convent or the external walls of a public building – are all used as flat surfaces to be decorated and coated in paint. They are, in other words, simply grounds, like the canvases used by more conventional artists.

As an art student at Winchester School of Art between 1985 and 1988 and from 1988 to 1990 as a postgraduate at the Slade School of Fine Art, Woods was classed as a sculptor, but even then he often made large architectural objects (in steel, wood or plaster) with a view to painting their surfaces, including *Painted landscape* (1988) and the three works called *Untitled* (1989–90) that featured in his MA degree show. Eventually he found it 'more resonant just to cover the stuff of the real world',[2] leading him to make sculptures such as *Made in Leytonstone* (1996) and *18 Choppers* (1998). Between 1997 and 2000 he produced a series made with real carpets (some presented flat, others rolled up) whose original patterns he faithfully painted over in enamel paint as if neatly and obediently filling in the outlines of a

1.
While the unfettered character of Richard Woods's art is one of its most admirable qualities, I hope that readers will take note of my own superhuman restraint in rejecting all the puns on wood that I might have been tempted to use in the title of my essay. Assuming that such predictable and banal plays on language will feature in almost every article to be published about his work, at least while he continues to use wood grain as a motif, I thought I would do the decent thing on this occasion and ignore them. To reward myself for not succumbing to clichés or cheap jokes, I have instead stolen my title from that of the opening song on the first Roxy Music album, released in 1972. My respectful apologies to Bryan Ferry for this act of vandalism.

2.
All quotations are from a conversation with Richard Woods at his studio in London on 25 January 2005 or from a public interview I conducted with him at the Long Room, New College, Oxford on 25 May 2005 under the title 'Changing Rooms'.

colouring book; by submitting himself to existing designs in this way, he removed his own taste from the art-making process, demonstrating a refusal even to express a preference for one style or another.[3] *Renovated bathroom carpet no. 1* (1997), *Renovated bathroom carpet no. 2* (1997), *Rolled Axminster* (1999), *Modernist bedroom carpet* (1999) and *Floral carpet* (1999) are noteworthy examples from the series. None of this early student work survives, as much of it was on an enormous scale that made it impossible to store. From the beginning he felt drawn to working large, both because he was attracted to the Herculean labour involved and because spectators would relate to the resulting objects not just with their eyes, but with their entire bodies as they circumnavigated them. Moving to London intensified the desire he already had to make art, like *Gallery floor* (1999), that conveyed the experience of living in a modern urban environment: 'It's always about the journeys you do, the sort of places you wander, the city or the architecture and drawing it all together. Everything is big and architectural because it's like intensifying just really normal things.'[4]

Woods found the atmosphere at the Slade too 'stark' and 'wannabe conceptual' for his taste at the time. Between 1992 and 1996, after he left college, he spent periods of up to three months in New York, where he made work – all without titles – and became friends with artists with whom he felt in greater sympathy. He was particularly close to those concerned with expanding definitions of painting: Jessica Stockholder, James Hyde and Fabian Marcaccio were prominent among them.[5]

When Woods takes advantage of an essential aspect of printmaking, its capacity for repetition and endless replication, it is not for the usual purpose of producing an edition of identical objects to be dispersed to collectors on the marketplace. On the contrary: when he reinterprets procedures such as woodblock printing or linocut, it is almost always because such methods are appropriate to the materials he is mimicking. What better way of representing floorboards, which by their nature are pretty much identical, anyway, than by printing them from enormous blocks whose gouged-out wood grain patterns are 'inked up' with enamel paint? The separate planks are all different yet closely related, as if hewn from the same logs.

'The printed element of the work comes from wanting a physicality,' says Woods, 'but also not wanting to get too close. So I don't want to paint all the flooring. I want the physicality, but I also want to keep a little bit away from the surface.' Printing, which involves transferring the gloss paint from one surface to another, thus becomes a way of removing his hand; with the gigantic scale and the lurid colours, the process results in a delirious effect.

The subject matter of any particular work dictates the form it is going to take. Thus, in devising a mock Tudor exterior, Woods operates in a different way – constructing reliefs rather than printing the motifs – in order to produce a more convincing illusion of the structure he is re-enacting. 'It's what you would do if you were "mock Tudoring".'

The energy and spirit of Woods's art comes partly from the risks he takes in making works that are not necessarily going to be sold, but are just going to be displayed for a short period.

18 Choppers, 1998

3.
This neutral attitude towards a found, manufactured object is entirely consistent with that of Marcel Duchamp, who had devised the concept of the readymade nearly a century earlier. In a talk delivered at the Museum of Modern Art, New York on 19 October 1961, Duchamp left his position in no doubt:
'A POINT WHICH I WANT VERY MUCH TO ESTABLISH IS THAT THE CHOICE OF THESE "READYMADES" WAS NEVER DICTATED BY ESTHETIC DELECTATION.
THE CHOICE WAS BASED ON A REACTION OF VISUAL INDIFFERENCE WITH AT THE SAME TIME A TOTAL ABSENCE OF GOOD OR BAD TASTE… IN FACT A COMPLETE ANESTHESIA.'
Published in *Art and Artists*, vol. 1, no. 4, July 1966, p. 47, and reprinted in *The Essential Writings of Marcel Duchamp* (London: Thames and Hudson, 1975), edited by Michel Sanouillet and Elmer Paterson, p. 141.

4.
Christo's wrapped buildings, which completely reconfigure existing structures in a skin made by the artist, come to mind as a precedent, but they were not a point of reference for Woods. Christo is more of a formalist than Woods and more interested in tackling projects that have a certain grandeur; for Woods the attraction, on the contrary, is in the mundane and the domestic, in how things are made in the everyday environment. Works have to be made on a certain scale because that is the size they happen to be, not out of any desire to overwhelm or impress the viewer or to provide a transcendent experience. As a student, he was much more interested in the work and ideas of William Morris, who in the late 19th century was thinking in terms of complete decorative schemes that combined art and architecture into a seamless whole.

5.
Woods also acknowledges an interest in the work of American artist Clay Ketter, a former carpenter whose paradoxical synthesis of geometric abstraction and architectural structures with DIY home improvements has strong parallels with his own art. Although he does not know him personally, he has encountered Ketter's art in the homes of various collectors and has seen some of his solo shows. When I questioned him about an American artist of an older generation with whom I also saw parallels, Richard Artschwager, Woods readily admitted to being a fan. Artschwager's sculptures simulating travelling crates, and his use of synthetic materials such as Formica to create objects masquerading as furniture and other ordinary things, are among the precedents for Woods's witty engagement with the real and the illusionistic, and his own exploration of the territory shared by the found object and the handmade approximation of it. Ultimately such comparisons serve as much to highlight the differences between the artists as their shared enthusiasms. 'Probably the things that Artschwager likes looking at are very similar to the things that I like looking at,' comments Woods of an artist who has reinvented wood grain as often and as playfully as Woods himself.

He compounds the financial precariousness of this situation by avoiding too much reliance on public funds, which would introduce inevitable constraints, and by working instead with commercial galleries and enlightened private patrons. By not making himself dependent on bureaucrats, committees and funding bodies, he can make what he wants as long as he is able to transmit his enthusiasm about any particular project to a few individuals willing to back his vision without having to justify the expense to anyone else.

Woods always brings his art back down to earth and to a visual language and a physical situation that everybody can relate to, whether they know about contemporary art or not. Offering the contentious generalisation that 'artists just make work about themselves', he explains that 'what I have ended up making is a physical manifestation of the way that I have spent my life'. This is particularly true of his floor pieces, which have become his signature works. 'When we started doing the printed floors – four years ago, or whenever it was – Iain[6] and I were working as carpenters, to support ourselves, and we used to lay a lot of laminate floors for people, as a job. We were putting a skin on the floor of every house we went to. And I think the floors just came out of that. It seemed like the whole world at that time was being covered in laminate. I just wanted to make a laminate floor for myself, my version of what it would be.'

There was no single eureka moment when he was laying the floors and it suddenly struck him that he could adapt the procedure to make art. 'It was just more the idea that I was struck by how strange it was that so much of this laminate flooring was being laid down, and why people wanted it. And the fact that it was a surface and we were covering up this and that. But then maybe I was only interested in that because I was always making sculptures that were to do with the surface, anyway.'

The commercial laminate floors they were laying were designed to deceive the eye, whereas in his exaggerated, cartoon-like versions, Woods always makes it very obvious that the material is not what it pretends to be. Yet such is the unpretentious and democratic tone of his art that Woods plays constantly on the similarities between his procedures and materials and those employed every day in more prosaic situations. On television home improvement programmes aimed at the DIY [do-it-yourself] enthusiast, it often seems that whatever your problem, you can solve it with a bit of medium density fibreboard, known in the trade as MDF. Woods sees the funny side, but turns the humour against himself by relying on exactly the same materials, admitting: 'It's the same in here!' His commitment to household gloss paint, first used as a medium for fine art in the late 1950s and early 1960s by such Pop painters as Peter Blake and Patrick Caulfield, is part and parcel of this DIY aesthetic.

Some of the playful spirit of these floor pieces comes from the illicit thrill one experiences in walking all over a work of art, after years of having it drummed into you that art is such a precious, valuable and fragile thing that it should not even be touched. As long ago as the 1960s, the American Minimalist sculptor Carl Andre created sculptures made of conjoined metal plates that were meant to be walked on, so that the spectator

Woodblock for *Floral repeat no. 6*, 2003

6.
Iain Herdman, himself an artist, assists Woods in the production of most of his work.

could feel the weight, texture and thickness of the material under his or her feet; yet when one sees these displayed in museums or galleries even today, it becomes apparent – from the way people daintily step around them – how reluctant many visitors still are to tread on the works for fear of damaging them. By covering the entire floor area in his fake laminate (now there is a tautology!), Woods offers the spectator no choice. Depending on how well brought up you have been, and how respectful of art as representing a higher order of experience, you can easily feel like a naughty child, if not exactly an outlaw, when stepping on these floors. And that sensation of transgression, undoubtedly, is part of the appeal. The humorous rendering of the floorboards further challenges the sense of decorum with which one is meant to approach a work of art. By all these means, Woods generously and seductively makes a case for art as a vibrant, life-enhancing element of everyday experience. The floor pieces prove, in a bluntly literal way, that art can be determinedly down-to-earth, but that it can still envelop us in its expansive embrace.

The imitation floorboards begin as small tracings, with felt-tip pen on A4 sheets of acetate, from actual knots and wood grain patterns on doors in the artist's home. This drawing phase tends to be an after-hours activity that he can carry out at leisure on his return from the studio, enabling him to stockpile numerous variations for future use. Although these originate as faithful replicas of found patterns, the artist feels free to elaborate them to enhance the effects. The acetates are then taken to a photocopy shop where they are enlarged to 8 feet in length. The resulting printouts are glued onto sheets of plywood, and the spaces between the drawn lines are grouted out. The process, though making use of current technology, is very much like that used for the making of Japanese woodblock prints in the 19th century: it is as if he has drawn his design on the block, which is then prepared for printing by the professional woodblock cutter. He agrees that at that point, it does not matter at all who does the actual physical cutting into the block, as they are just following the marks, the contours of the design. He and his assistant Iain work together all the time, with occasional additional help (particularly when there is a big job to print). Who does the printing is also immaterial, since the important decisions are all made at the early drawing stage and the result will be more or less the same as long as the person knows how the procedure works. In this sense, the division of labour removes the artist's hand much as it did under Andy Warhol's watchful eye when screenprinting paintings or sculptures at his Factory in New York. Warhol's work – and even specific devices such as the use of self-designed printed wallpaper to wrap the spaces for a number of his gallery and museum shows[7] – is certainly an important touchstone for Woods, but with a fundamental difference. The Woods set-up, more overtly primitive than Warhol's in its tools and handmade procedures, is not so much a factory as a cottage industry.

The floors vary from piece to piece, even in terms of the patterns in which the boards are laid down. For each new floor commission a completely new set of blocks is made, sometimes based on tracings he has used before. The artist knows instantly which blocks belong to each piece: they are colour-coded or identified on the back. Though lying well below a gallery-goer's normal level of vision, these often candy-coloured makeovers – which spill over and consume entire spaces – are unlikely to escape anyone's attention. They have appeared in a great variety of locations,

Printing of *Loft life renovation sculpture*, 2001

7.
For the *Super Tudor* projects in 2002 and 2003, Woods hung his own woodcuts on his own wallpaper, inevitably triggering memories of similar strategies employed by Warhol. For Woods, however, this emphasis on the decorative surface was not just a way of summoning the spirit of Warhol, but of synthesising Warhol with William Morris: a much more impure enterprise which, typically for Woods, collapses two distinct periods of history into the present. 'I suppose it's perverse, but I am more interested in linking Warhol with William Morris rather than with linking me with either one or the other. That obviously happens [anyway], because it's my work.'

Refit, 2000

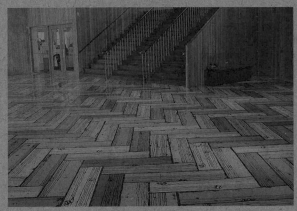

Logo no. 14, 2005

8.
Two cockatoos (red) papered the walls around *Various pouring and leaking sculptures*, filling a large gallery of a group show, *The Galleries Show*, at the Royal Academy of Arts, London from 14 September to 12 October 2002. Woods remarked of this work: 'The installation I did at the Royal Academy using classical fountains and reproduction furniture was an attempt to make an installation that was aspirational in its relationship to the building it was shown in. The fountains also add an absurd element.' Richard Woods, 'An installation by Richard Woods and an interview with the artist – by himself', *Modern Painters*, summer 2003, p.76.

each of which is subjected to the artist's thorough 'rebranding'. They have been seen in commercial galleries, including Modern Art Inc and Zwemmer Gallery in London in 2000, Deitch Projects in New York in 2002 and Cosmic Galerie in Paris in 2003. They have graced unassuming domestic spaces and grand country houses, as with *Refit* at Tabley House, Cheshire in 2000. They have occupied museums and public exhibition spaces, most spectacularly in the form of *Logo no. 14*, installed in the foyer and fourth floor terrace of The New Art Gallery, Walsall in 2005. A particularly stylish, swaggering black-and-white floor even transformed the flagship Osaka store of the fashion house COMME des GARÇONS in 2002.

'I've done probably 50 printed wood floors in various places,' Woods comments, 'and I really like the idea that they are just printed wood floors. I wouldn't be desperately upset if Habitat decided to sell them. As long as they can stay the same, I like the idea that they can literally become part of the "real". They do go back into life. I really like the idea that they do just go everywhere. And almost like the more of them there are, to me the more interesting it is. It doesn't work like that with other things, like I only want to make one mock Tudor.' Asked how he would feel if someone foretold that he would eventually make many hundreds of variations on those floor pieces, he replies with a smile: 'Just bring it on!'

'Decorative' has been a pejorative term for many artists during the past century, although less so for those who, like Woods, describe themselves as 'postmodern'. Woods not only accepts the decorative, he embraces it. He often works not just with conventional, but sometimes with really old-fashioned, out-of-date designs and forms, such as hand-blocked wallpaper, for which there was a vogue in the 18th century, but which almost nobody would normally think of using now even in a domestic setting, let alone as art. In his defence, he says: 'I like the notion of reintroducing those things, and even more perversely how they can be reintroduced almost as a fashionable thing, and definitely as a kitsch thing. When we did the warehouse in Miami (*Nice life no. 2* for Deitch Projects in 2003), the actual pattern I bought from an American version of B&Q, so already it had been reintroduced. It wasn't purely kitsch any more.' Much of this imagery is taken second-hand; the parrots he featured as wallpaper motifs for an installation at the Royal Academy in 2002, for instance, were taken from found illustrations.[8]

'There is a lot of picture making in a very conventional sense in the little paintings that we do. I like to keep that going. I suppose there is a sort of thing underneath all this that ties it all together, an interest in decorative arts and quite conventional histories of art and craft. I suppose I like the journey where art and design and crafts all meet. I like those moments, and then they all go apart again. It's quite important to me to keep this side of it going.'

Responding to a commission to create works for the high back wall of the foyer at Sadler's Wells theatre in London in 2005, Woods presented *Mock Tudor painting*, an extremely restrained rereading of mock Tudor architecture in the form of severe reliefs resembling neoplasticist or constructivist paintings of the 1920s or works made several decades later

by members of the Zero group. The purity and self-sufficiency of geometric abstraction and of the theatre's sleek architecture alike, however, have been 'tainted' by the intrusion of references to a discredited style of cosy suburban architecture. 'The idea', explains Woods, 'was to make something that looked like it could have been made in 1974 in Düsseldorf or something, with the confidence of High Modernism. But the confidence of High Modernism is obviously completely at odds with the rosy warm glow of mock Tudorising.' Official modernist accounts of art history used to put forward the example of an artist such as Piet Mondrian as representing the purest form of abstraction, but now we understand that even that work all actually derived ultimately from observation of nature. There are few now who can believe wholeheartedly in the idea of pure abstraction; there is always some link with the everyday world. So it is that these works by Woods appear on first glance to be geometrical abstractions, until it registers in one's mind that they, like almost all his work, are related to architectural forms.[9] Contrary as always, Woods found a way of making objects that looked like paintings, but that are actually sculptural constructions, neither flat nor painted.

Mock Tudor tends to make me shudder because my own close encounters with it are of a rather unpleasant kind. A short period of my childhood was spent in a suburb of Detroit, Michigan called Sherwood Forest, where most residents lived in a kind of fantasyland of half-timbered Englishness, made all the more preposterous for the fact that nowhere in the vicinity could the 'real' thing be found. Thirty years later, in a moment of madness as an adult, I found myself living again in the suburbs, this time in a 1930s semi-detached house in a particularly charmless stretch of Twickenham, on the outskirts of London. These rather traumatising experiences made me acutely aware of all that was wrong with the style: the method of construction, with supposedly structural elements merely tacked on to the outside, its overly regular rectilinear geometry, the fact that nothing is organic to the way that such architecture would have been made originally.

Woods clearly has a more forgiving nature than I do in this respect, or perhaps a more affectionate sense of humour for the buildings that surrounded him in his native city of Chester. 'I always found it fascinating that people thought it was Tudor, but it's obviously Victorian.' As he points out, it is not exactly a charade, more of a lie that is an open secret but that is never discussed, carried out on an enormous scale. 'I completely love the idea that the whole town lives this lie. There are maybe about half a dozen genuine old buildings in the whole town. It's a Roman town, it's obviously a very old town, but it's mostly Victorian. But it's not a theme park, it's not done to excess. It's just there.' There is no malice, no mockery or satire in Woods's acknowledgement of the nostalgic elements inherent to architectural revivals of periods long gone, or of the connotations of self-aggrandisement built into the popular taste for such decorative schemes. It is not just others who behave pompously 'as to the manor born'. In choosing the style in which we live, whatever it may be, we all consciously or subconsciously make a statement about how we would wish to be perceived.

Barry Humphries's alter-ego Dame Edna Everage once pointed out in a television travelogue that the English love of quaint

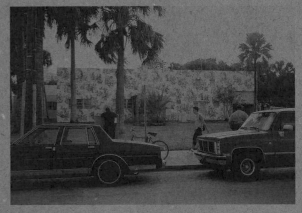

Nice life no. 2, 2003

9.
The deceptively abstract relief paintings based on window frames and other architectural details made in the late 1940s and early 1950s by an American then living in Paris, Ellsworth Kelly, provide a telling precedent for *Mock Tudor painting*, although it is doubtful that Woods would have had these elegant works consciously in his mind. There is a particularly close parallel with Kelly's *Window, Museum of Modern Art, Paris*, 1949 (oil on wood and canvas, 128.5 × 49.5 × 2 cm overall), reproduced in *Ellsworth Kelly: The Years in France 1948–1954* (Munich: Prestel-Verlag, 1992), cat. no. 36.

rusticity manifested in half-timbering sometimes seems to have run riot: even a popular car, the Morris Minor, was given the treatment. In an English situation mock Tudor has particularly strong connotations, but Woods is at pains to point out that he is using it as something from his environment rather than as a statement about Englishness. Forms of mock Tudor exist, after all, in other parts of the world, too, including Germany and the USA. In all its manifestations, however, it carries with it a rather petit bourgeois craving for respectability and upward mobility; as if anybody could be fooled by these trappings into thinking that the inhabitants of such homes were descended from some distinguished and ancient family line.

'The work, I suppose, always deals with notions of aspiration. That's what decoration often is,' explains Woods. The television schedules these days – at prime time, rather than just at the cheap end of 'daytime TV' – seem to be in the grip of an obsession with home improvements and makeovers of rooms. Viewers are constantly promised that they can disguise the weaknesses of their properties by covering the surfaces to tally with some exotic theme, or by hanging paintings they can produce in five minutes with a little household paint, masking tape and stencils. By acknowledging this context for his art, Woods sails very close to the wind: 'It definitely comes out of that. And I think for it to be successful as art, it has to keep close to that ethos. I want this work to be made with the spirit of "we can make this room better with MDF" as opposed to an academic saying "aren't people mad for trying to make it better?"'

Although Woods speaks of his use of an 'aspirational' language without a hint of sarcasm or irony, in the art itself the situation is more ambiguous. Aspiration can be weighted with pretence, with the desperation to 'keep up appearances'; the joke at the root of Woods's art is that he does not even make the effort to pretend. He uses ordinary materials and accentuates their cheap and tacky look, for example through the way the gloss paint is applied or in the broad, caricatural style of drawing. These strategies result in the all too human acknowledgement of our frequent failure to reach lofty goals. In spirit, we are closer to Quentin Crisp's characteristically mordant advice not to waste one's energy trying to keep up with the Joneses; why bother, when you can drag them down to your own level? Yet Woods is wary of interpretations of his work that invoke the notion of kitsch, because he finds the very term offensive and patronising. What interests him more is to examine how taste migrates from community to community or period to period, transmuting itself as it goes. Crazy paving, which he has also employed as a motif, now suggests a kind of suburban tastelessness in much the same way as mock Tudor does, but it originated in an appreciation of Italian terrazzo flooring. 'Obviously,' says Woods, 'I am only drawing from things that culturally mean something to me, because I come from the sort of place where people have crazy paving drives and fountains in the garden and mock Tudor houses. That's my background. It is talking about that, but it's only talking about that because it's the only thing I know.'

Existing architecture serves as a foil for much of Woods's production to date. For the moment, he cannot imagine applying his language to a totally invented structure, preferring always

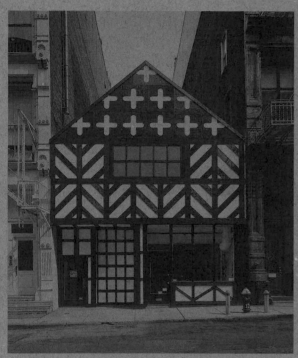

Super Tudor, 2002

to work against an existing building, wall or floor. 'Because what I do is so theatrical, it has to be linked to something that is real.' The transformation is an essential part of the process.

'Theatrical' is an adjective that (at least until recently) would have made many artists wince. But it is not an entirely appropriate term for Woods's work, since the artist turns the notion on its head. For a stage set, the designer is creating an illusion of reality out of nothing. Woods, by contrast, is actually covering a massive chunk of reality in an almost paper-thin illusion of something synthetic and artificial, as if denying the existence of the actual objects on which that façade of phoniness rests. Sometimes, though not always, the original structure is entirely covered, so that the viewer has to take on trust what lies below or beyond. The mass of the building that serves as the point of departure is denied by the way it has been covered in a new skin, yet it has not been spirited away. It is still actually physically there and in one's memory, but at the same time it has somehow been made to disappear as if in some extraordinary conjuring trick. This is undoubtedly a strange notion of sculpture, one that plays on an unsettling interaction between presence and absence, three-dimensional bulk and two-dimensional illusion. It is both insistently there and not there: like our own lives, and like the buildings in which we take shelter, it is here today and gone tomorrow. In fundamental ways it fulfils some of the promise in Claes Oldenburg's celebrated incantation in favour of an art 'that does something other than sit on its ass in a museum [… and] that is heavy and coarse and blunt and sweet and stupid as life itself'.[10]

Woods has created works in a variety of contexts as far afield as Japan, Italy and the USA. In each case, he has devised a solution that takes into account what is needed to get the art noticed and to make sense of its place within that environment. So far he has not had to face the challenge of recladding a building in a city such as Los Angeles, where so many buildings are clothed in pastiches of different (and often inappropriate) historical styles, or to make a work that might otherwise be rendered almost invisible: for example, if he was to mock Tudorise a suburban semi-detached house that was itself designed as mock Tudor. Since it is vital for him to create a 'hyper version' of any chosen style, and to deposit it, like some alien object, so that it clashes with everything surrounding it, his response has consistently entailed a poetry of opposites. Although reliant on commissions to produce large-scale, costly and labour-intensive work that would otherwise not have occasion to be made, Woods is always clear about maintaining control over all the creative decisions. 'The client doesn't really get what they want,' he says, matter-of-factly, 'and that is what they want: to get something they don't want. Because otherwise it's architecture, and as architecture it's just awful!'

There is a strange but also oddly thrilling contradiction at the heart of Woods's art, which is to make huge, physically very present objects that are also very ephemeral. Woods says that he likes that journey from the toil involved in making something to an understanding that it later exists only in the mind, living on as a kind of story, or is remembered at a remove in the form of photographic documentation. In a period where much of what we think we have experienced is actually viewed second-hand, at a distance – in photographs, on television, in newspapers and

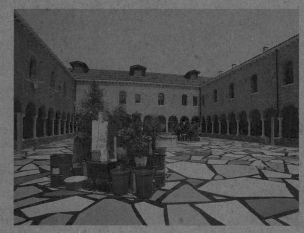

Import/export sculpture, 2003

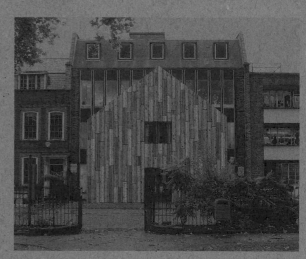

Countrystyle, 2004

10.
Claes Oldenburg, *Store Days* (New York: Something Else Press, Inc., 1967), p.39.

magazines – Woods rewards those willing to make the effort with the physical impact of his art when experienced in the flesh. For all its self-deprecating humour, constantly reminding us that what we are looking at is a fake, synthetic and stylised rendering of reality, every work by Woods revels in the intensity of its material presence. There is no substitute – not this book, not this text, not even the officially sanctioned photographs of the works shot under the artist's direction – for the experience of confronting the work itself.

Whether reconfiguring an interior space or the outside of a building, Woods takes on board the audience's expectations and memories of how that building has been before. Almost all buildings undergo constant modification and changes of use over time. What Woods does is thus in one sense simply a more extreme form of what regularly occurs in the world at large, exaggerated to such a pitch that even the most habitually blasé and myopic person cannot fail to take note and, in so doing, to begin to apply a more active and inquisitive attention to every aspect of the environment through which he or she travels every day. With any building or interior that has been altered, a ghost remains of its former self. The same holds true for those works by Woods that have only a temporary existence as physical things, before returning to their former identity. It is with this understanding that Woods conceives his structures, patterns and surface embellishments as sufficiently simple visually to be retained in the viewer's memory.

There is a clear pattern to the way Woods chooses his architectural references as a way of compressing two distinct time periods into one, or of incongruously transporting the spectator conceptually from the given location to its polar opposite. When he worked on *Super Tudor* with Deitch Projects on Grand Street in Lower Manhattan in 2002 or on the *Super Tudor* refurbishment of Adam Lindemann's residence in upstate New York the following year, for which he reconfigured a bland post-war house, he used an older idiom as a way of introducing a medieval or (more precisely) a fake medieval feeling to a modern environment. (It was not the original Tudor style that he was referencing, but its bastardised modern version: so 'super Tudor' is configured as 'mock-mock Tudor'.) Bringing an essentially rural style to the big city, both with *Super Tudor* and in 2004 with the log-cabin look of a façade in London's inner-city Hoxton Square (*Countrystyle*, for Kenny Schachter ROVE), he has also taken the post-war English suburbs out on holiday to the Mediterranean: in summer 2003, he created *Import/export sculpture*, transforming the imposing cloister of the Convento dei Santi Cosma e Damiano on the Giudecca in Venice into the suburban crazy-paved driveway to end all such driveways. As Woods explains: 'I grew up in a rather suburban environment, and one of the first big cultural memories for me in the mid-1970s was the rise of crazy paving. This tied in with people going to Spain and Italy on holiday for the first time. So that work was about that strange leap, that distance, and then ending up back there. I was dealing with a big space, but really it was about making sense of that space in the same way as your driveway.'[11]

Two years later, at New College in Oxford, Woods took a genuine medieval building, the 14th-century Long Room, and gave it a 1980s Wimpey house look, calling the work *NewBUILD*. By creating an unnaturally large brick for the

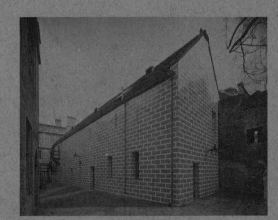

NewBUILD, 2005

11.
The vogue for crazy paving evidently started a little earlier than Woods remembers. English painter Stephen Buckley, 22 years older than Woods, used crazy paving as a motif for his notionally abstract paintings as early as 1968, when Woods was just two. See the reproductions of *Crazy Paving*, 1968 in *Stephen Buckley: Many Angles* (Oxford: Museum of Modern Art, 1985), p. 11, cat. no. 5, and of *Crazy Paving*, 1969 in Marco Livingstone, editor, *Stephen Buckley* (Kyoto: Kyoto Shoin, 1989), unpaginated. The genesis and exploitation of the crazy paving motif in Buckley's work is discussed in my text of the Oxford catalogue, p. 38.

repeat pattern wrapped around three sides of the building, Woods shrank the whole structure so that it registered on the mind as a small house. He describes the project, only half facetiously, as 'making something hideously big and red and white and cartoony. It's not about covering some enormous building, it's just thinking about why buildings get built that look like Brookside Close or industrial estates. There is so much strange regeneration going on at the moment, and Oxford is supposedly the place that least needed it. So I liked the idea that I was forcing a bit of urban regeneration onto it'. He did not set out to make a political point about Oxford as a seat of privilege, reinvented as a redbrick university, but he readily accepted these implications as something 'you get for free' as a by-product of the visual idea.

The Oxford piece was the first of two works in 2005 clothed in the same distinctive red brick 'wallpaper'. The other, a suburban house in Wimbledon titled *RENOVATION*, was chosen for its contrasting milieu. Taken together, they accentuate the interaction between the location, the original identity of the building and the style or motif with which it is reclothed. It is from the dialogue of these distinct elements that each work accrues meanings, and from the synthesis of these variations that the paired projects make sense.

The transformations effected by Woods are invariably visually jarring, almost shocking, making it immediately apparent even to the most unprepared spectator that a determined and somewhat brutal intervention has occurred to the landscape. Such strategies contrive to get the work noticed in a situation where one would not normally expect to encounter art, and to make the mundane somehow desirable, glamorous, given a new lease of life. In the process, as with so much of his work, Woods jolts the spectator into noticing, as if for the first time, the beauty, the humour and the wonder of a world all too often taken for granted.

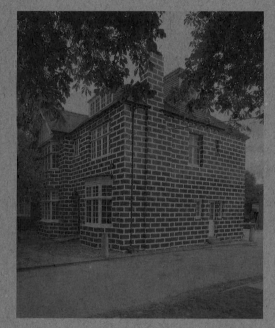

RENOVATION, 2005

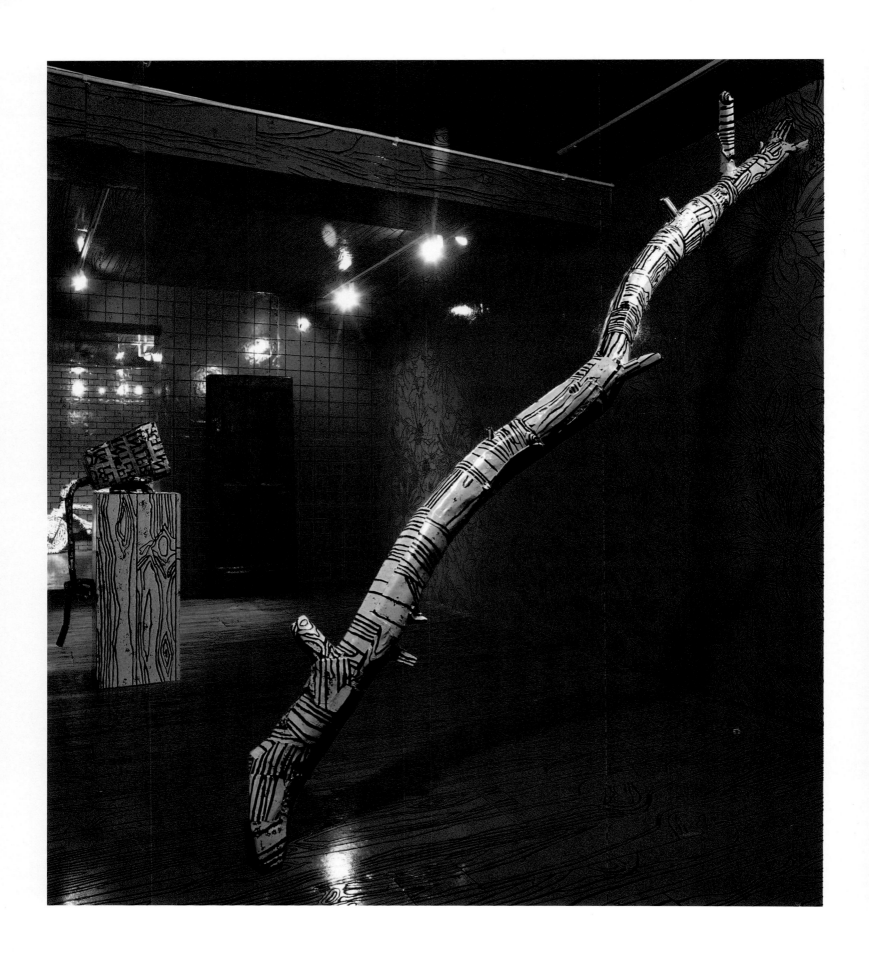

Richard Woods, Modern Art Inc, London, 2000

Richard Woods, Modern Art Inc, London, 2000

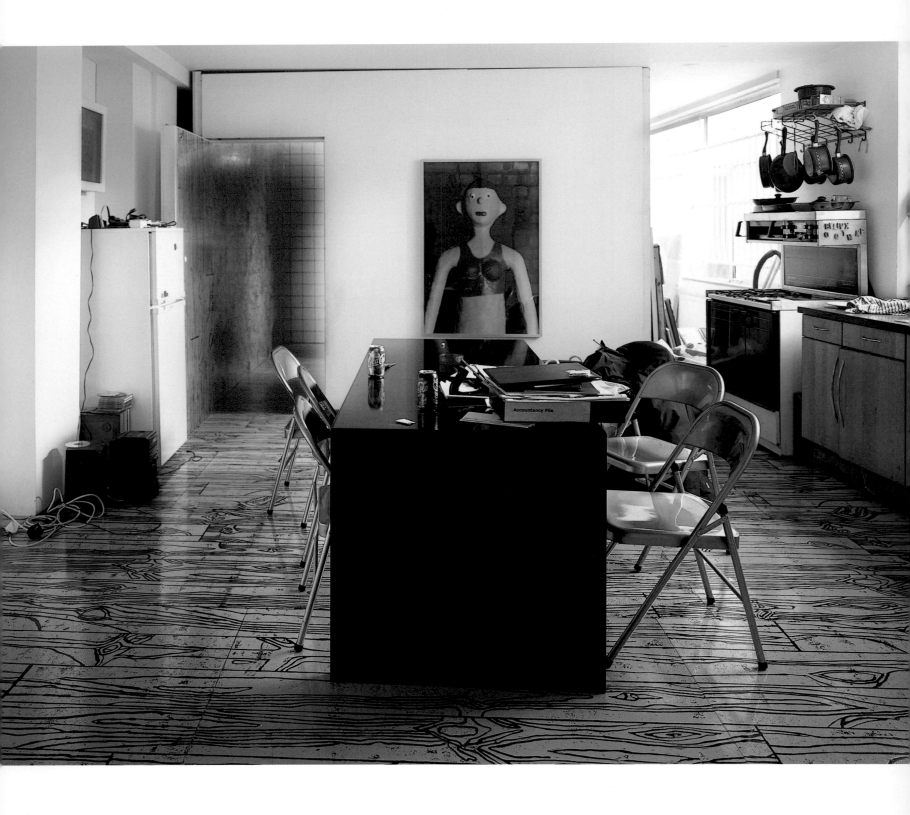

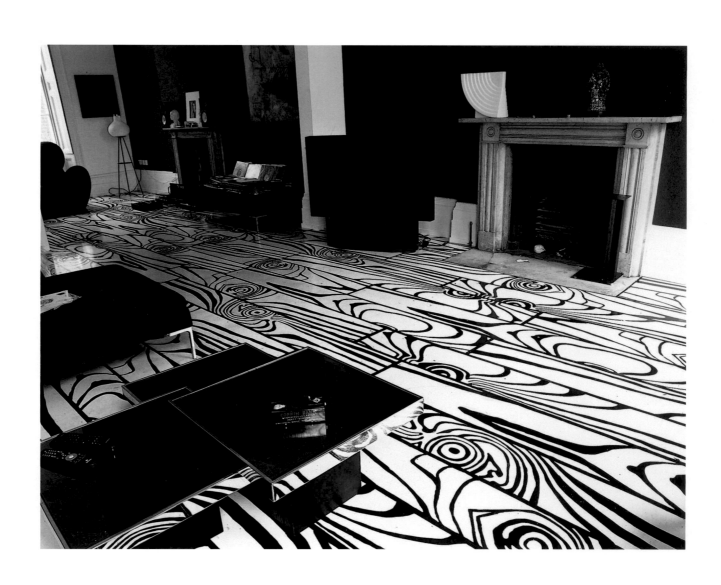

Logo no. 2 (2000), Collection Dave Dorrell, London

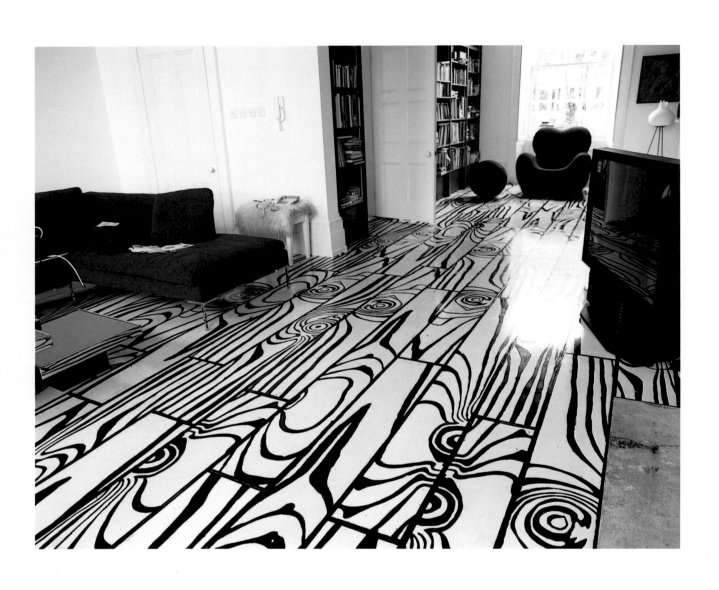

GORDON BURN: Detmar and Isabella Blow have sold up and moved since you 'Woodsied' their house. Have they taken the floors that you did with them to their new house?

RICHARD WOODS: When you pull these floors up, when you get rid of them, a certain cleansing goes on. The Blows own the block [which holds the pattern], and the block is the important thing.

So you would be happy for them to prise up the boards and burn them?

Absolutely.

I'm surprised. Not many artists would think that way.

Maybe it's a case of the act of laying the floors being a mixture of art and a job. I feel the real artwork is the woodblock, and the installation in the house is the job or end result of that thing.

What would you think about somebody else – the new owners of the Waterloo house – inheriting the floor?

The way it works is that I don't mind if they want to leave the floor for someone else, but it can't be reproduced anywhere else while it's still there. So if they want to stick it in their new house they have to get rid of it out of the old one first.

This raises interesting issues to do with authenticity. If they leave the floor in Waterloo, the people who inherit it can say they have an original Richard Woods. But because the Blows own the woodblock, they can get someone else to reprint and install the new one. It seems to me the authentic floor is the original one as you physically put it in place.

The real thing is the woodblock. That's the thing.

That's the thing that has monetary value.

Long after I have passed away through inhaling toxic paint fumes, I'll be quite happy for other people to reprint and lay these floors.

Is the block MDF [medium density fibreboard] or wood?

MDF. It's purposely simple and easy to use.

Like a potato cut.

I want to make things that are really low tech. I like the idea that it's that simple. In the case of the Blows' piece, I'm really interested in the idea of doing them in lots of different places. There are over fifty wood floors in existence, and they are all called *Logo*. I feel the more of them that exist, the better, because they're about each different space.

Damien Hirst has said about his spot paintings that he sees them as one big painting, and at some point he wants to bring them all together into the same space. The spots continue into infinity.

The fact that my woodblock pieces are a logo of wood patterns means they can go on forever. I know a lot of people have a problem with this, but I think it would be so cool to get B&Q to make them, I like the idea of having them in different places – fancy design shops, friends having them in their bathrooms, collectors having houses made of them. That's not to do with them having to be all over the world, it's about them existing in all these different architectural and contextual situations.

What would make them different from any other commercial laminates you can buy?

Nothing.

Would they be art, or would they be utilitarian floors?

That's not for me to decide, but I don't worry about these things. I don't spend a lot of time worrying about the secondary market. But if we could mass-produce these floors, and they could be cheaper, that would be an interesting thing to think about.

Is there a link in any way with what Gregor Schneider does, in terms of making interventions in domestic or museum spaces? Often he builds a wall in front of a wall, in a way no one realises, or a ceiling under a ceiling.

What I do is much more about the floors or walls making you look at the rest of the space differently. With *NewBUILD* in Oxford, the red brick surface made you notice the real bits of architecture around it. Similarly, the cartoon style of the floors makes you look at the room that's there to begin with. So I guess my stuff is more to do with pointing out the really normal things. If I did one in your library it would change the way you look at the shelves… It's the difference between the 'graphics logo' of what goes on the floor and your bookshelves. It's the graphic that makes you look at the stuff around you. If you've been shopping and you plonk the bright shopping bags in your house, you suddenly notice the table is different in relation to the bags. That's something about the function of graphics and their relation to real things. It's about all those different spaces and highlighting all those different DIY moments that may have gone on in those spaces, and the design moments… I'm not worried that my floors could be commerce or design. It's not a concern for me.

People have traditionally used architecture and design as a status statement about how much money they've got. With *Super Tudor* in Woodstock Adam Lindemann could be seen as making a similar statement that he lives in a work of art.

Of course, and he does.

The owners of the original mock Tudor houses were making a statement about taste and money and status, and he and the Blows are using art in the same way.

That's true, and that contradiction, if that's what it is, is what's interesting to me. If you think about William Morris, the people who had a William Morris wallpaper a hundred years ago would run a million miles from Liberty today. You can't control the reading of decoration or pattern because it changes all the time.

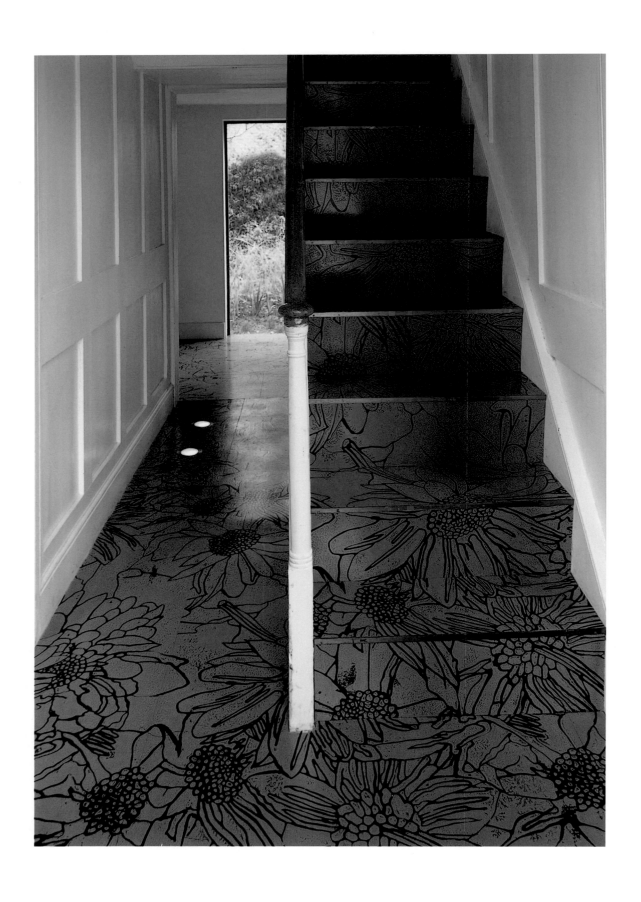

Floral repeat no. 1 (2000), Collection Detmar and Isabella Blow, London

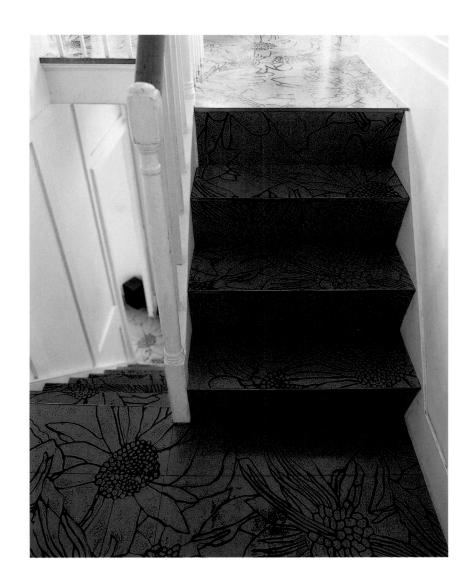

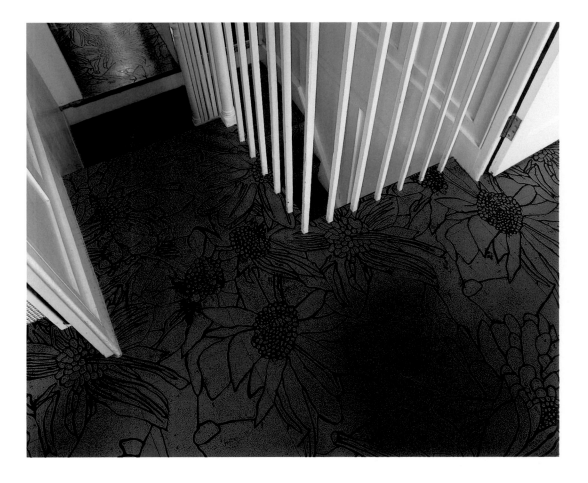

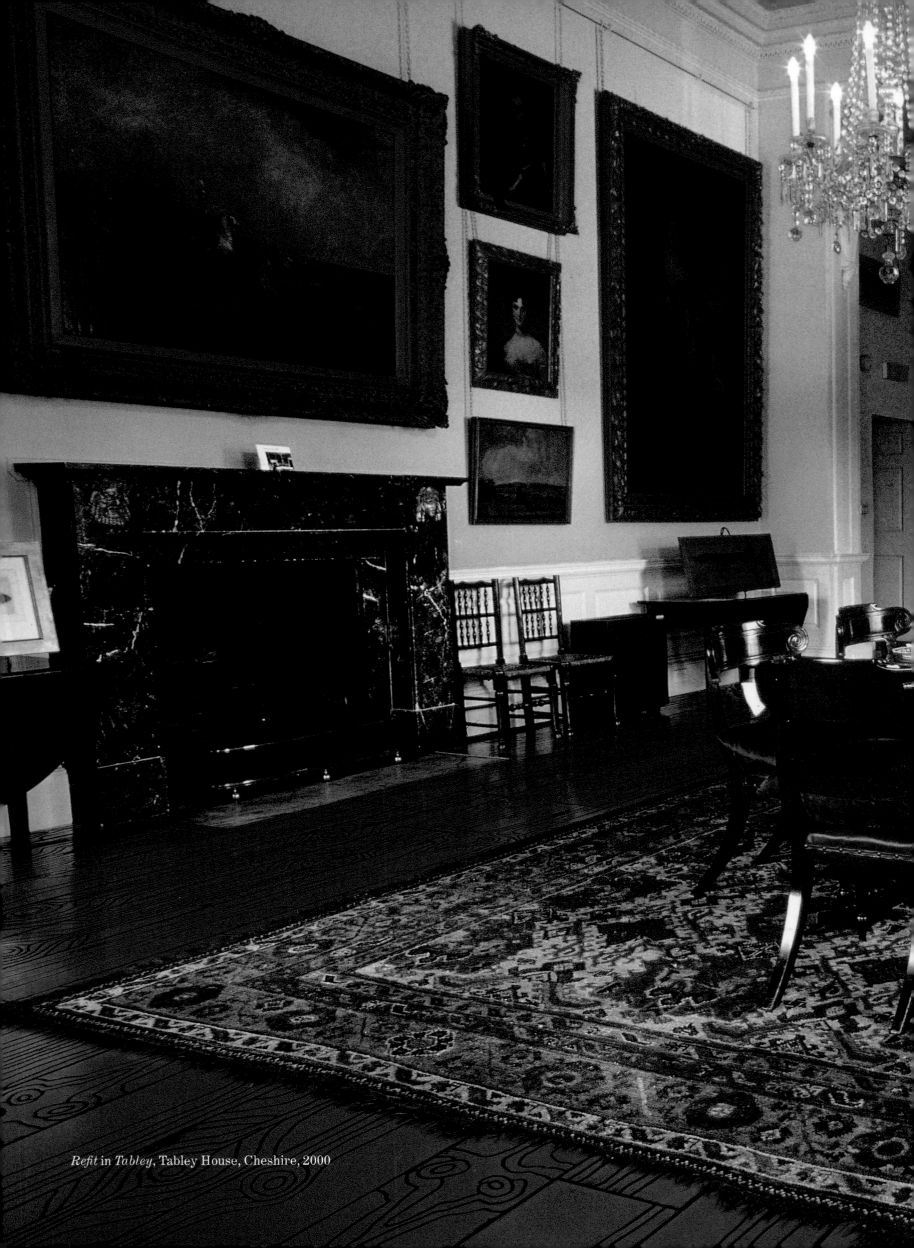

Refit in *Tabley*, Tabley House, Cheshire, 2000

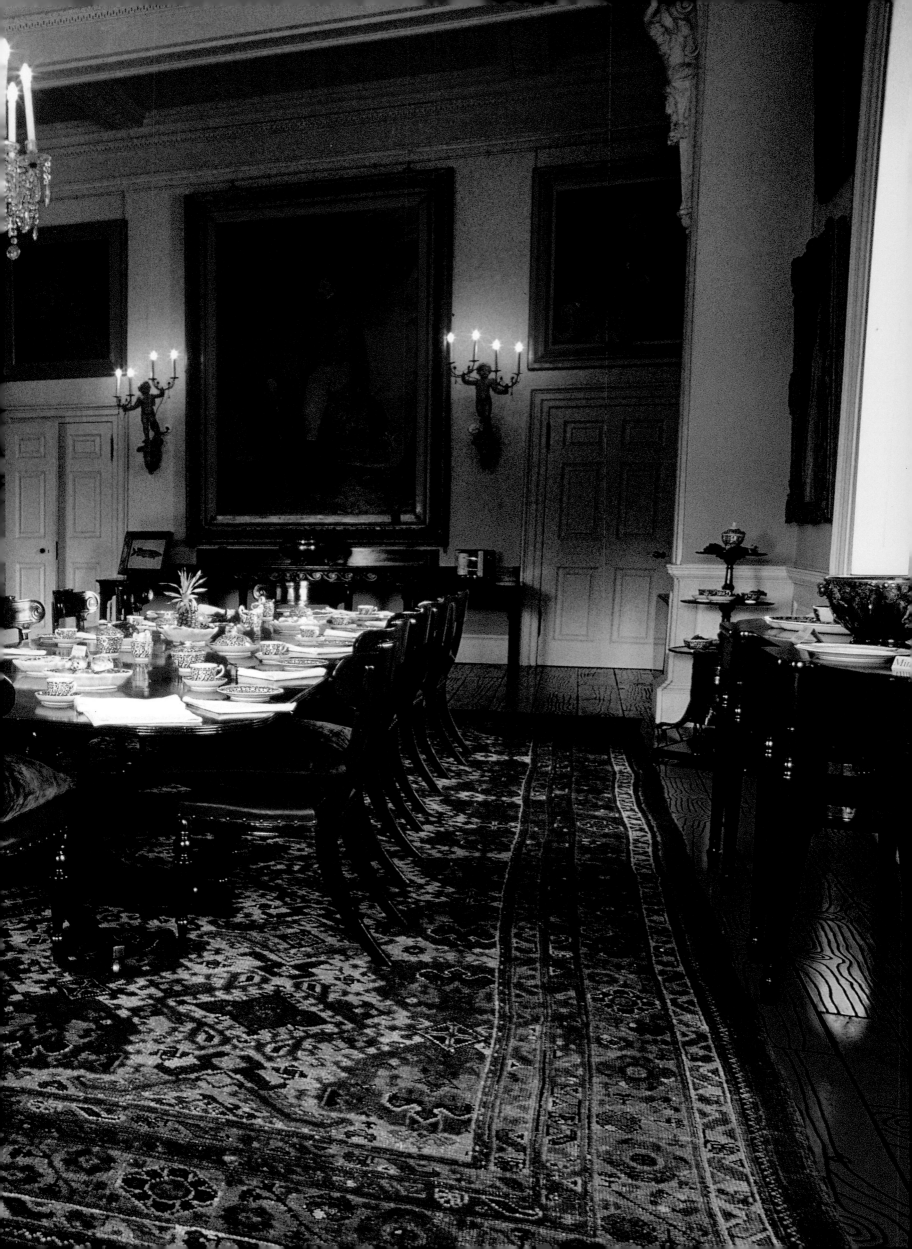

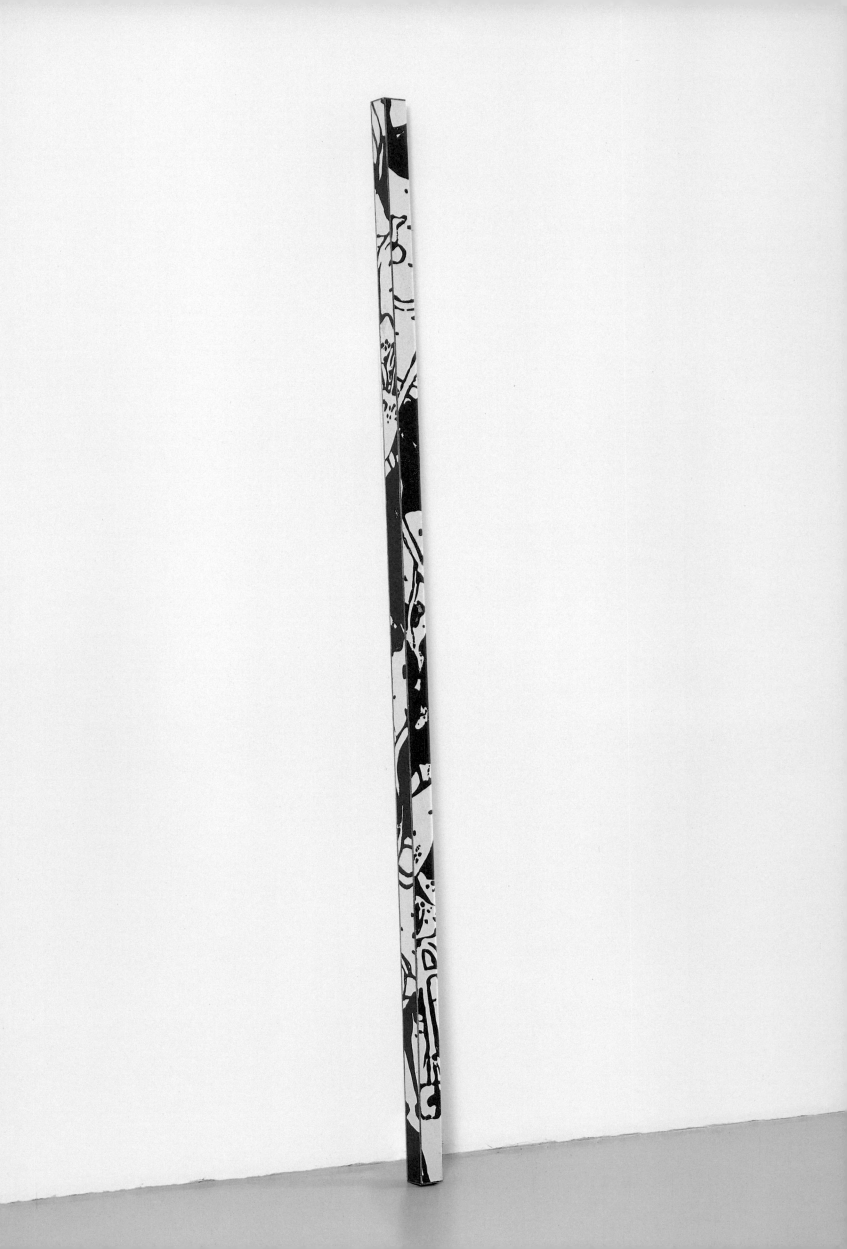

GORDON BURN: How did you get to make the kind of work you make now, as opposed to conventional sculpture or painting?

RICHARD WOODS: I was always in the sculpture departments at college, but I was always more interested in painting. I suppose it's that surface thing again. I've always wanted to make three-dimensional paintings, I suppose.

Tell me what you're trying to achieve with the poles.

They are chopped-up sculptures that have surfaces that have come from other projects. These patterns over here [in the studio] are from a carpet that went into a show in Japan, and we basically had lots of…

…offcuts. [Laughter]

Yeah, and they're all called *Chopped stock sculpture*. The idea is that there's a stock of patterns.

It's like going back to an earlier time when nothing was wasted. I remember we used to have lino on the floor – oil-cloth – and have leftover bits cut off and we stuck them down somewhere else, 'round the kitchen sink or the toilet or somewhere irregular like that.

I like that the 1950s floral pattern is very much at odds with the objects, it's chopped up and made into very regular rods.

They're a bit like surveyors' rods, marked up with feet and metres…

…or 'two-by-twos' in the timber yard. Just a bit of wood. I need to change the colours, to make them mine, but I do like the idea that they're offcuts.

We were talking earlier about environmental or installation artists that only work on a large scale. Is it important for you to make small things for economic reasons?

No, it's almost the opposite. The reason I have a studio practice is because ideas come into the work at differing paces, and from different places – where I grew up, where I went to school, what exhibitions I've been to see, what music I'm listening to. But in a huge amount of what I do the ideas come out of actually using stuff and making things – chopping up wood. And as a result I very much need a studio. One of the difficulties of working on a lot of big projects is that you don't always get the material coming back at you in the same way. It's almost like working in an architect's practice. So to have this space to mess around in is really important; it's like a garden shed thing.

It must get tedious, doing big public projects that require permissions, dealing with the bureaucracy. I imagine it takes the energy away from the work.

I hate it, but if you want to make something big and in public there are certain procedures that need to be followed. With a project like *NewBUILD*, say, the way something like that comes about is partly to do with reading about the building's history and so on, but it also comes about through being interested in gloss paint and chopping things up and being in the studio.

A lot of people would say that, at the end of five years of being an art student and fifteen years as a practising artist, to come back to saying 'I like gloss paint and chopping things up', you should go to work in a builder's yard or a timber merchants.

The objects are really important to me, but so are the ideas. I want my work to be based in a relationship with material. I don't want to be an artist that's got a big desk and just draws ideas. I think objects are where ideas and materiality come together. That's what interests me. That's what makes things magical – somewhere between ideas and the physical manifestation of that idea. Some things in the studio, like these poles, may end up as part of some enormous building, or they might stay the way they are. It's important to keep that DIY thing in play. I know that's not a normal working pattern.

Lots of people would simply employ a lot of assistants. Once they've done the idea at the desk, they wouldn't get involved in the fabrication of the piece themselves.

Well, I do have assistants, but the surface of the building is a sculpture and it's up to me to make it live.

In the course of the construction, you mean?

Yes, although that's not a hard and fast rule. I have done projects where I haven't had time to be there, but I do prefer to be about in case things change or need to be changed. I know when they're photographed the things look glossy, but on the surface you can read a roughness or a sense of speed, signs about how they have been put together. Also I may be chopping up red bricks in Oxford and Wimbledon, and I think it might be cool to make something with the offcuts. That sort of thing wouldn't happen if I was away planning the next project. Mixtures of scale have always interested me. I've always done loads of pictures and paintings for that reason. Some of the pictures that I'm doing at the moment are just print blocks placed against the wall, because I'm interested in the way the paint on the blocks is just like the surface of the paint on the pictures, only the other way 'round. I like the way the black flower is only a black flower because it's a bit of wood painted black.

Chopped stock sculpture Mi.02 (2006)
Household gloss paint on plywood
240 × 5 × 5 cm

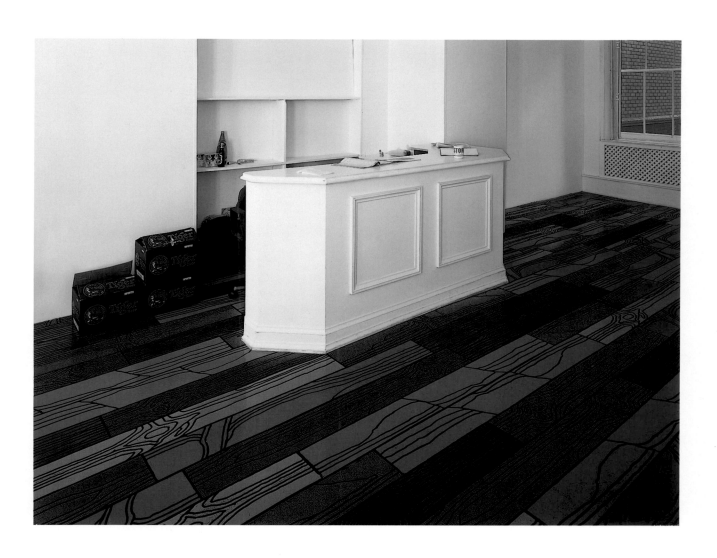

Logo no. 1, Zwemmer Gallery, London, 2000

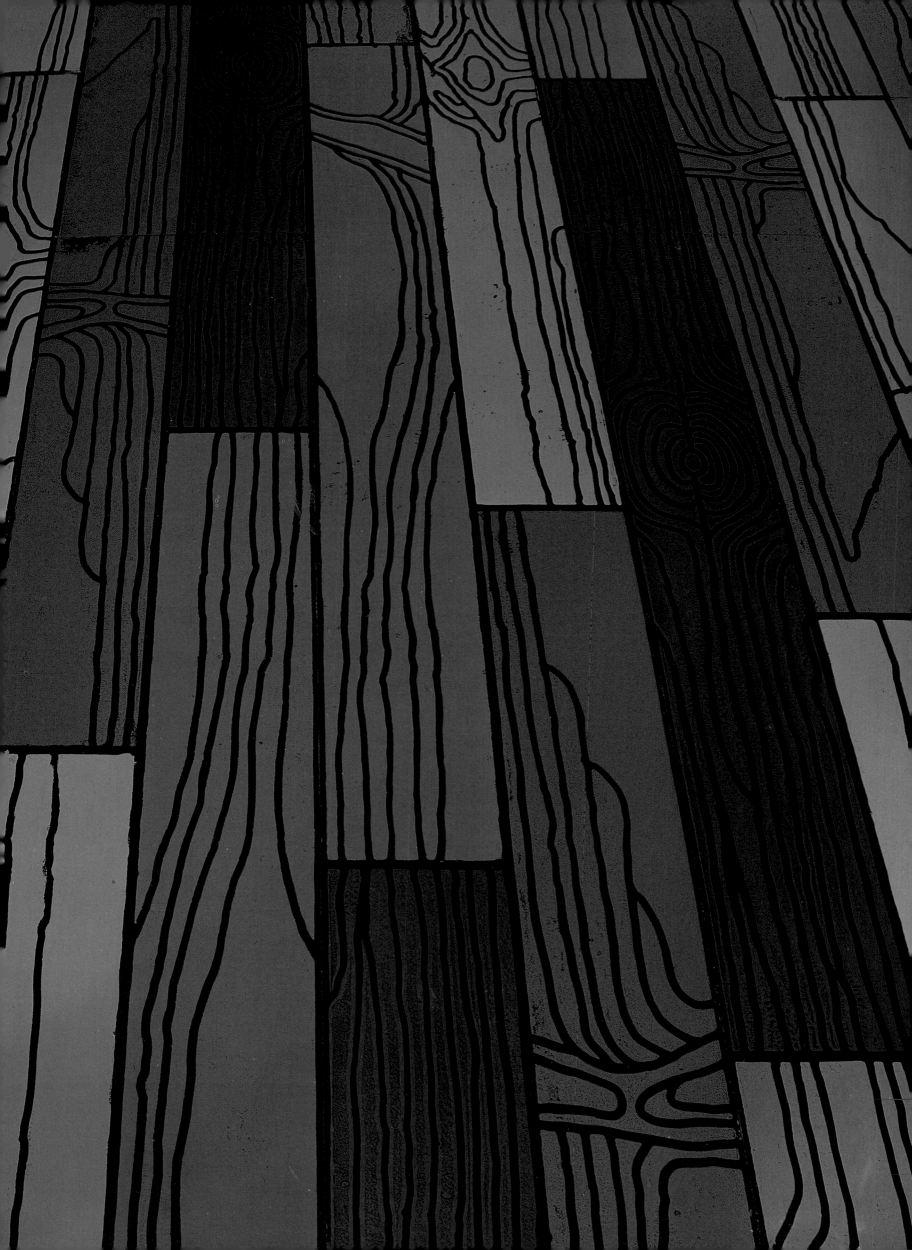

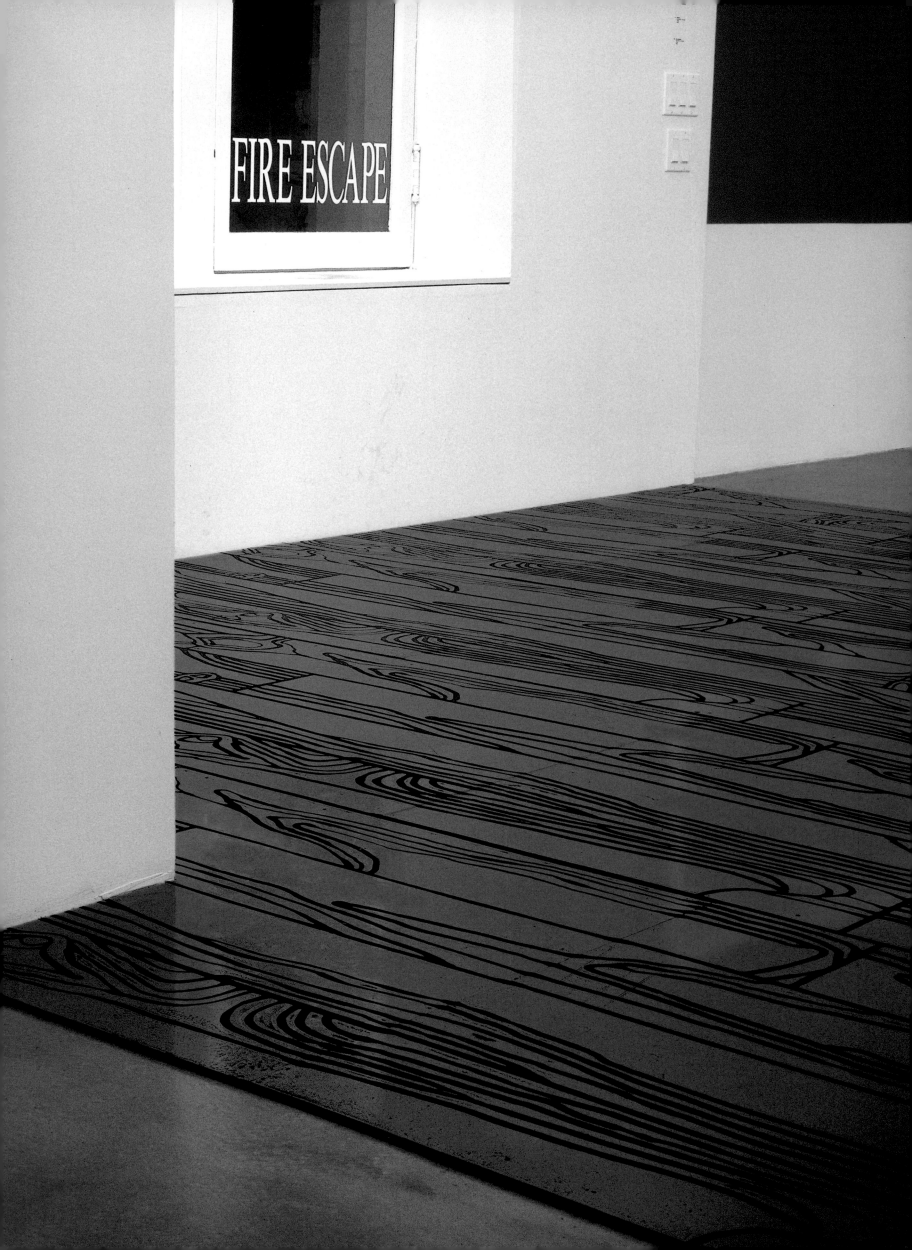

Green floorboard repeat in *Let's get to work*, Susquehanna
Art Museum, Harrisburg, Pennsylvannia, 2001

Green floorboard repeat in *Let's get to work*,
Marcel Sitcoske Gallery, San Francisco, 2000

Green floorboard repeat in *Let's get to work*, Philadelphia
University of the Arts Gallery, 2001

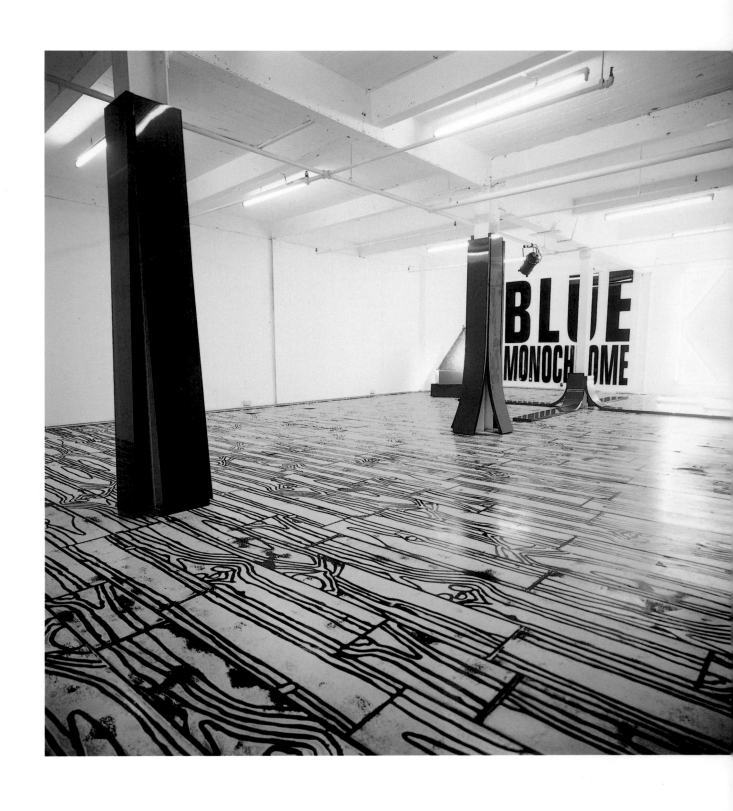

Loft life renovation sculpture in *Richard Forster and Richard Woods*,
Waygood Gallery & Studios, Newcastle upon Tyne, 2001

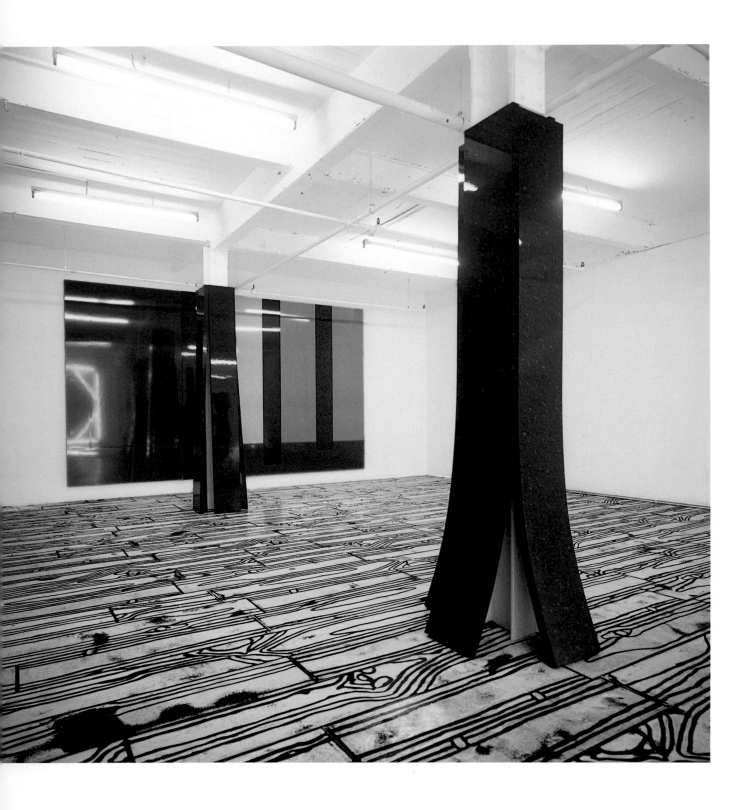

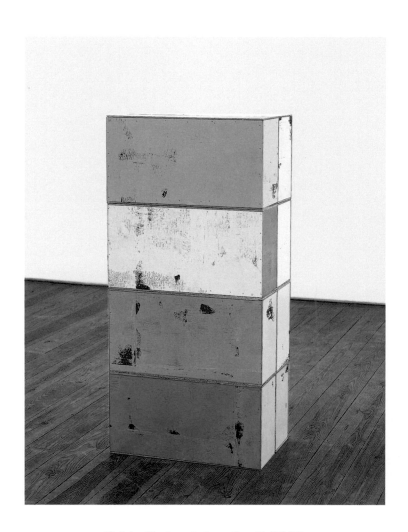

Brick effect sculpture Jm.02 (2006)
Household gloss paint on plywood
$112 \times 52 \times 34$ cm

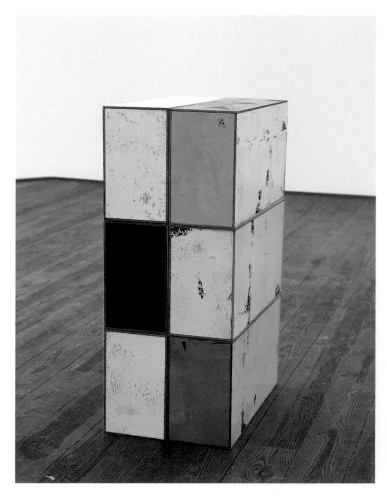

Brick effect sculpture Jm.04 (2006)
Household gloss paint on plywood
$84 \times 52 \times 34$ cm

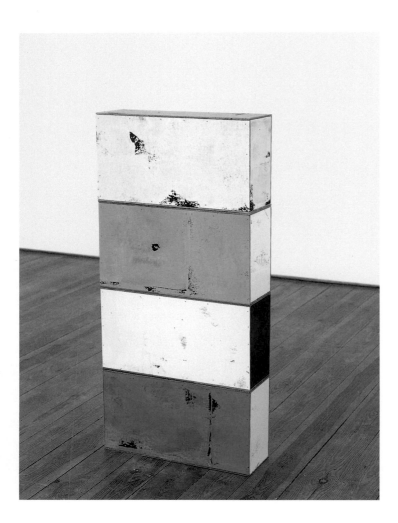

Brick effect sculpture Jm.06 (2006)
Household gloss paint on plywood
112 × 52 × 17 cm

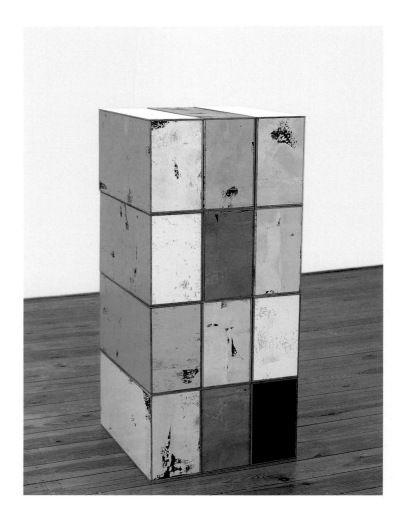

Brick effect sculpture Jm.01 (2006)
Household gloss paint on plywood
112 × 52 × 51 cm

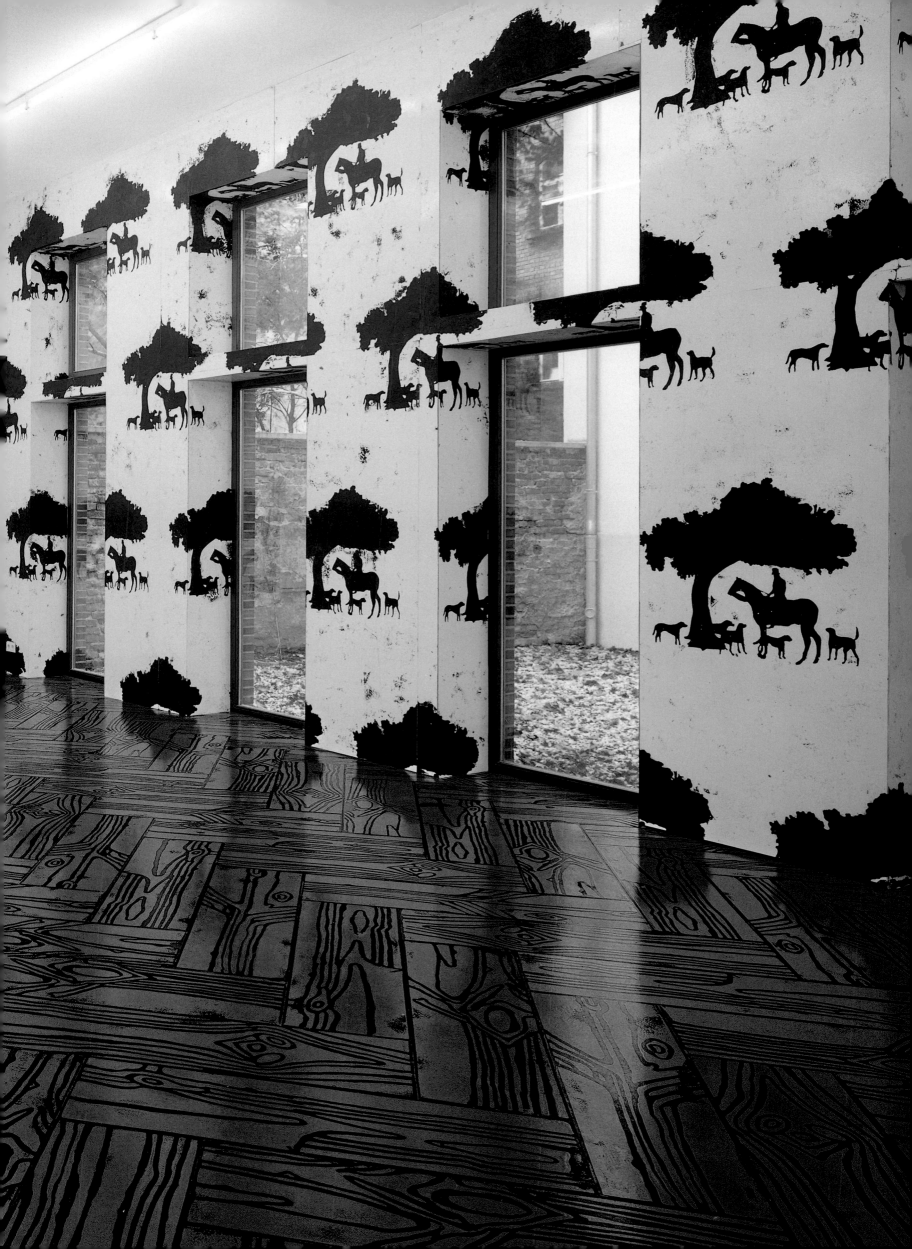

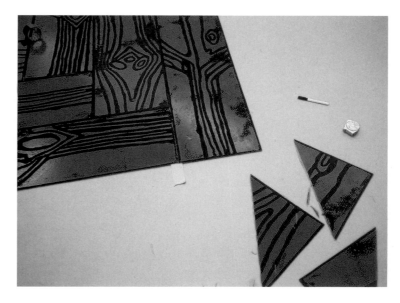

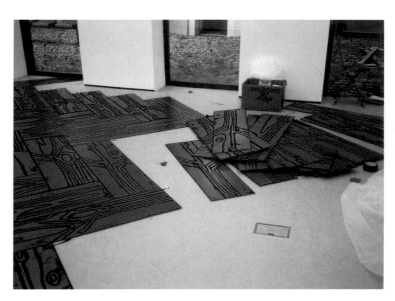
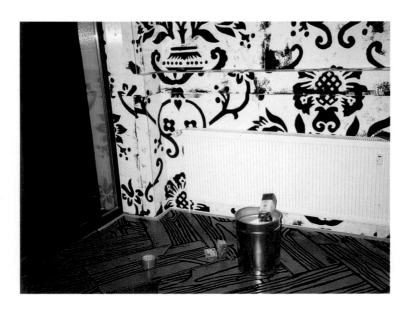
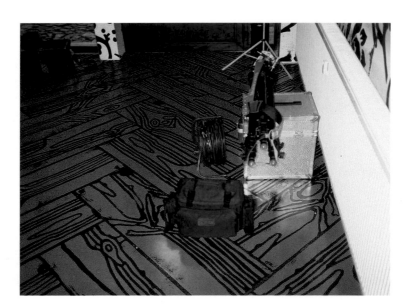

Richard Woods, griedervonputtkammer GmbH, Berlin, 2001

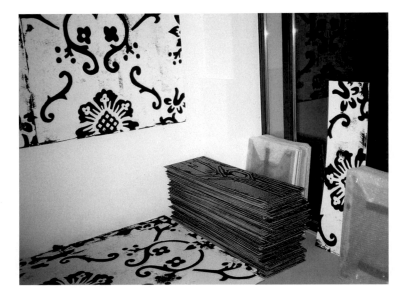

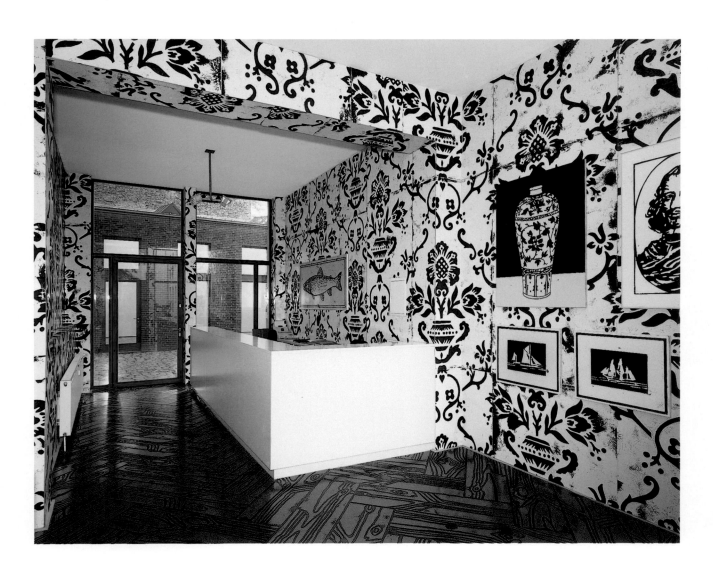

Richard Woods, griedervonputtkammer GmbH, Berlin, 2001

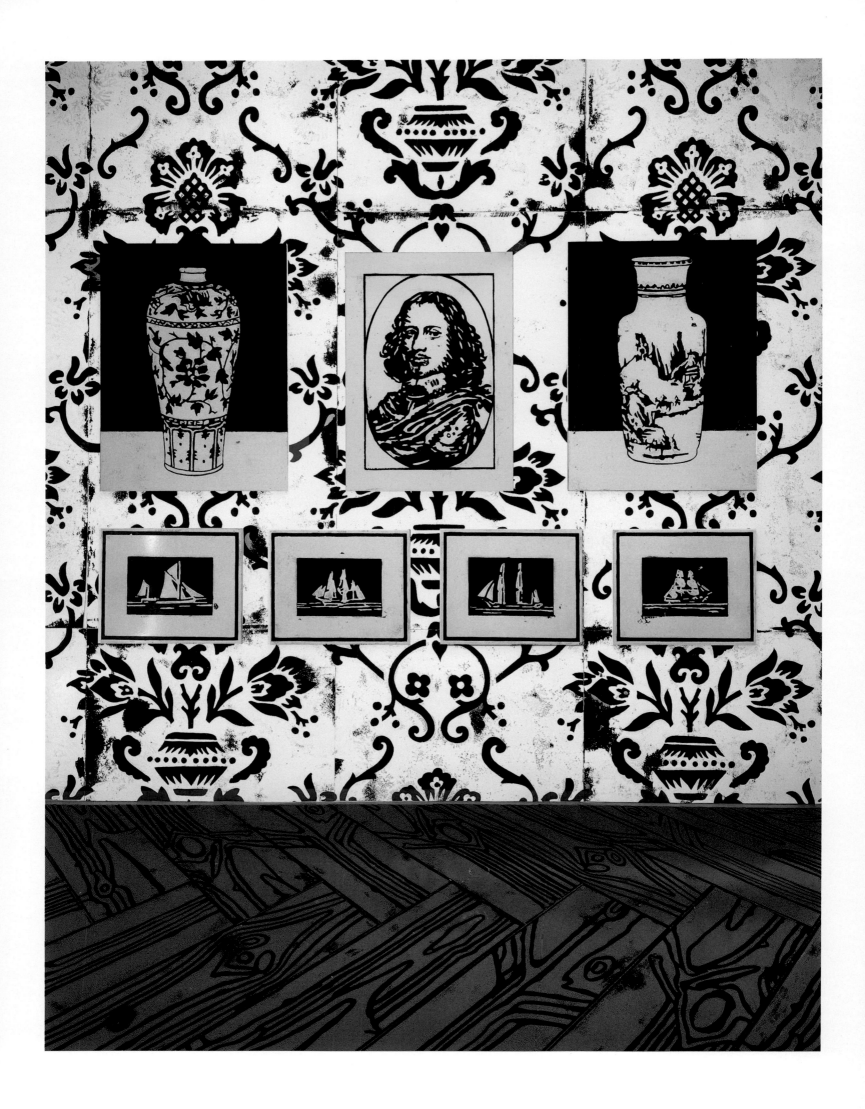

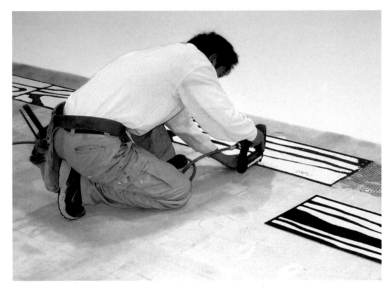

Floor and furniture for the store interior of the Osaka branch
of the fashion house COMME des GARÇONS, 2002

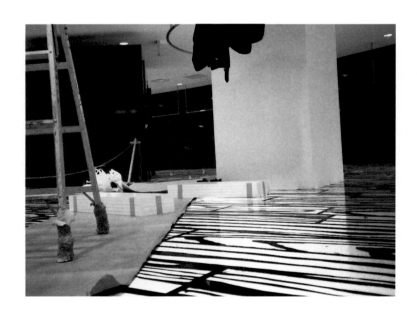 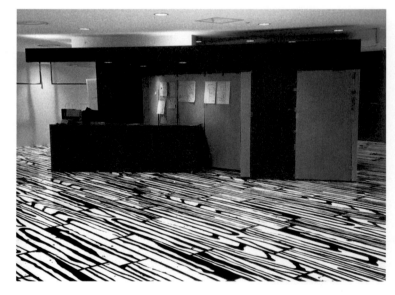

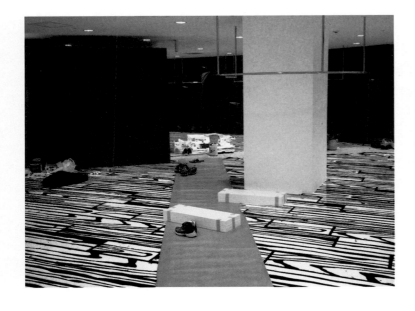
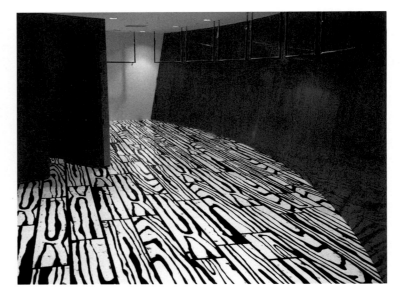
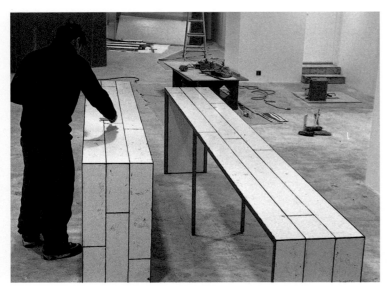

Floor and furniture for the store interior of the Osaka branch
of the fashion house COMME des GARÇONS, 2002

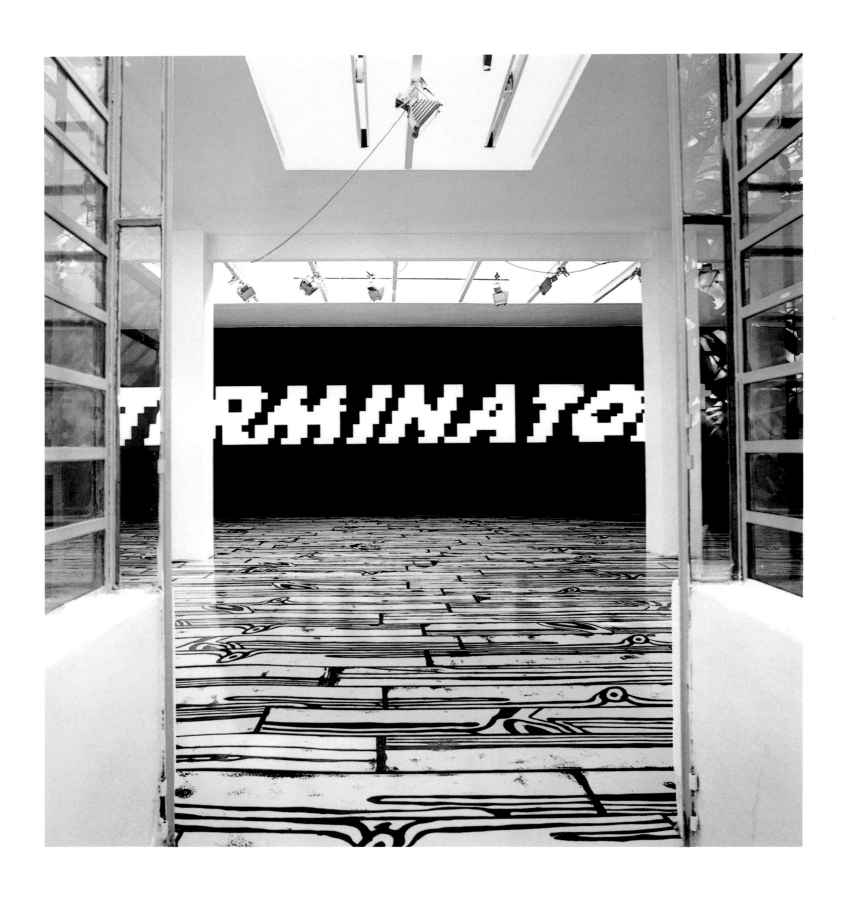

Logo no. 5 in *Framing My View*, Galleria Maze, Turin, 2002

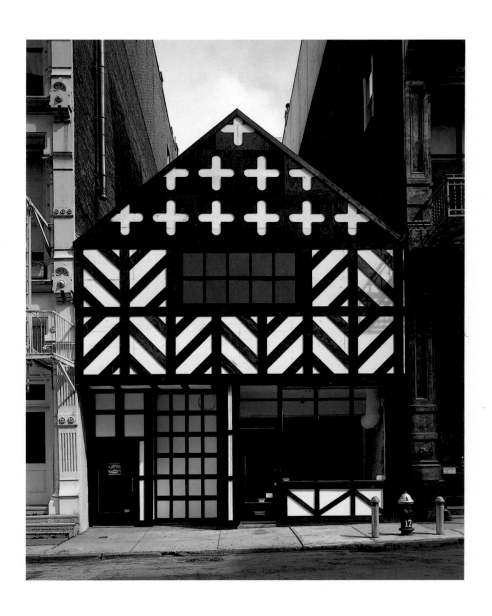

Super Tudor, Deitch Projects, New York, 2002

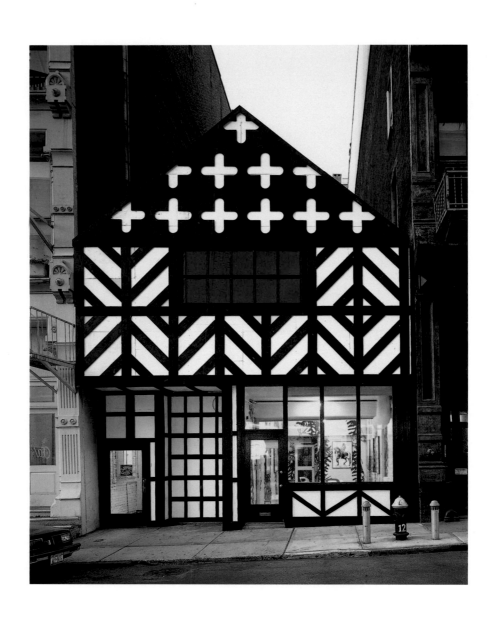

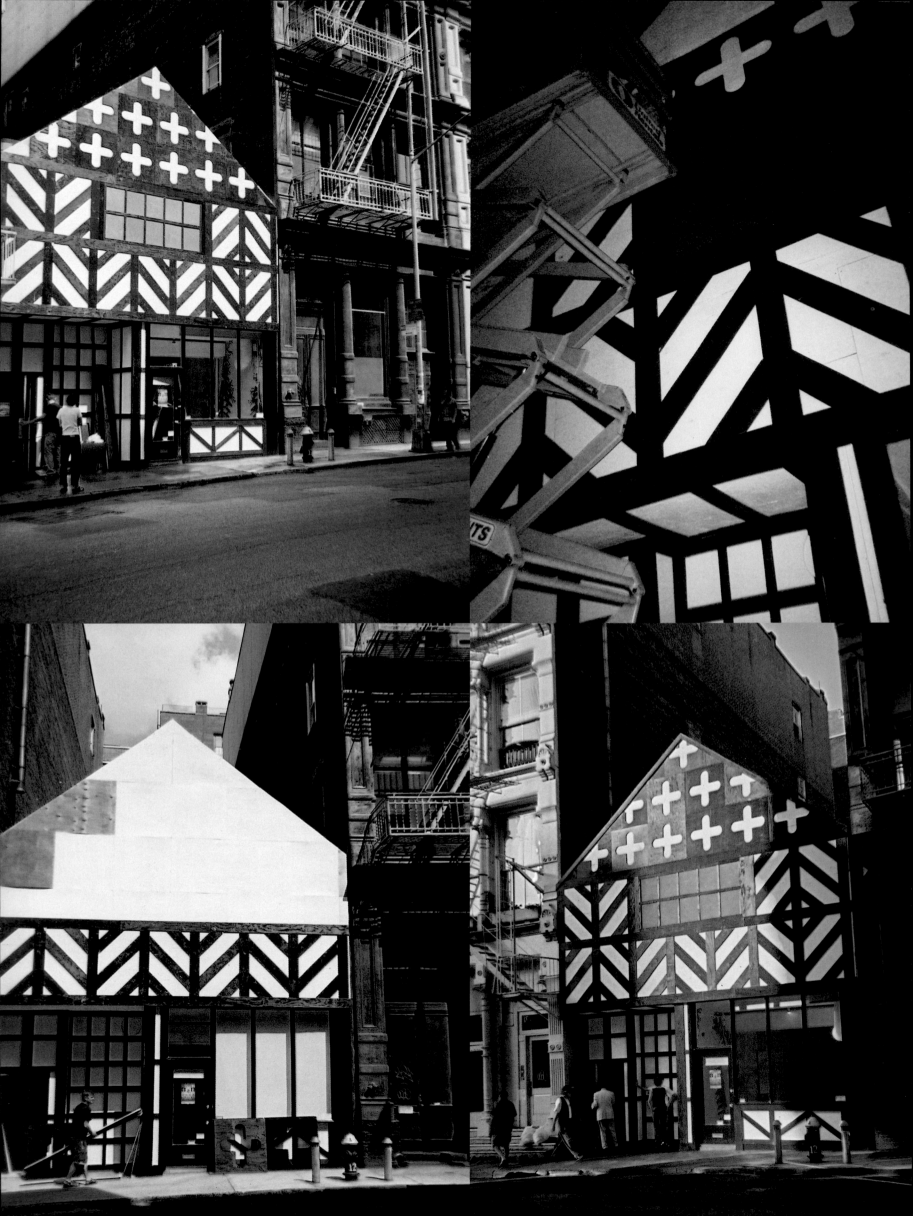

GORDON BURN: I have always had the idea you grew up in the countryside.

RICHARD WOODS: I grew up in a village five miles outside Chester [in north-west England]. It was very much rural.

And yet the work is full of references to suburban architecture and the artefacts of suburbia.

Well, it's a strange mix, because I grew up in a big row of council houses that were sort of in the middle of nowhere, like a lot of villages.

These were agricultural workers' cottages?

No, 'new-build' 1950s. Obviously the village was agricultural, but this row of cottages was built just after the war to house the children of people whose families had been agricultural workers… If you drive 'round the country, through a rural idyll, you often come across a big row of council houses.

They're often tucked away, aren't they, screened behind trees? They're usually carefully out of sight.

Yes.

So as not to be a blot on the landscape.

These looked quite nice, but they were quite big, maybe forty houses next to each other.

In one row?

No, a dogleg. But in a village that maybe only had three hundred people in it, it was like doubling the size of the village overnight, in a big 1950s housing boom.

Was that surrounded by vernacular, country-type architecture?

Yes, exactly.

There you go. Say no more. It's as simple as that. There's the whole story right there. [Laughter]

So it was very rural, but…

…not like mock Tudor and that Chester-type of half-timbered architecture?

Chester is a very weird mixture, because in the middle you've got Victorian mock Tudor, but then whole swathes of suburban 1950s and 1960s and 1970s mock Tudor.

What was around your terrace? What kind of architecture, what kind of rustic buildings were you surrounded by then, when you were growing up?

Well, like all those Cheshire villages, there's sort of everything. There's the real thing and then there's the Victorian and then there's the post-war styles. So it was a kind of hotchpotch… The terrace I'm from is brick; they're very familiar buildings.

The kind with arched alleyways down between them, leading out the back?

Exactly. There was obviously a big housing boom after the war, and these rural places needed council housing, for people who were the children of people who lived in the villages, and for people who wanted to move out of the towns.

What did your dad do?

My dad was originally a draughtsman who spent most of his working life being a trade union…

…dictator. [Laughter]

So, basically his skill was as a draughtsman, but he was a trade unionist.

Why did he move from the city to the country?

I think it was a love thing.

When he met your mum?

Yeah. My mum's from the village, and I think he fancied an escape from 'the smoke'. I think that was the reason.

Do you think there's a class element in your work? Sometimes just the dislocation between what you make and where it's shown – the Royal Academy of Arts, Tabley House in Cheshire – is enough to suggest that is the case.

For me it's quite hard to make work that isn't class-conscious. My work is overtly that way.

Yet surprisingly few people have picked up on that aspect of it. Maybe it's the elephant in the room. One of those things so obvious it doesn't merit a mention.

One of those things you don't mention…

…either out of politeness, or it's so obvious, you don't see it.

If you take aesthetic moments that you think of as 'taste' out of one context and put them into another, which is basically what I do, I think there's an equivalence with what the working classes are often accused or even ridiculed for doing. That is, taking an aesthetic they like and putting it in their houses where it supposedly doesn't fit. I guess I do the same thing. That makes what I do class-based. But hopefully it's not in any way a judgement. The work is not intended to be judgemental.

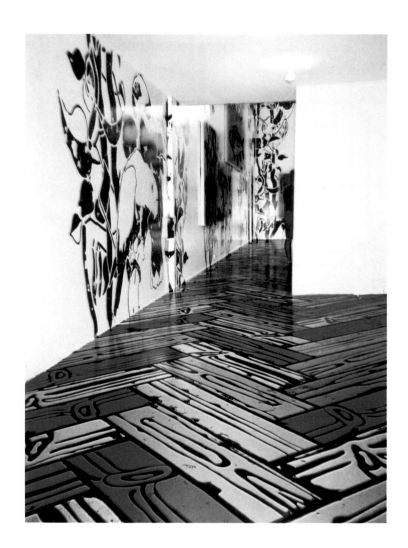

Super Tudor, Deitch Projects, New York, 2002

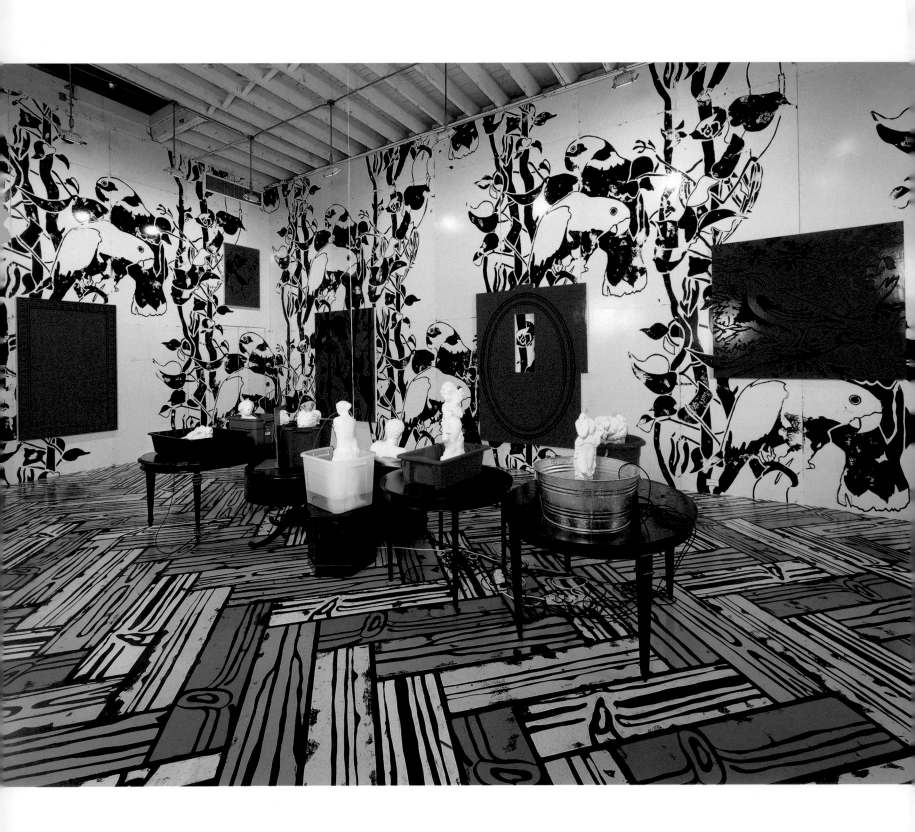

Super Tudor, Deitch Projects, New York, 2002

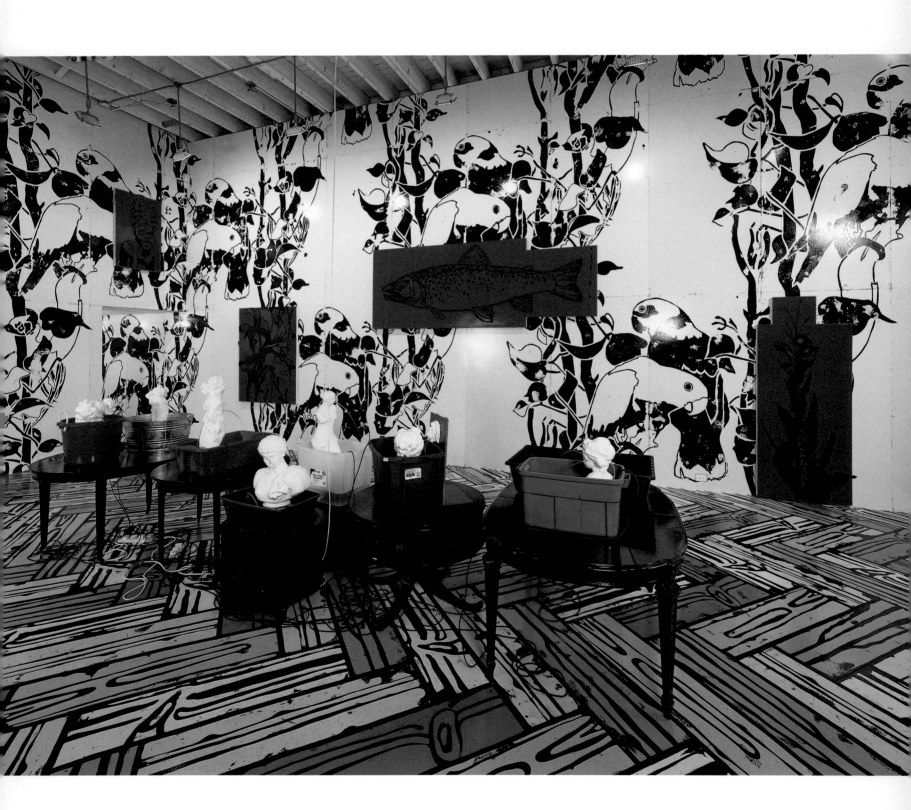

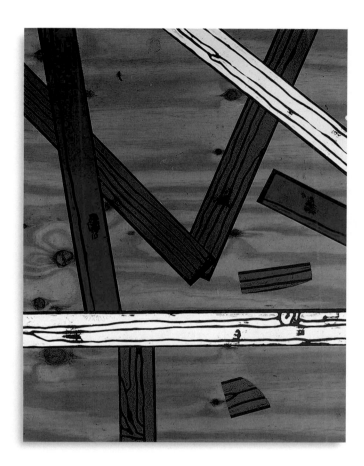

Offcut inlay picture no. 3 (2006)
Household gloss paint on MDF with plywood
122 × 90 cm

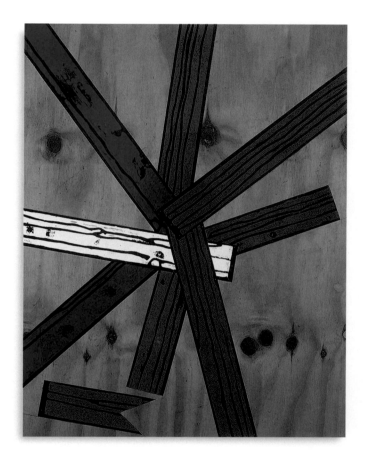

Offcut inlay picture no. 1 (2006)
Household gloss paint on MDF with plywood
122 × 90 cm

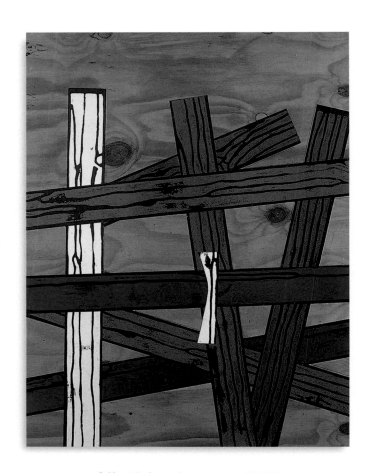

Offcut inlay picture no. 6 (2006)
Household gloss paint on MDF with plywood
122 × 90 cm

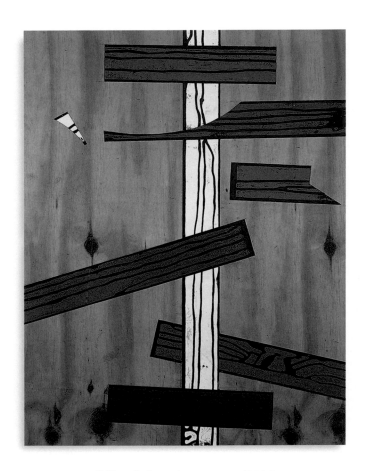

Offcut inlay picture no. 5 (2006)
Household gloss paint on MDF with plywood
122 × 90 cm

GORDON BURN: A lot of people seeing the lurid parrot wallpaper and the leaking garden centre fountains in the Royal Academy could easily have assumed that there was something judgemental going on – that you were making a hierarchical distinction or at least a comment on the difference between popular culture and difficult art.

RICHARD WOODS: No, not at all. What I really enjoy is where aesthetics sort of takes routes – maybe where the fine arts influence design or textiles – and then maybe there's an influence that comes back again into fine art. So it's more where different visual art histories meet and then move apart and then come together again. I just like with *Various pouring and leaking sculptures* that they are obviously garden sculptures that you can buy from any garden centre.

They're the sort of things that certain people who regard themselves as having exalted taste would laugh at, like garden gnomes. The fountains are a cheap plastic version of marble. It's always the kind of thing that will raise a laugh, isn't it?

Yes. But I suppose what I like is that for me they have aesthetic qualities that are really interesting, and I like the idea that there's been a journey, where they are the result of influence and style, and class. And that they end up back there again.

A journey from somewhere like the Royal Academy…

…back to Essex. [Laughter]

Marble into plastic, into a suburban garden, and back to the Royal Academy.

A lot of my works make those sorts of journeys.

Let's stick with the Royal Academy for a moment. In that show you've got so many levels of stuff going on. You've got the parrot wallpaper, which is a blown-up version of fairly basic, cheap, household wallpaper. You've got the plastic statues standing in the cheap plastic receptacles, some of which have still got the labels or price tags on. These are then placed on 'repro' occasional tables, painted with gooey serviceable brown paint. There's a blizzard of references going on that makes it hard to work out if it is or is not ironic, and where the artist is coming from. A lot of people would read that installation as a contentious or fairly political statement. And if you showed it in a white cube gallery it wouldn't have anything like the same depth of reference.

I wouldn't want to show that installation in a white cube gallery. The most important layer of reference is the fact that it was shown at the Royal Academy. Somewhere that taste has been dictated, people go there to acquire…

…a worldly sophistication.

Exactly. I've been asked to show the sculptures in another space, but I feel they have been and done their thing. We did take a version out to Venice for *Import/export sculpture*, but that again was a context thing. They need that kind of context. I can't think why I'd want to put them into a white cube gallery because the textural complexity would simply disappear.

Why did some pour and some leak? In other words, in some of the statues the water came out of conventional statuary holes, and in others the water came out of accidental holes. Well, apparently accidental holes you'd made on purpose. [Laughter]

Two cockatoos (red) and *Various pouring and leaking sculptures* at Modern Art in *The Galleries Show*, Royal Academy of Arts, London, 2002

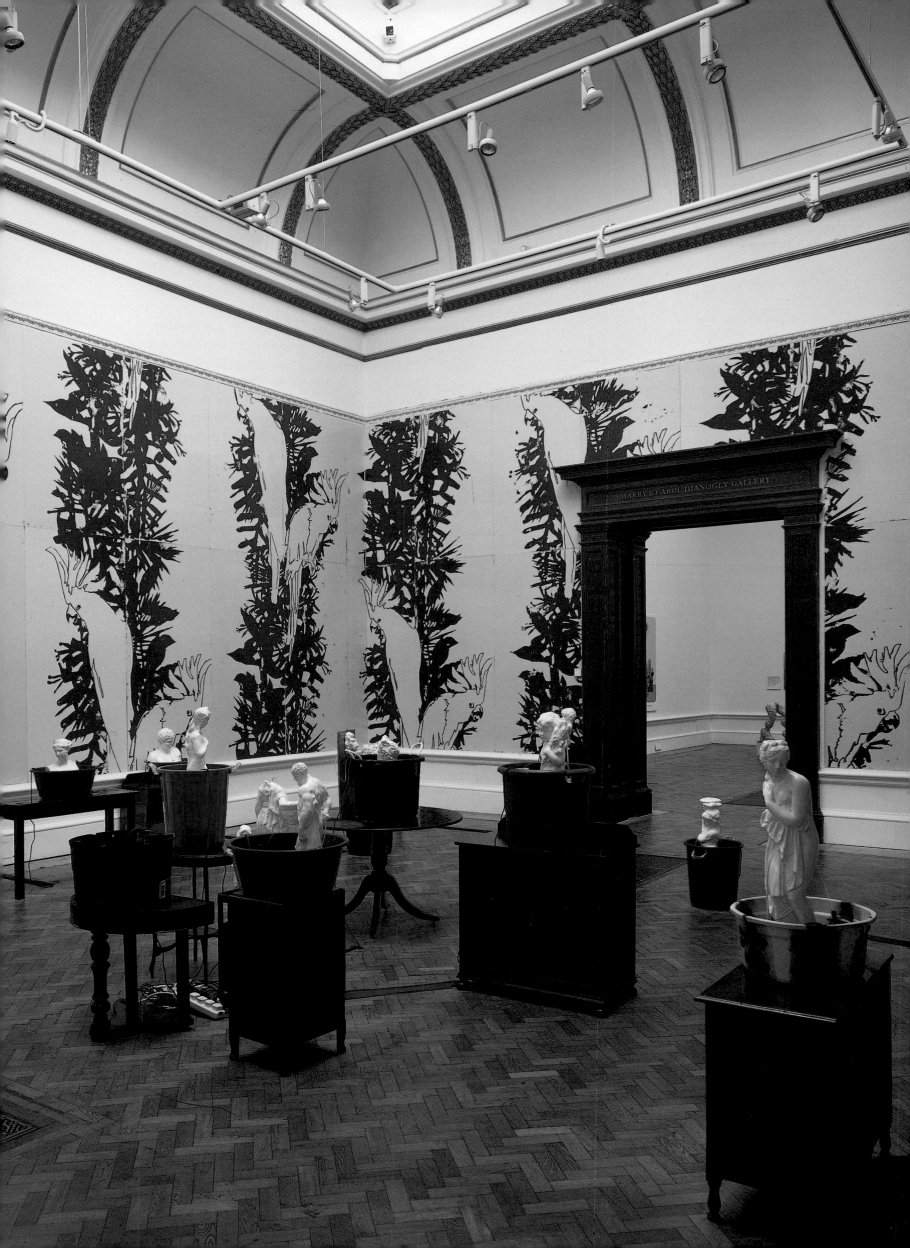

HARRY & CAROL DJANOGLY GALLERY

What was the difference?

I just liked the idea that the pumps were different sizes so some of them looked like there was a sort of grandeur to the water coming out and others, where the pumps were small, looked like there was a sort of…

…leak. [Laughter]

Or a trickle. I know it sounds base, but I also just liked the idea of getting those things and drilling holes in them. I just enjoyed it. And then putting them back in the Royal Academy.

I was going to say that it could be seen as mutilation, but there's a long and dishonourable history of that in art.

There are also plenty of stately homes where water trickles down legs and runs out of strange holes.

And that's just the inhabitants. [Laughter]

Of course, drilling into anything is an aggressive act. There's obviously aggressiveness in all the work. But there are plenty of stately homes where there are Victorian casts of Greek sculptures where water trickles out of some unusual places. I just see it as slightly 'cranking up the knobs' a bit more.

What was the thinking behind having them stand in industrial trays on junk shop tables?

I liked the idea of the buckets, that it's just what you get from ordinary, suburban garden centres. I liked the matter-of-factness. And the graphics – the shape of the buckets, the colours, the stickers. I suppose there's a matter-of-factness in quite a lot of my work that is at odds with the decorativeness. I like the idea you go to garden centres and there are just loads and loads of buckets there. Obviously you don't normally put sculptures in them, but they just sort of worked. They just seem to be stuck in them, there's a sense of them being stranded.

The figures are stranded?

Yes, they're just plonked there; it's just a very matter-of-fact statement.

Seeing loads and loads of buckets together is a sort of pop image isn't it, a Warhol-type image? And leaving the stickers on is a Pop Art statement, in a way that the imagery – which refers back to the Victorians and earlier – isn't.

The sculptures are not sold with the stickers on, but the buckets are. And the sculptures were all given a heavy coat of gloss paint. So there was a weird thing where the sculptures were painted with a uniform coat of white or marbley paint.

Was the intention to make them look marbley?

It was to make them look like it's just about the surface, to make them look like a *version* of marble, or a *version* of concrete. But that surface exists in everything; everything gets a shiny version of its real surface. That white or marbley painted surface on the sculptures for me was making them the same as the buckets.

But you didn't give the buckets a painted plastic patina.

A bucket doesn't need one; it's already a symbol of itself.

In other words, the buckets weren't pretending to be a fake wooden or fake other bucket?

But the furniture needed a coat of paint.

Some of it.

All of it got a good coat of paint.

Dirty brown.

Black, dark brown.

Institutional brown. Boarding-house brown.

Just different woody versions, an all-over aesthetic.

A funny question: Has your name influenced doing this stuff, that fact that you're called Woods? When you were at school, you were probably called Woody.

Well, I suppose we're all a make-up of our ancestors, aren't we, and, probably not going too far back, one of my ancestors spent a lot of time making things out of wood or lived in the countryside. We're all a big mishmash of education and social influences, and parents.

Garden sculptures used in *Various pouring and leaking sculptures*

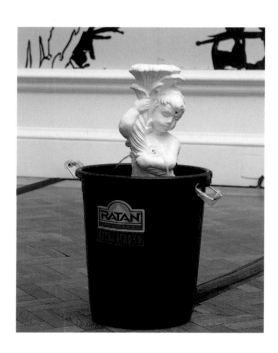

Two cockatoos (red) and *Various pouring and leaking sculptures*
at Modern Art in *The Galleries Show*, Royal Academy of Arts,
London, 2002

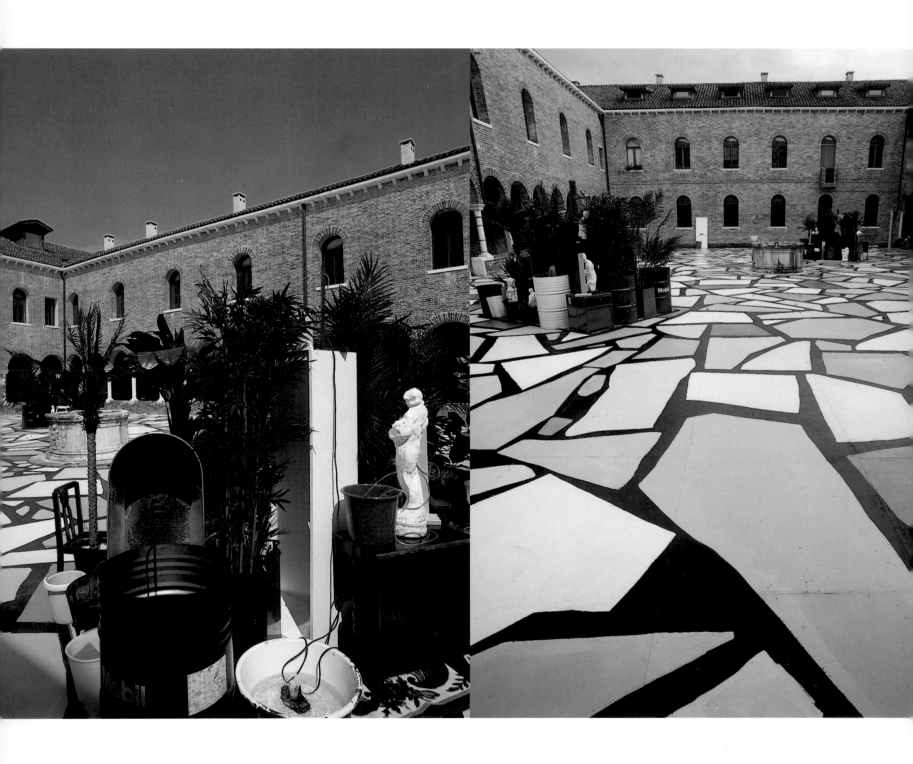

Import/export sculpture in *Stopover*, The Henry Moore
Foundation Contemporary Projects, 50th International
Venice Biennale of Art, 2003

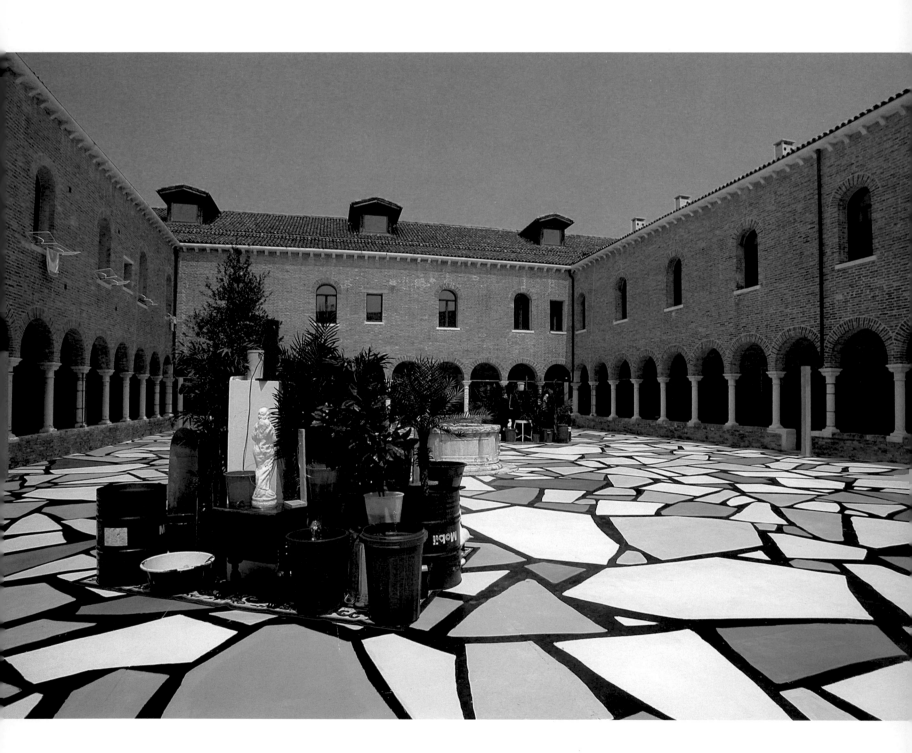

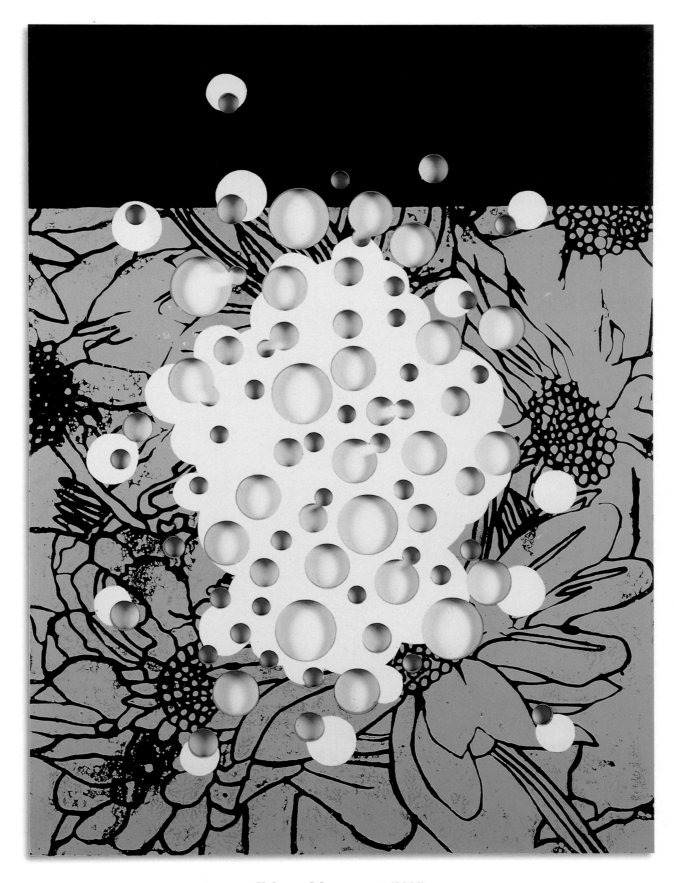

Holes and flowers no. 6 (2006)
Household gloss paint on plywood
122 × 90 cm
Collection Keith Tyson, London

Holes and wood no. 8 (2006)
Household gloss paint on plywood
122 × 90 cm

RICHARD WOODS: When I started to work on the Deitch show it was uppermost in my mind to make an artwork that was commercial. The idea being that we mock Tudorise the front of Deitch Projects in New York and then try to sell the work to someone who then has bought the right to mock Tudorise their own building. This right can be repeated as many times as the collector wants, as long as it only exists in one place at any time. The centre of the work is the fact that the collector is buying the right to mock Tudorise a building, something that they can obviously do without the purchasing of the artwork. The hope was that the work is sold on or remade a number of times and thus the artwork becomes more interesting the more times it is remade. The work exists as a certificate and a collection of photographs.

GORDON BURN: I'm trying to think of Adam Lindemann explaining to his Woodstock neighbours that not only has he decided to mock Tudorise his house, but that it's also a work of art. Plus he's paid money for the permission.

I think it's a really interesting idea, for somebody to purchase the right to do something that loads of ordinary people already do. There's a fine history of this in the arts.

Have you thought about decay, the world making its effect on the work?

Adam's house is permanent so it will change.

It won't last very long, will it?

Hopefully, it should last about twenty years.

The black and the white will fade?

Yes.

Woodstock is in upper New York State, so it gets cold and snowy. He's done the inside as well?

Yes.

Is it his full-time house or is it his weekend home?

It's his weekend house, but I think he's there a lot.

Woodstock's got the background of the Bob Dylan folksy thing going on: Dylan and the Band, *The Basement Tapes*, *Music from Big Pink*.

It's a fascinating place, and I made a lot of trips there over the summer during which the piece was made… Adam has bought this thing, the rights, which he can sell to someone else. The point is that anybody can mock Tudorise their house, but not everyone can do it with me. I like the idea that this piece of work only gives the same rights to mock Tudorise as anyone else has got. I really like that.

There's something going on with the relationship between the natural and the synthetic, isn't there? You've never actually used synthetic materials, such as Formica or decorative plastic surfaces, in the manner of, say, Richard Artschwager. Instead, you use an acid-coloured, cartoon version of a natural thing – wood, brick, marble, whatever.

My childhood was spent climbing trees and digging holes. It's an organic rural background. The things I'm interested in are wood, stone, trees, flowers. But the way that interest manifests itself is always very synthetic. I'm drawn to portraying nature and the natural, but it's always rendered in a noisy, urban-inflected kind of way. Even when the wood is yellow, it's a synthetic yellow. Always. It has always been there.

In some ways, it's a working-poor/agricultural-worker's aesthetic, isn't it? Go into a worker's cottage, or a council house like the one where you were brought up in the country, and it's never the cosy, rustic inglenook interior you might have been expecting. It's always patterned wallpapers and nylon carpets and bright paint. All the 'atmospheric' old stuff has gone and been replaced by the 'mod cons' and labour-saving devices that came in in the late-1950s. Instead of having enamel painted walls and utilitarian furniture suddenly it was all colour and brightness and…

There certainly was a lot of purple. [Laughter] What you're saying is something I think about a lot; it is that 'home and interiors' thing.

In his book *Chromophobia*, David Batchelor talks about the difference between what he calls digitised colour, commercial colour that comes in tins, and analogical colour, artists' colours that come out of a tube. The post-war period was the period of the digitisation of colour in art. This, Batchelor argues, 'was an entirely new conception of colour': 'More urban colours than the colours of nature. Artificial colours, city colours, industrial colours. Colours that are consistent with the images, materials and forms of an urban, industrial art.'

I tend to think of it as colour that tries to be something else or colour that tries to be itself. I'm comfortable with colour that's just being itself.

And industrially produced.

I like colours that are to do with making it now, although the images may be period or antique.

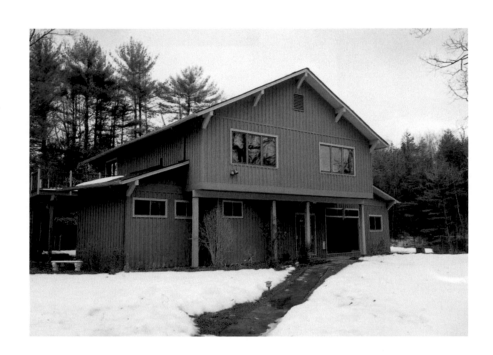

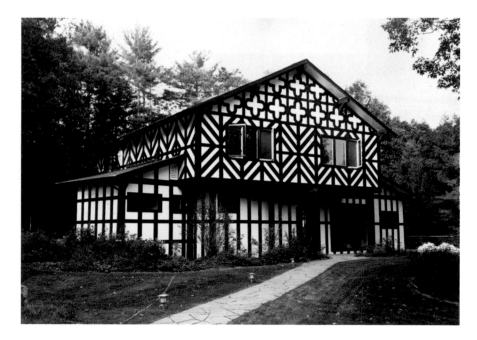

Super Tudor (2003), Collection Adam Lindemann, Woodstock, New York

AUTHENTICITY CERTIFICATE

ARTWORK: " Super Tudor "

ORIGINAL INSTALLATION DATE: September 2002

ORIGINAL INSTALLATION LOCATION: Deitch Projects, New York

ORIGINAL COLLECTOR: Adam Lindemann, New York

ORIGINALLY PURCHASED FROM: Deitch Projects, New York 2002

ARTWORK SPECIFICS: The artwork "Super Tudor", gives the collector the right to convert any building into a mock Tudor style. The process can be carried out as many times as the owner of the work chooses, with the provision that artwork can only exist in one form at any time. The Artwork can be re-sold. This certificate is accompanied by photographs of all previous manifestations of "Super Tudor".

[signature]

RICHARD WOODS

DATE: 20th September 2003

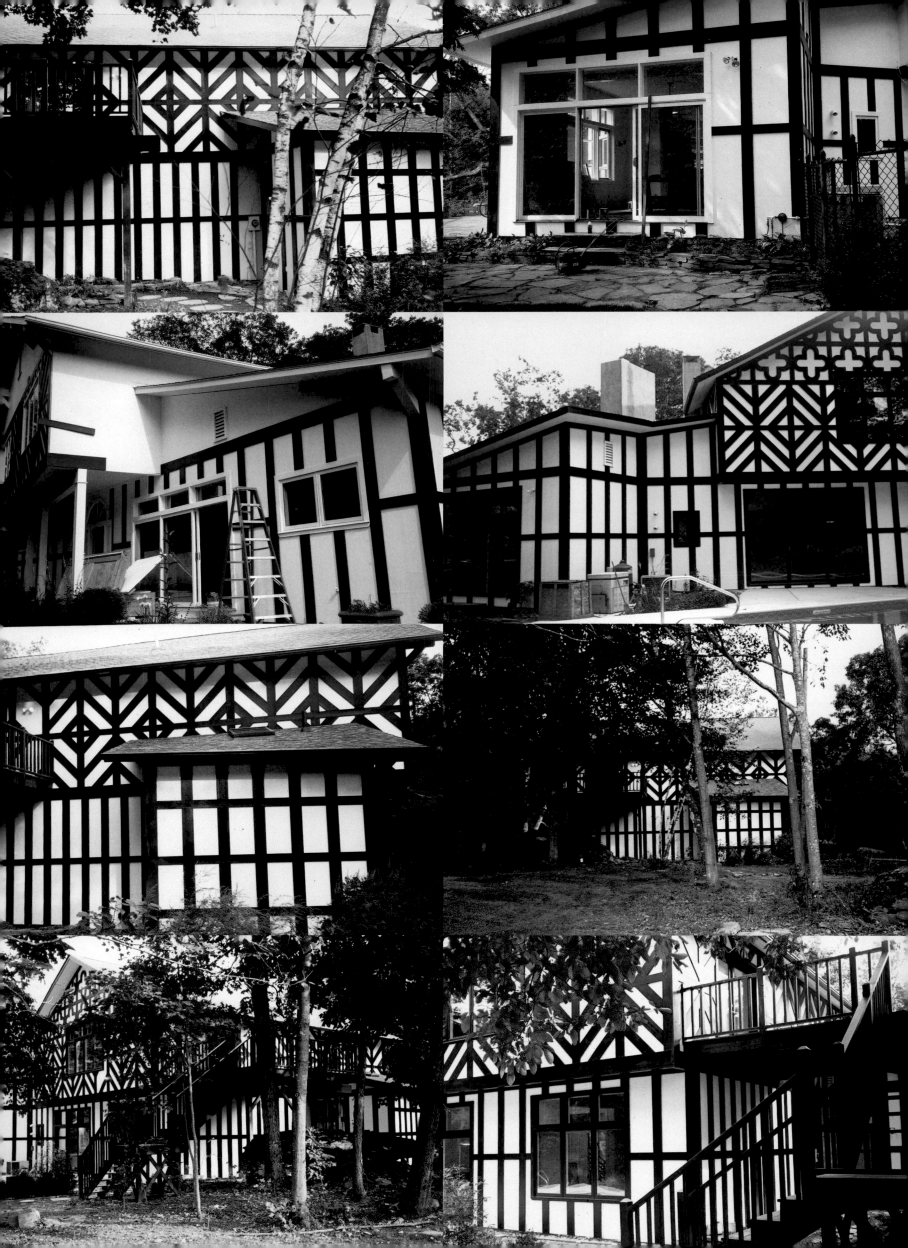

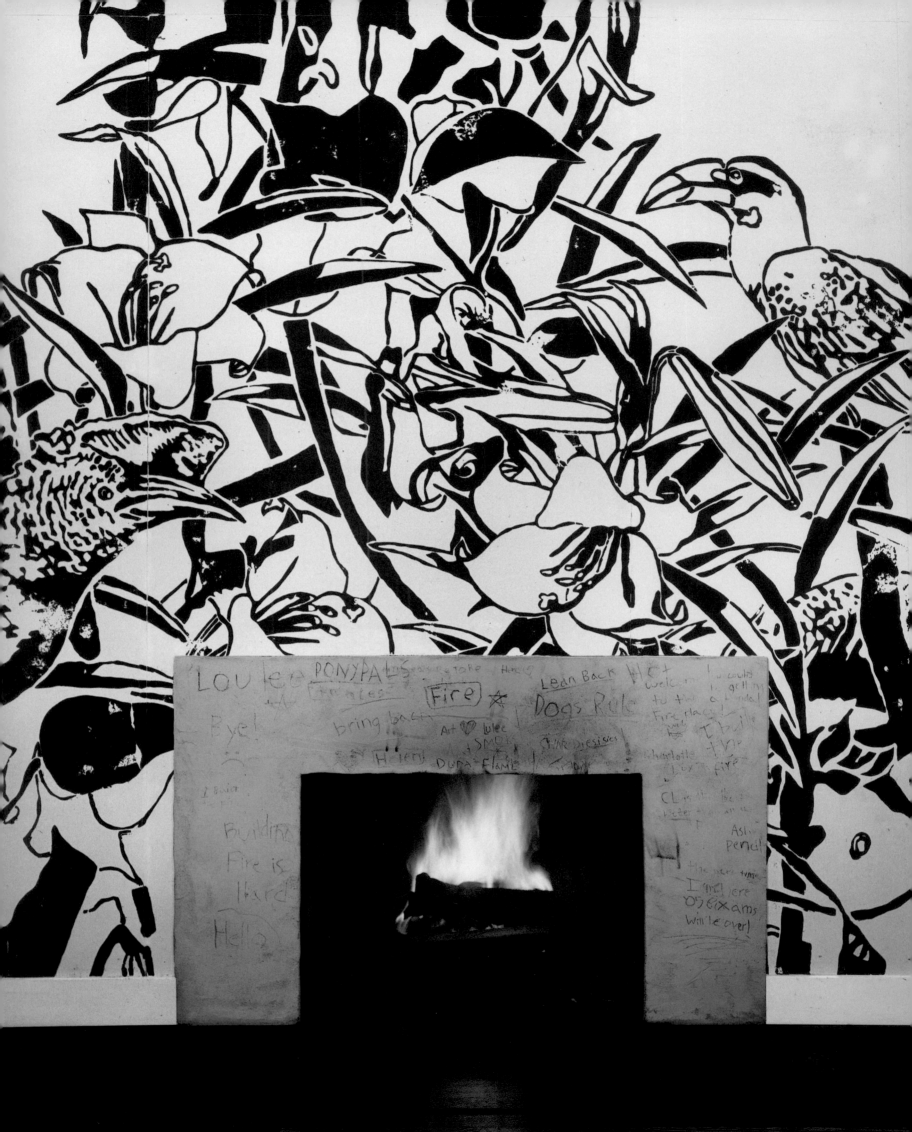

Floral repeat no. 5 (2003) and *Logo no. 7* (2003)
Collection Adam Lindemann, Woodstock, New York

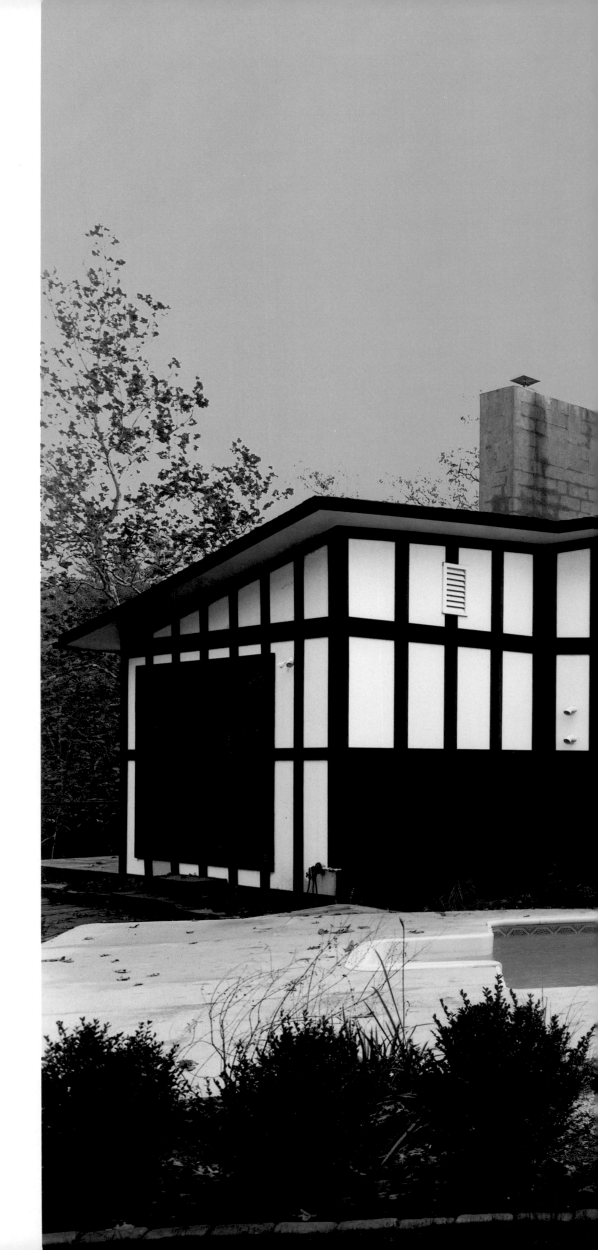

Super Tudor (2003), Collection Adam
Lindemann, Woodstock, New York

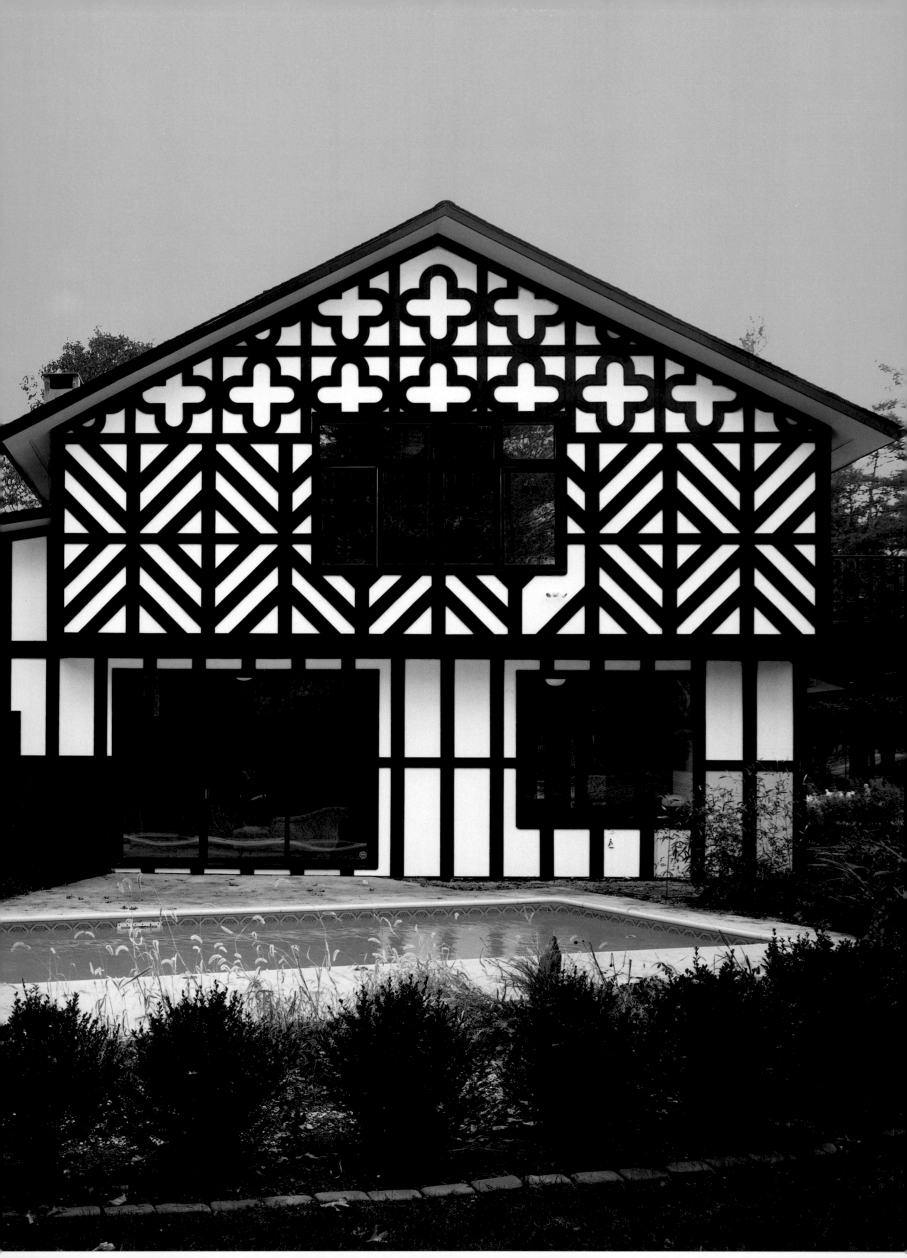

GORDON BURN: The Miami piece in some ways contradicts what you said about liking to mirror the surface of what's already there. You've used an interior surface on the outside of a building.

RICHARD WOODS: The Miami piece came about after visiting the site – an old library – and the surrounding area. There were lush green grounds and loads of people hanging out, playing guitars, children playing with dogs, people just chilling out, 'getting back to nature'. It struck me how it looked just like a toile wallpaper pattern where there are people hanging out in a 19th-century rural idyllic landscape, and sticking this in a slightly dodgy area.

So it wasn't the building itself? It was the environment?

I wanted to do a bit of wallpapering in the park.

Why have you concentrated on Thomas Bewick-era, 18th-century woodprints, like the one used here, and fake classical statuary and so on, as opposed to contemporary imagery?

For me they are charged things. Bewick or William Morris, taken out of context, there's something really interesting for me about that. Given a different, modern context, those vernacular images live in a modern way.

Thomas Bewick came from the north east of England, lived in London and then decided he hated metropolitan culture and moved back to the north-east. Again the class issue raises its ugly head.

I just like his images of rural life. I like the context of them now.

Do they relate to your own childhood growing up in a village in Cheshire?

I never came across Bewick until five years ago. He wasn't someone that, as a child, I was poring over. I don't think if you live in the country you'd be as interested in pictures of pigs as city dwellers might be. There's something about living in London that draws you to the rustic vernacular.

Bewick was part of a time in the 18th century when everyone thought the countryside was separate from manmade culture and commercial culture. But in fact at that time the countryside was completely manmade; rich people moved villages if they spoiled their view. It was completely designed. I wonder if that relates to your work in any way?

It's the distance that his work has from reality. The countryside isn't like that, it never was.

You're saying he romanticised it then?

He did, but he was fully aware of that romanticisation. He loved the people, the landscape and the animals that lived on it. He was promoting it.

In opposition to polite society and the artifice of London living, which valued 'the world' – conversation, external appearances, the surfaces of metropolitan life. Hence the irony, I suppose, of his woodcuts becoming the patterns of salon wallpaper – an irony heavily pointed up in your work.

It's about the way art history, commerce, changing tastes, the passing of time all allow a very different and constantly changing reading of what he was about.

Nice life no. 2, Deitch Projects, Miami, 2003

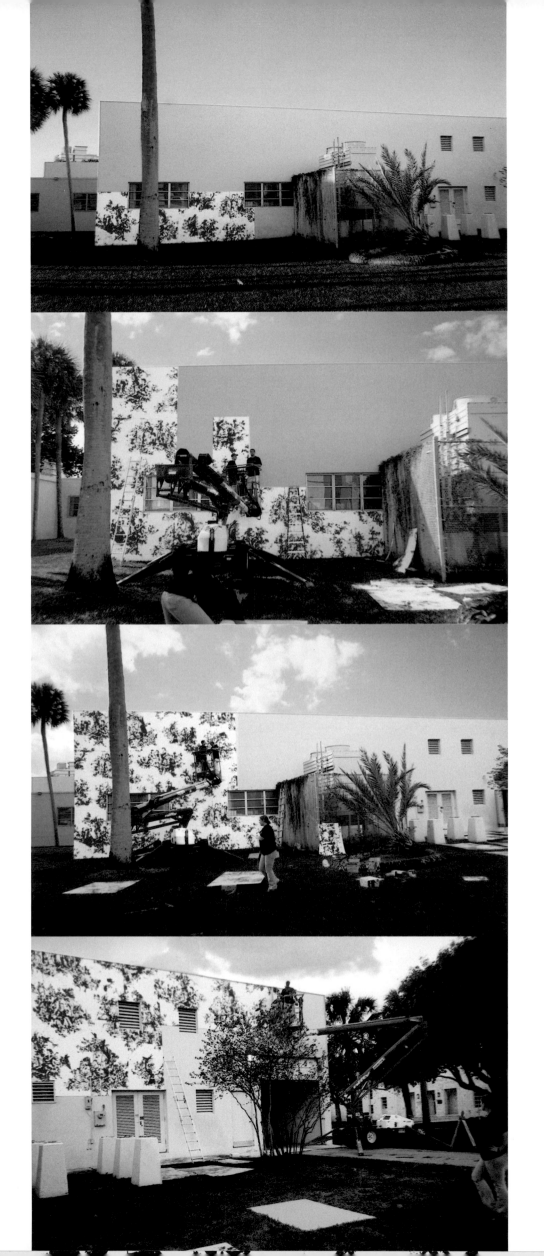

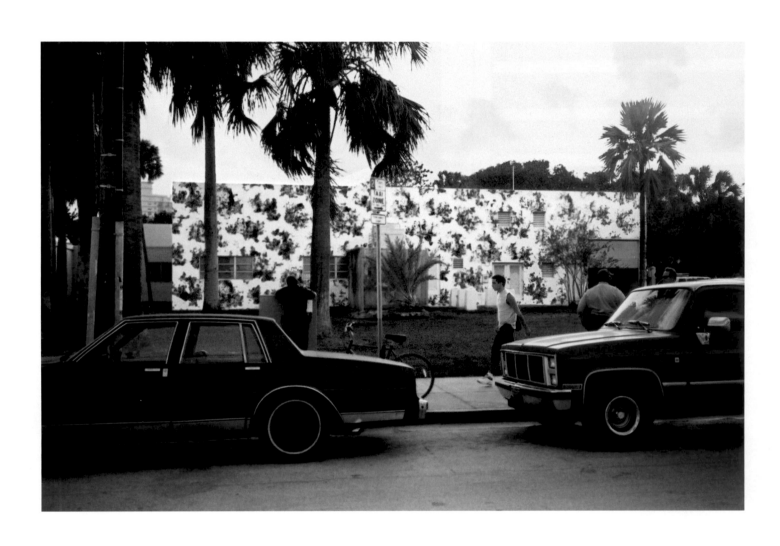

Nice life no. 2, Deitch Projects, Miami, 2003

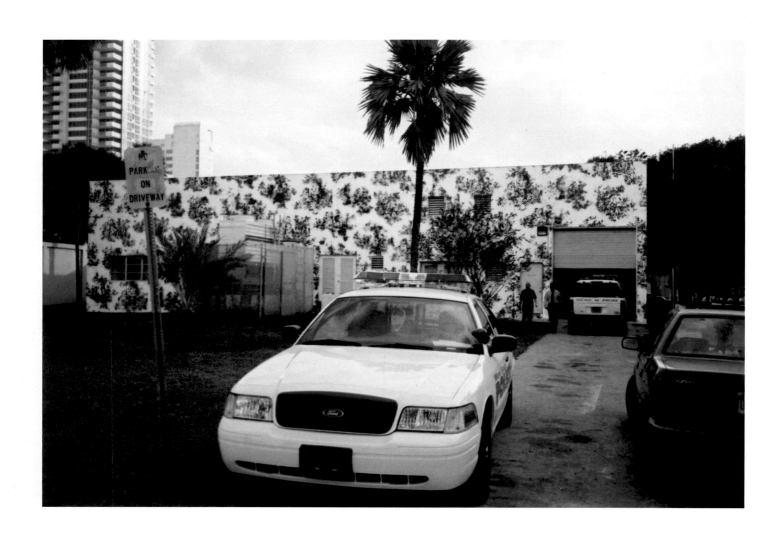

Logo no. 8 (2003) and *Swiss wood furniture* (2003)
Collection Claude Picasso, Switzerland

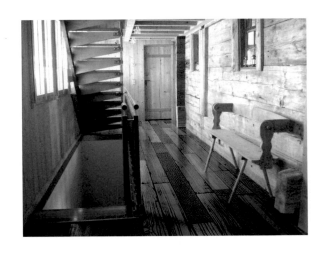

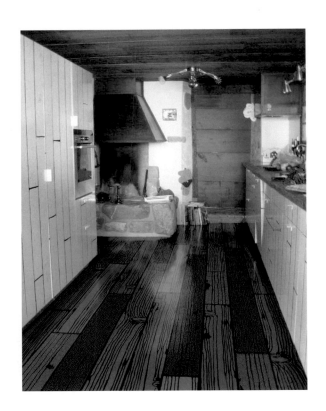

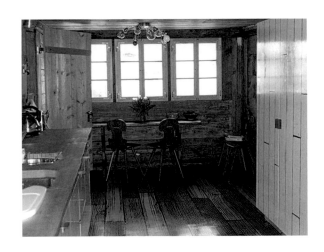

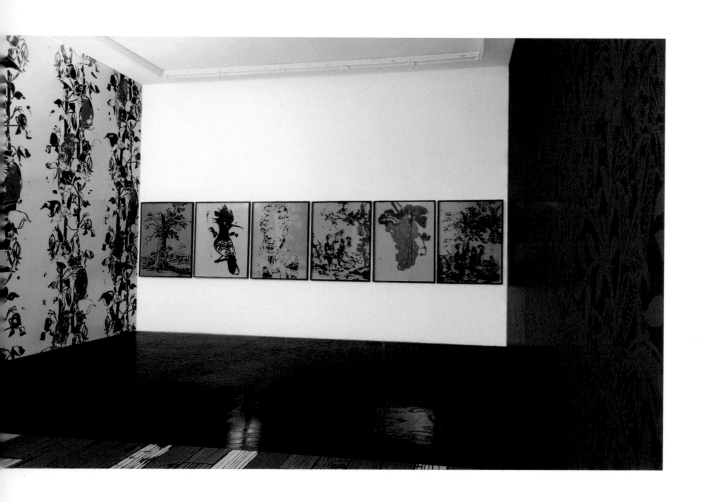

Renovation, Galleria S.A.L.E.S., Rome, 2003

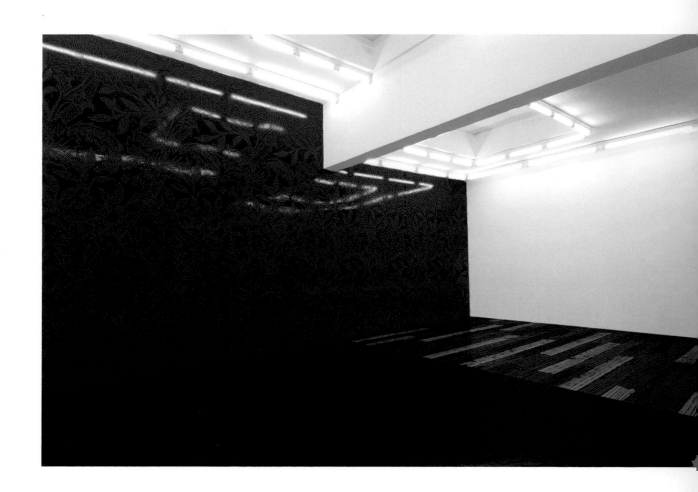

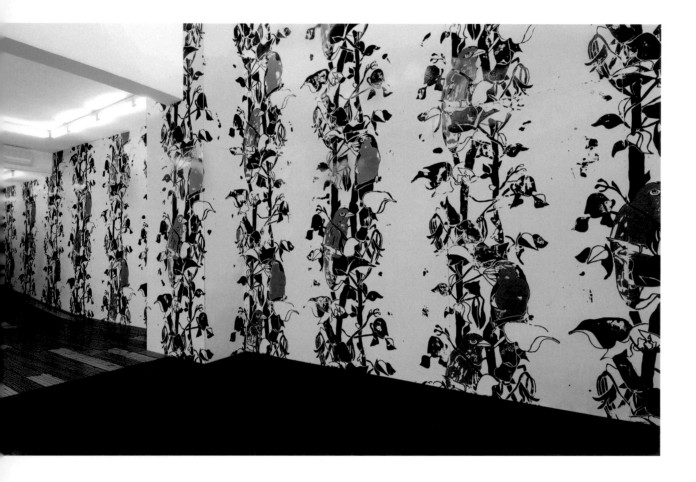

Renovation, Galleria S.A.L.E.S., Rome, 2003

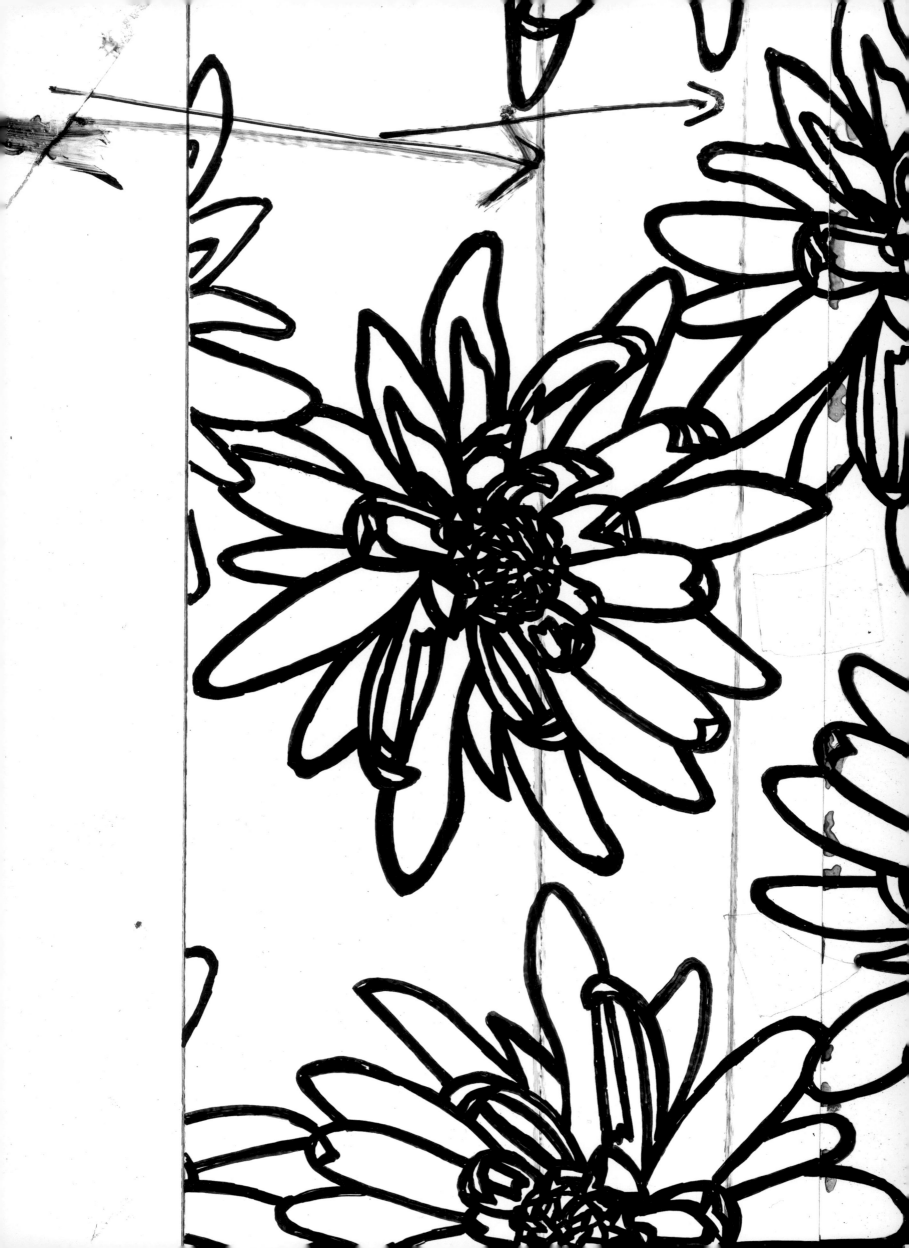

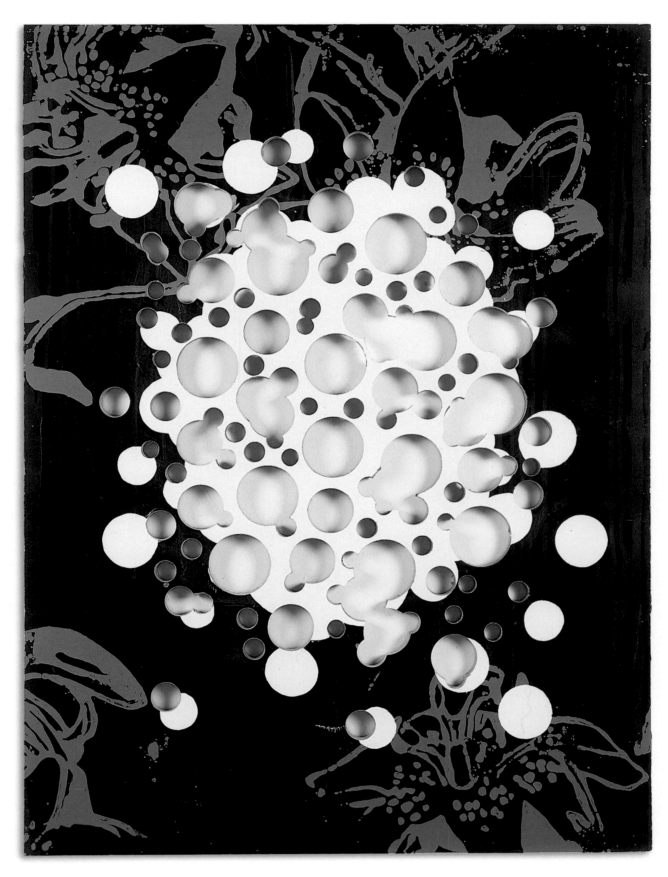

Holes and flowers no. 7 (2006)
Household gloss paint on plywood
122 × 90 cm

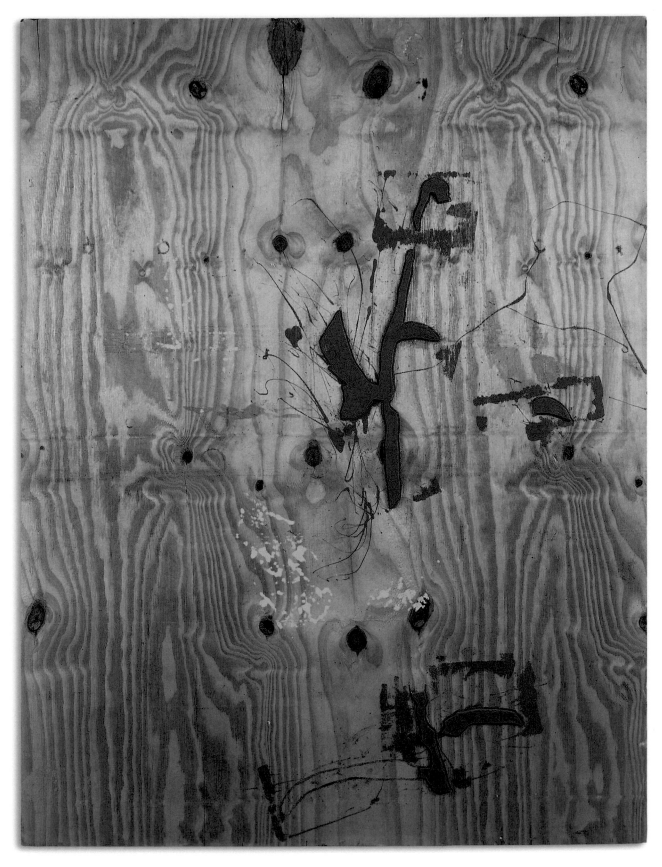

Painted leaves no. 4 (2006)
Household gloss paint on plywood
122 × 90 cm

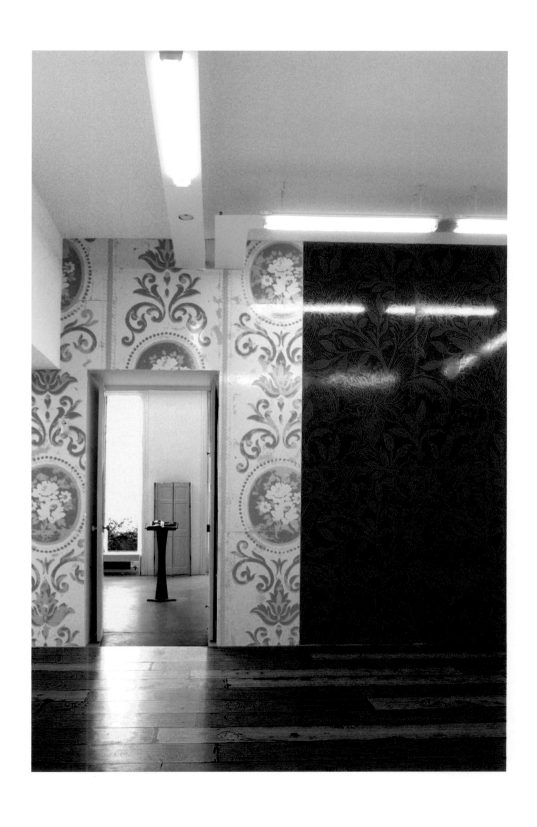

Floral repeat no. 6, *Floral repeat no. 11* and *Untitled*
in *Retinal Stain: Mat Collishaw, James Hopkins,*
Richard Woods, Cosmic Galerie, Paris, 2003

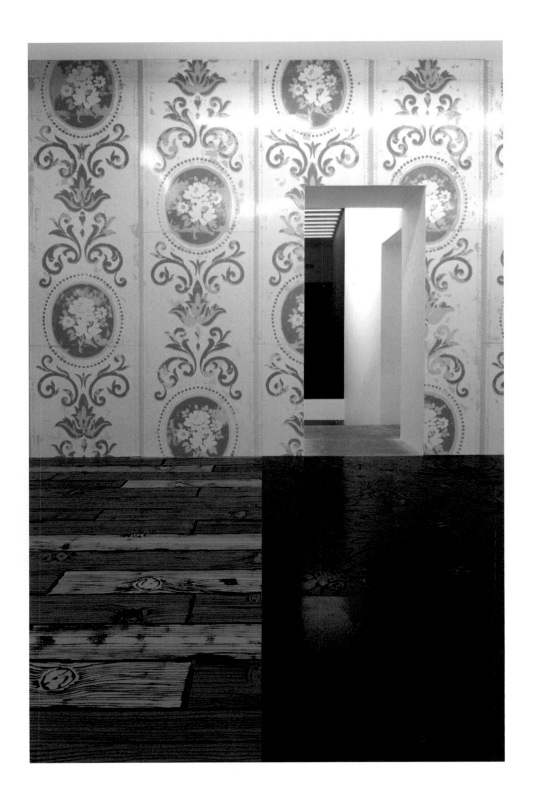

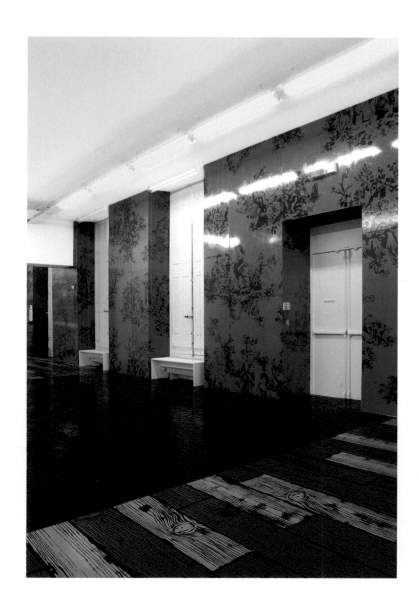

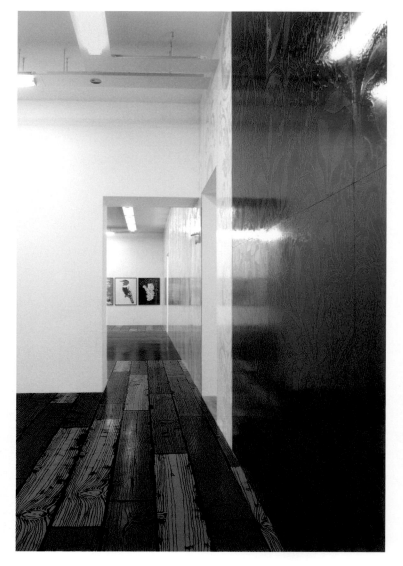

Floral repeat no. 6, *Floral repeat no. 11* and *Untitled*
in *Retinal Stain: Mat Collishaw, James Hopkins,*
Richard Woods, Cosmic Galerie, Paris, 2003

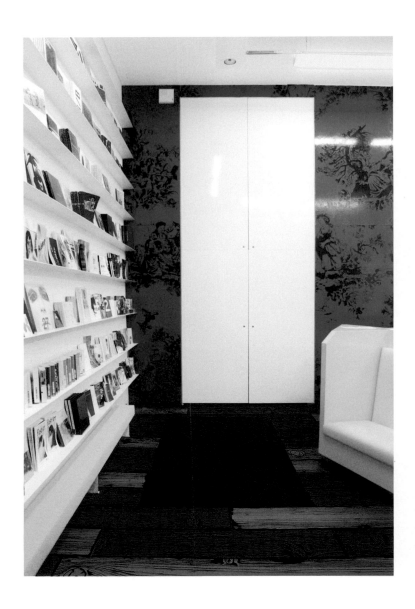

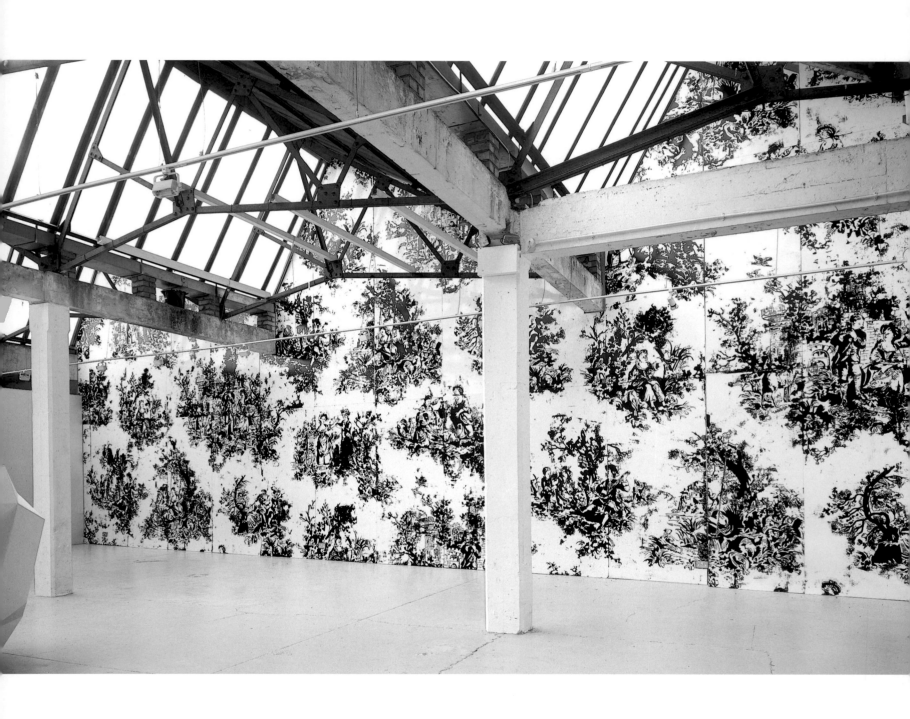

Nice life (black and white), New Wharf Road, London, 2004

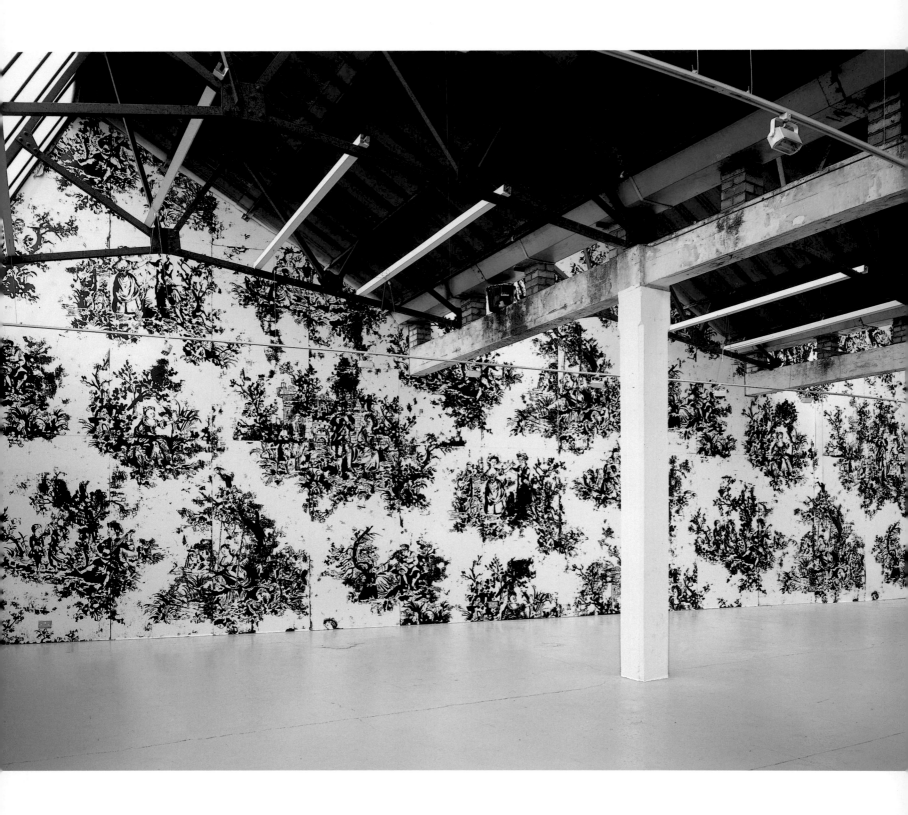

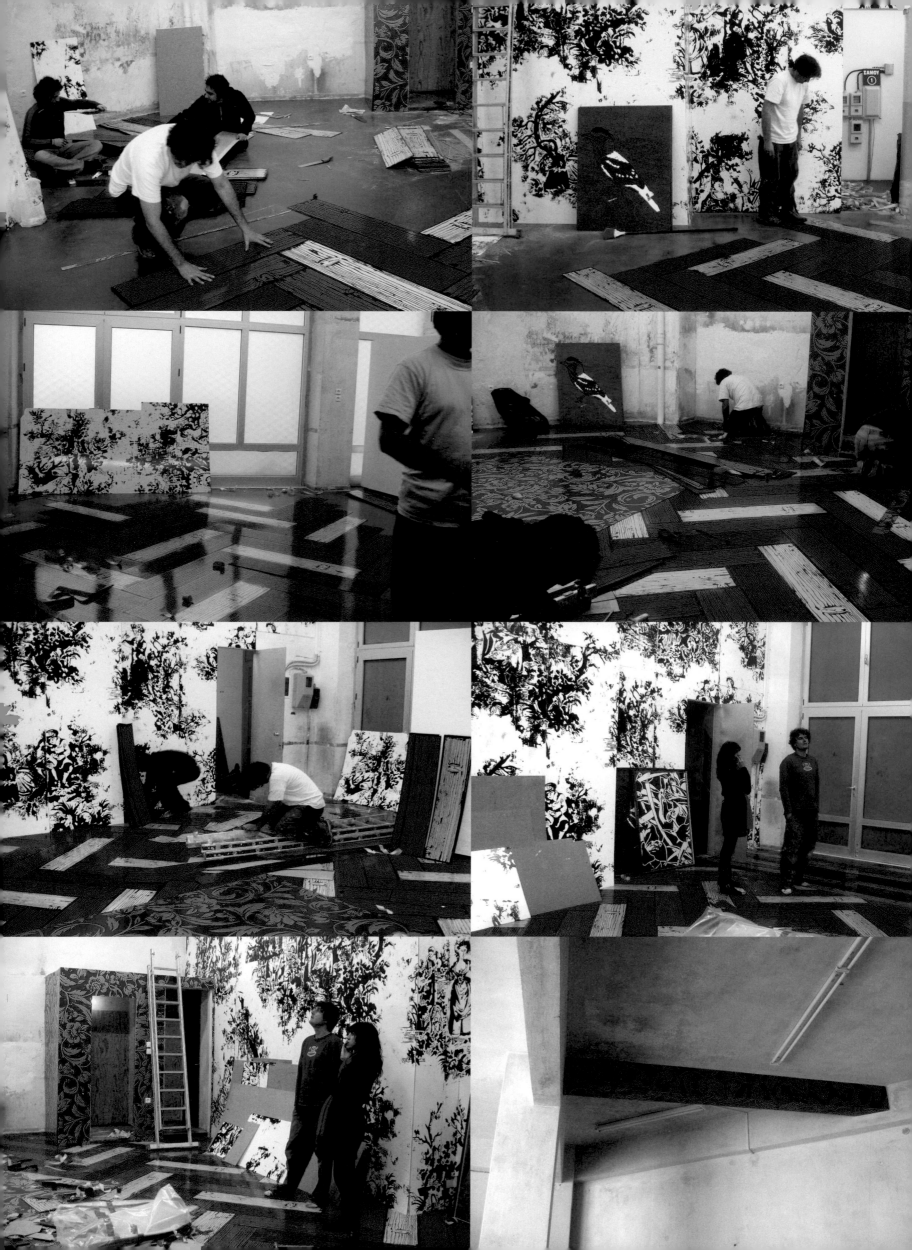

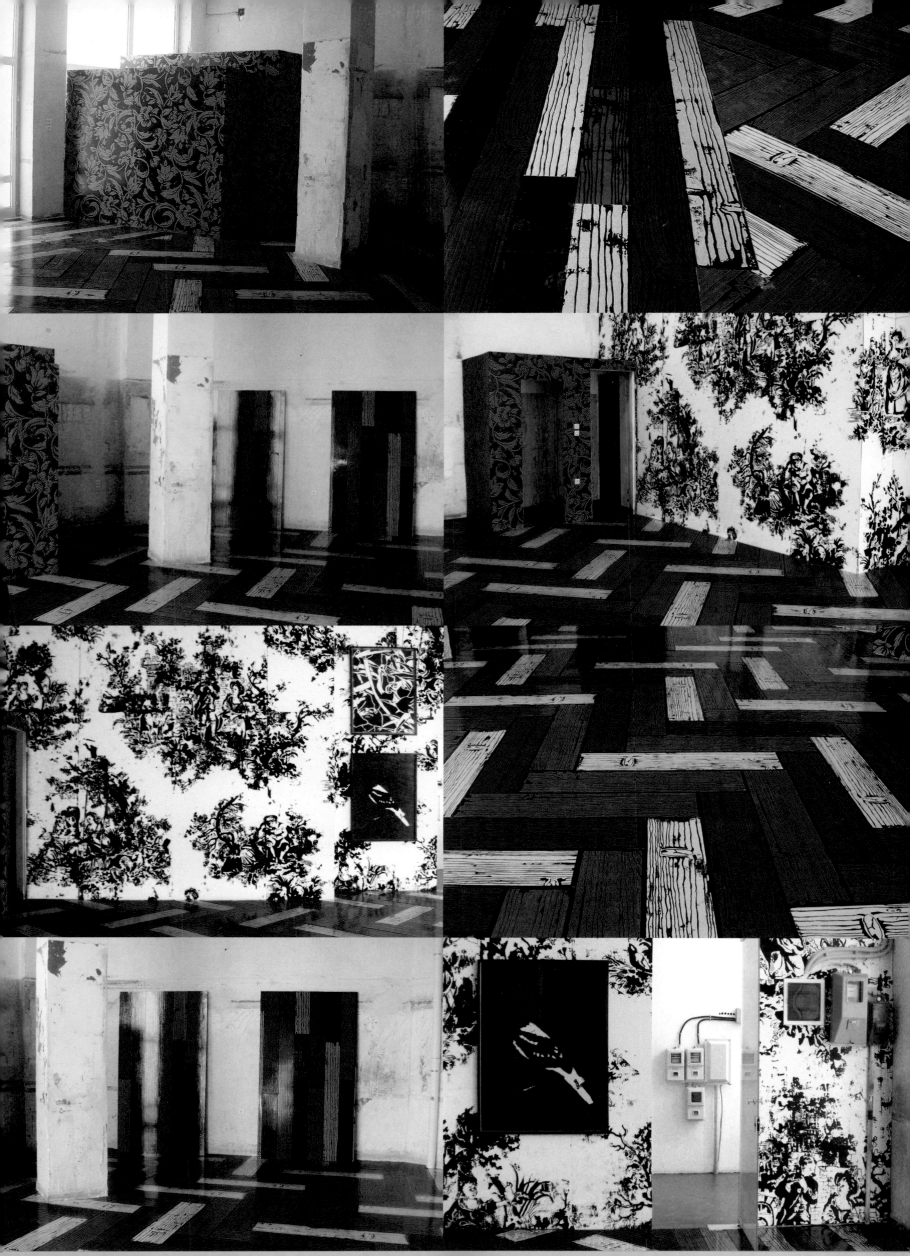

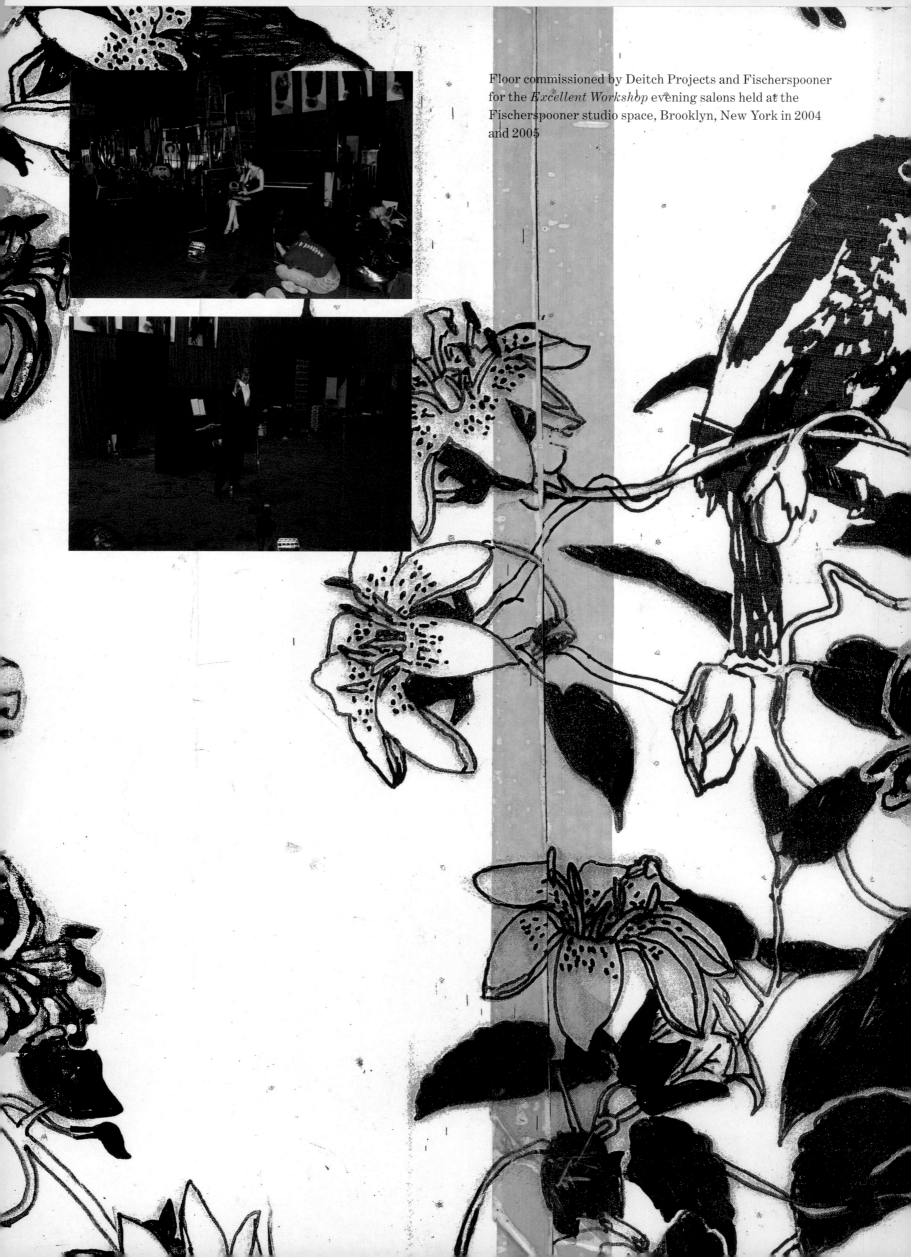

Floor commissioned by Deitch Projects and Fischerspooner for the *Excellent Workshop* evening salons held at the Fischerspooner studio space, Brooklyn, New York in 2004 and 2005

Fischerspooner
Deitch

black
+
Yellow

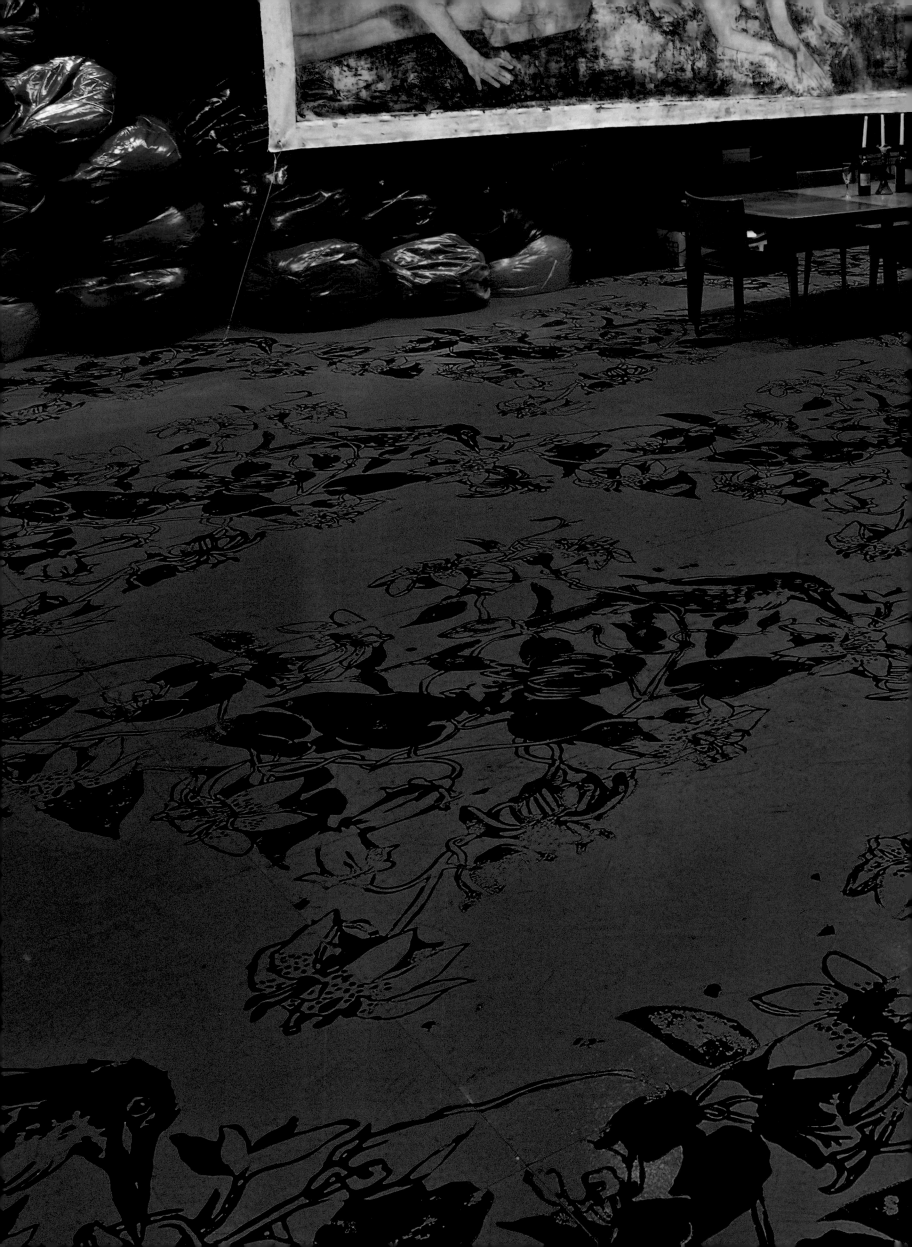

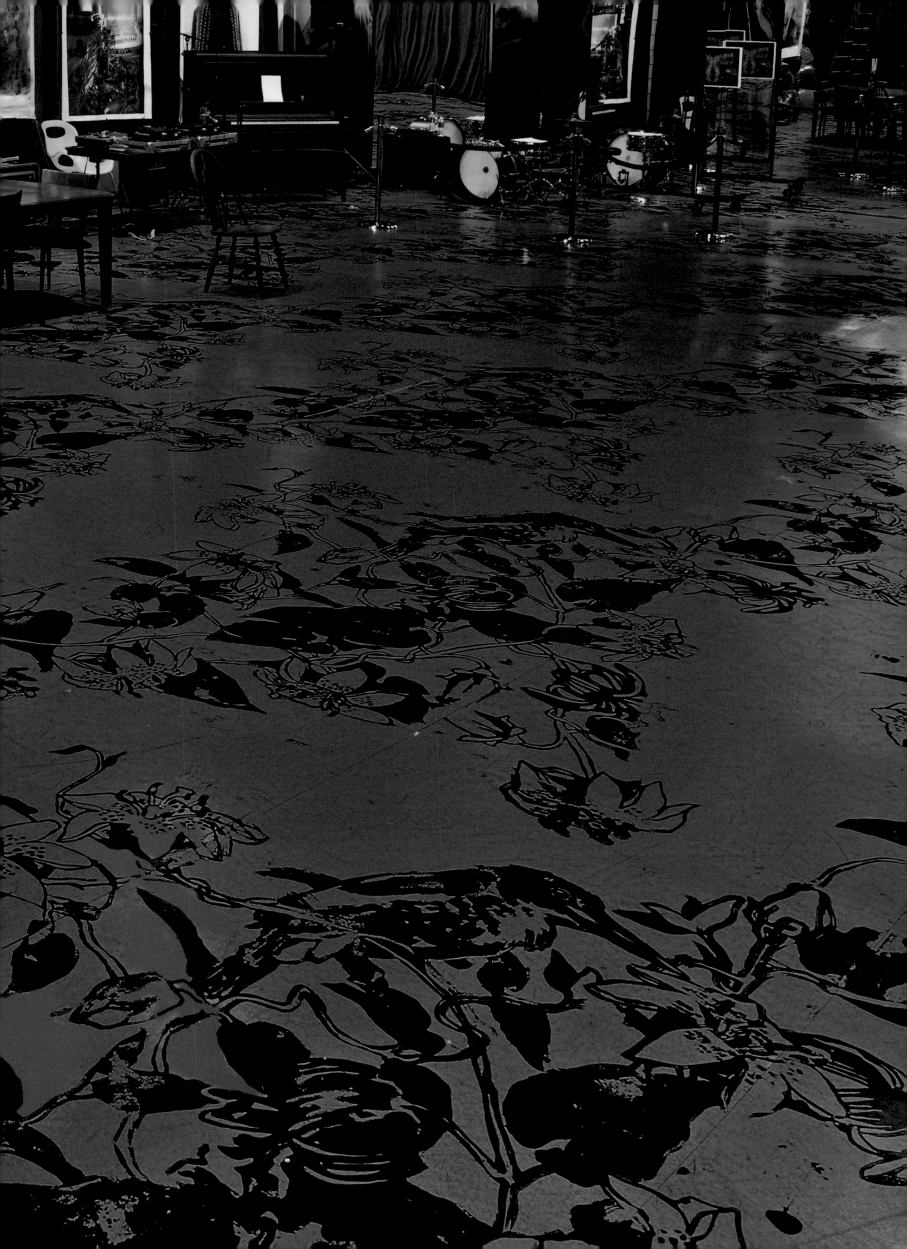

Logo no. 12 (2004), Collection Andrea Zegna, Milan
Courtesy Galleria S.A.L.E.S., Rome

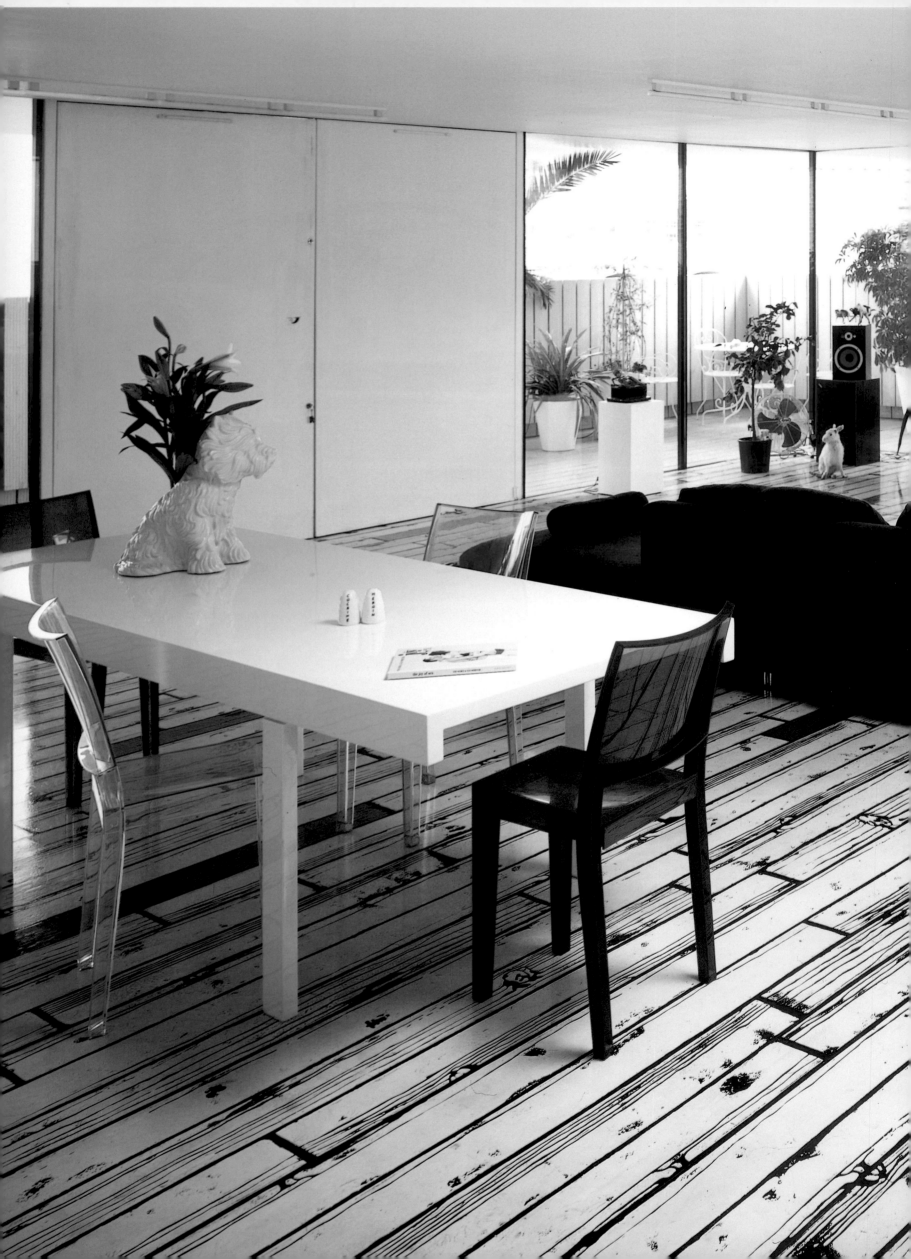

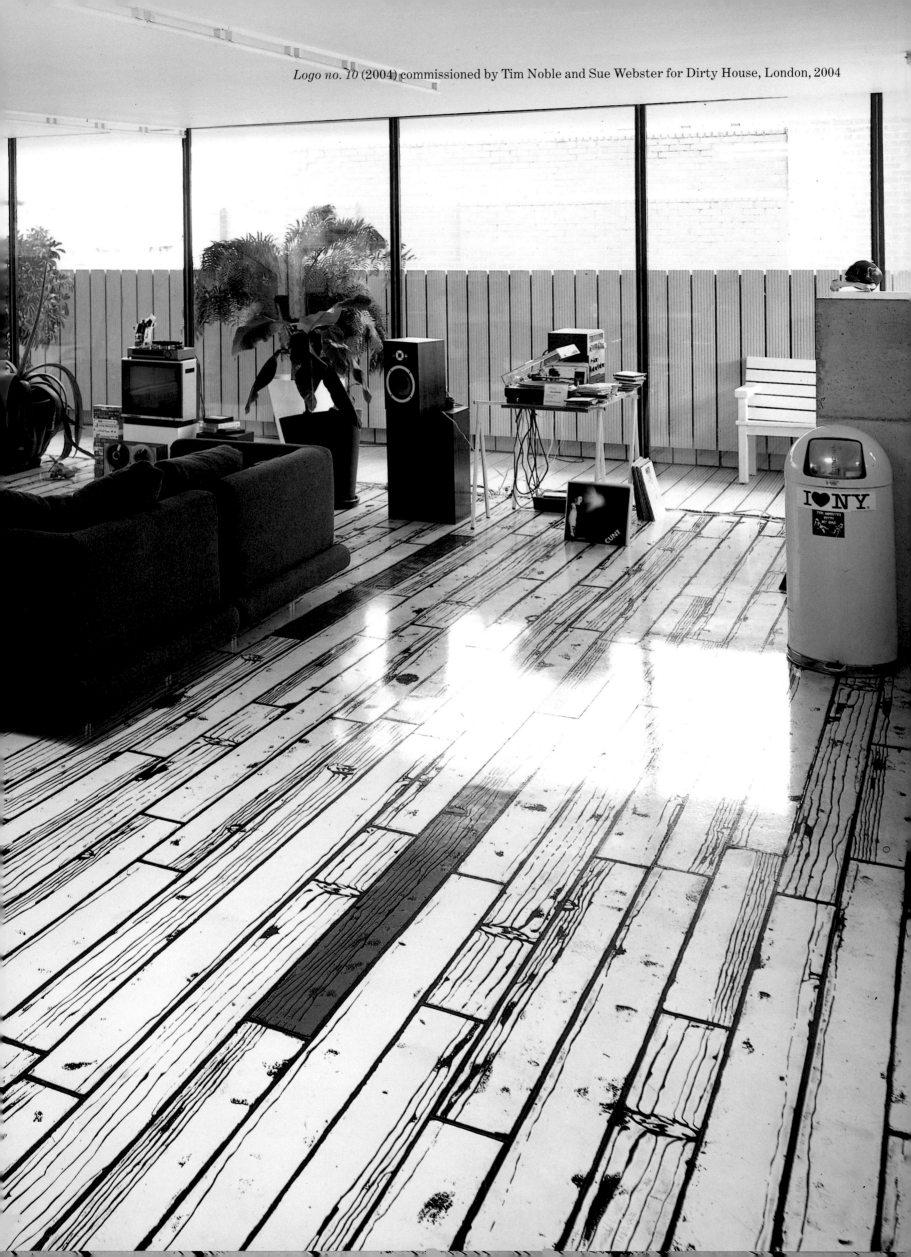

Logo no. 10 (2004) commissioned by Tim Noble and Sue Webster for Dirty House, London, 2004

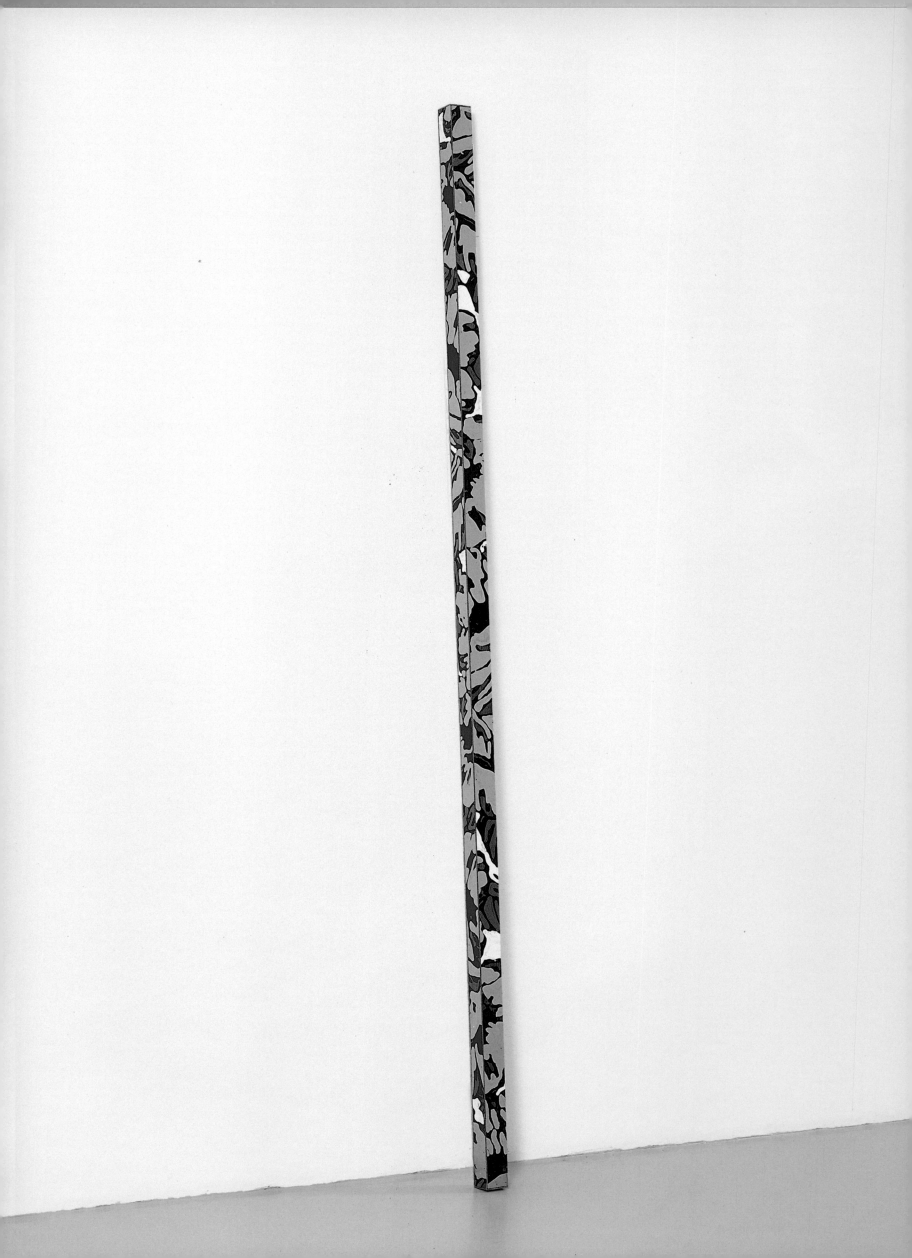

overleaf:
Countrystyle, Kenny Schachter ROVE, London, 2004

Chopped stock sculpture Mi.09 (2006)
Household gloss paint on plywood
$240 \times 5 \times 5$ cm

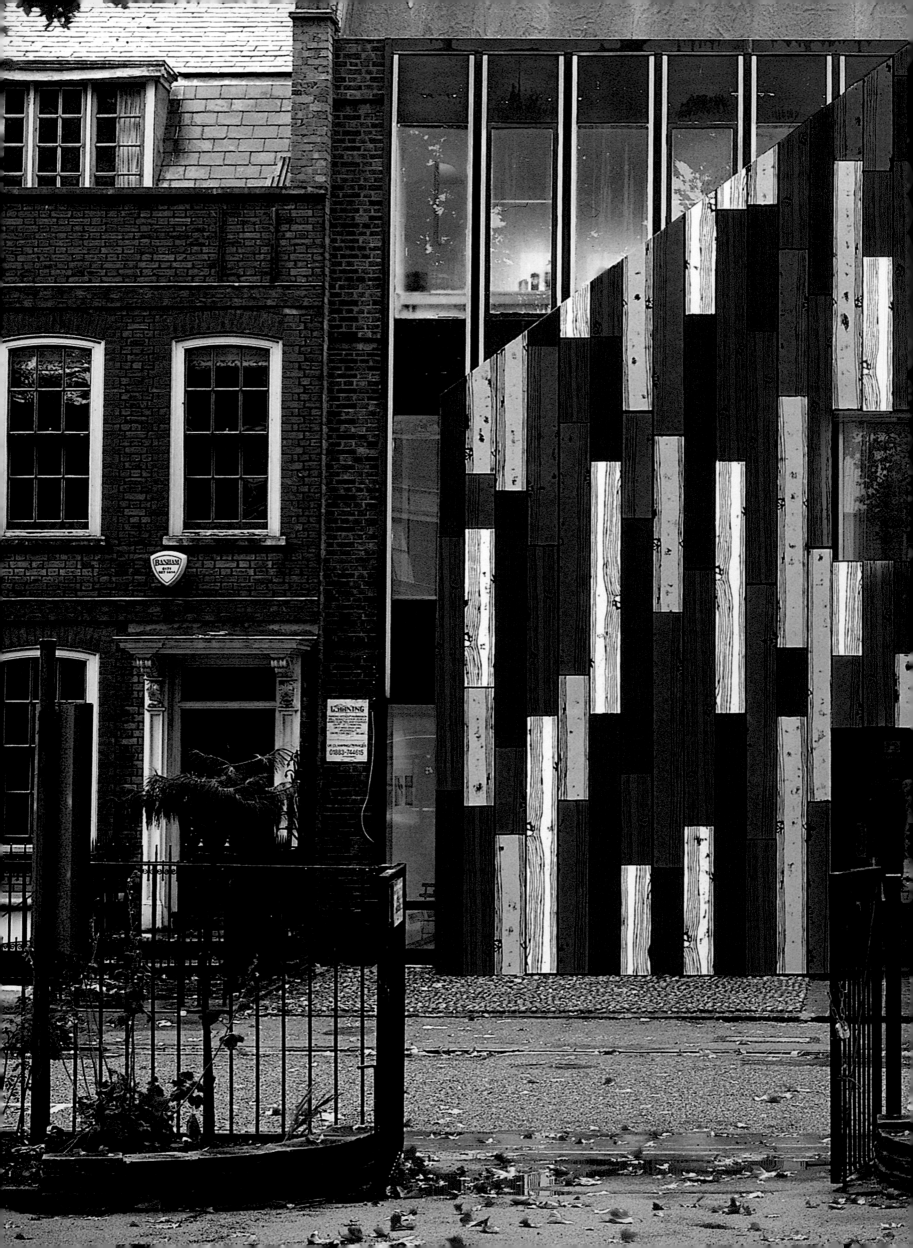

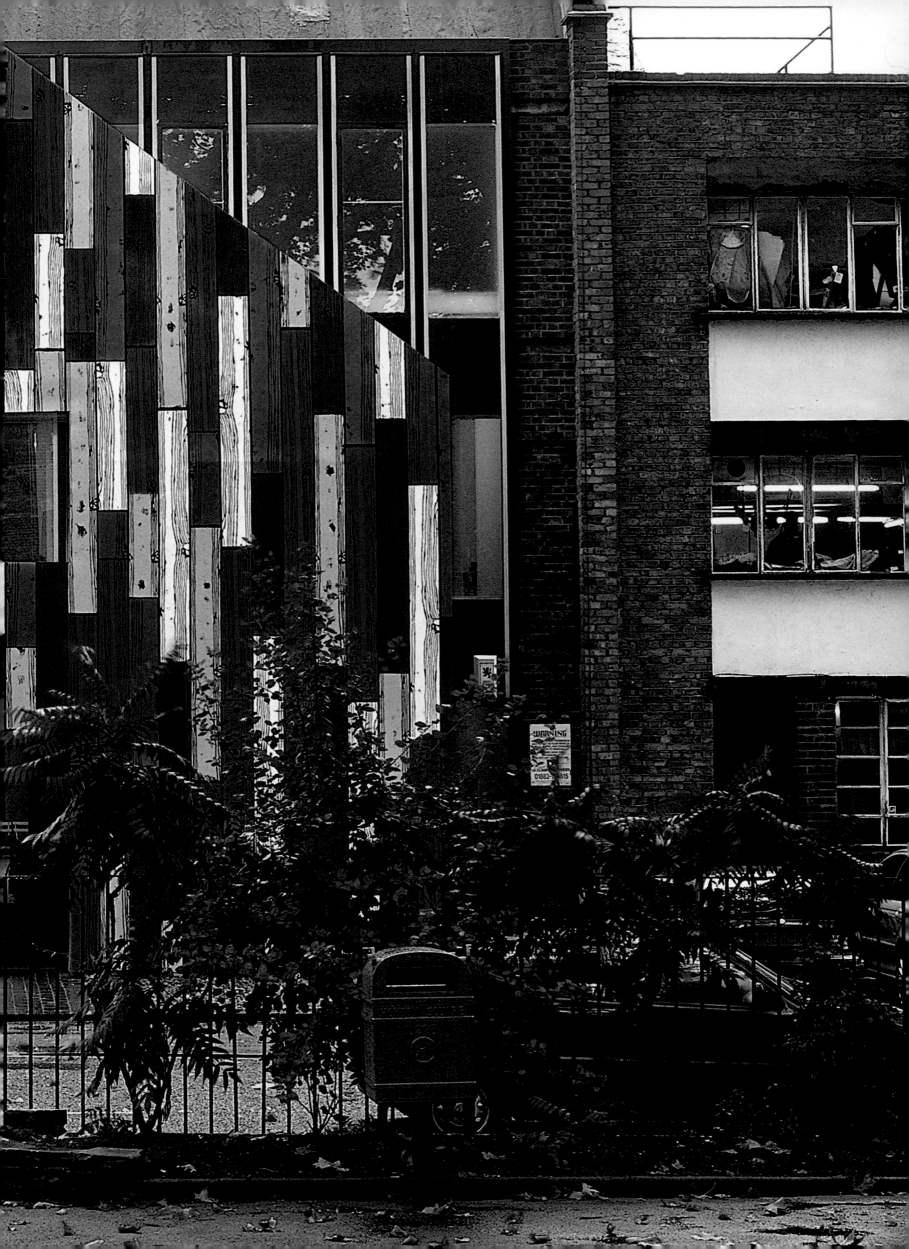

Blue flowers no. 1 (2006)
Household gloss paint on plywood
122 × 90 cm

Painted leaves no. 2 (2006)
Household gloss paint on plywood
122 × 90 cm

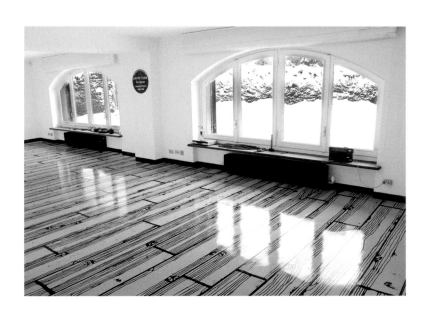

Logo no. 15 (2004), Private collection, Italy

overleaf:
Floral repeat no. 11 (2004), Collection Enzo Di Matteo, Vittoria
Architecture by Maria Giuseppina Grasso Cannizzo
Courtesy Galleria S.A.L.E.S., Rome

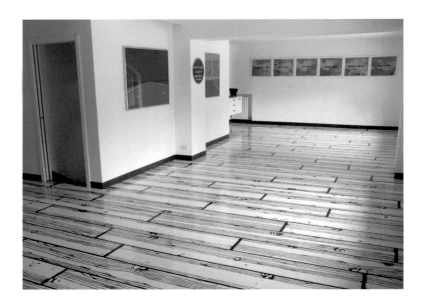

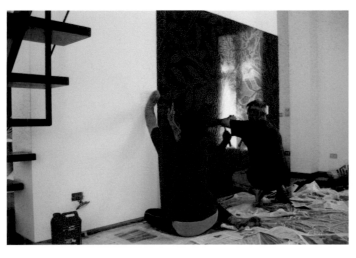
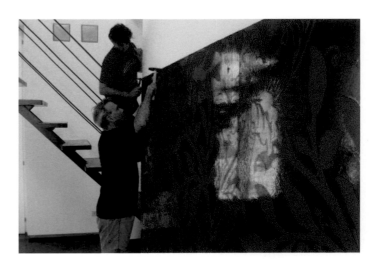
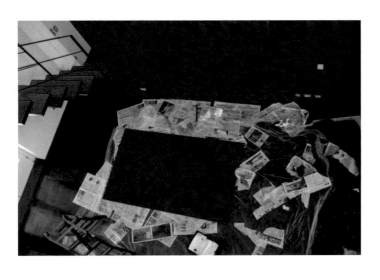

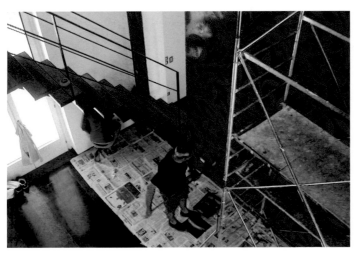

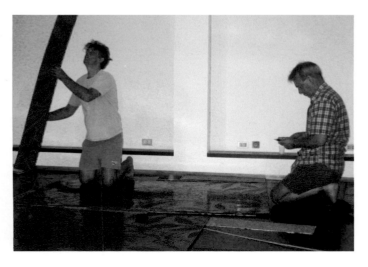

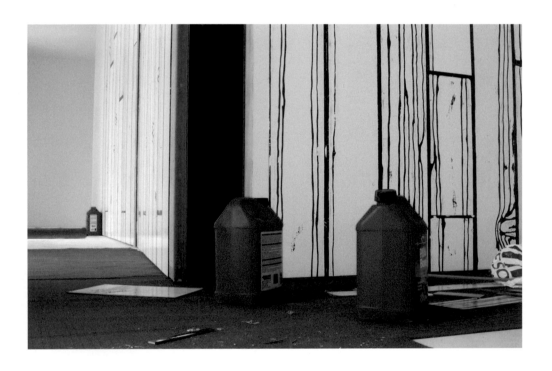

Logo no. 9 (2004), Collection Mariliana and Salvo Brachitta, Ragusa
Architecture by Maria Giuseppina Grasso Cannizzo
Courtesy Galleria S.A.L.E.S., Rome

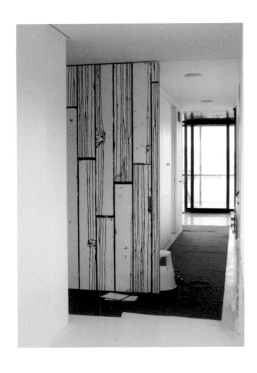
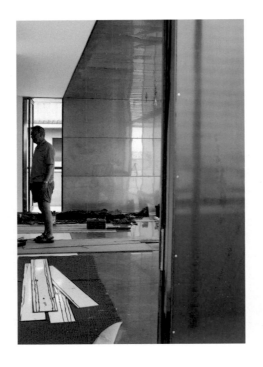

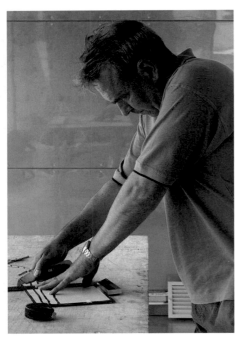
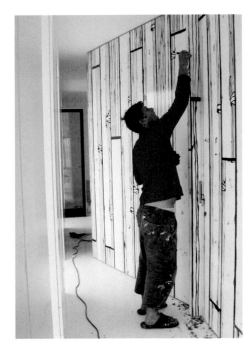
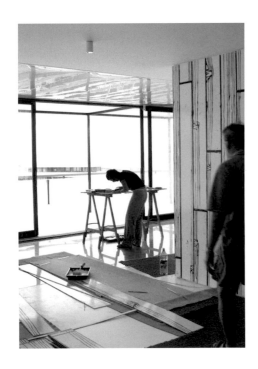

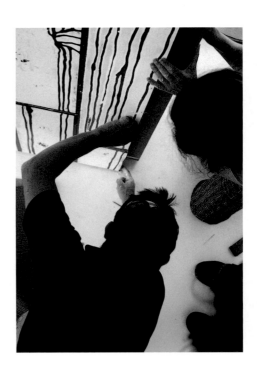

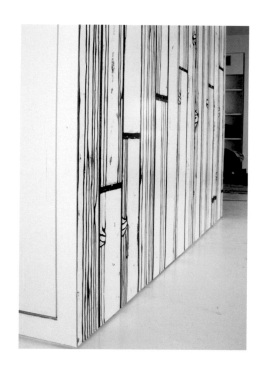

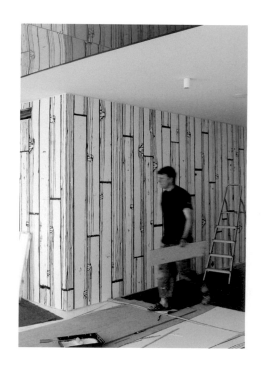

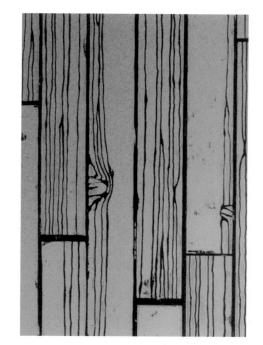
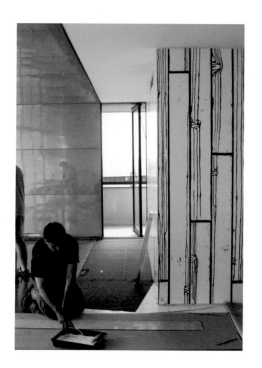
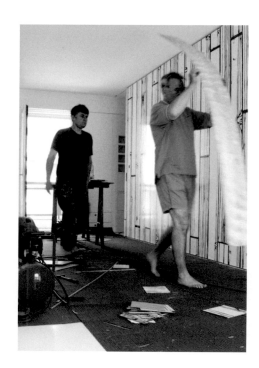
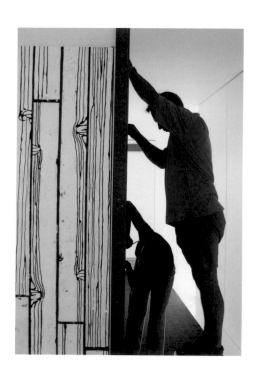

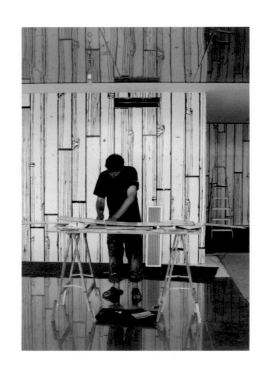

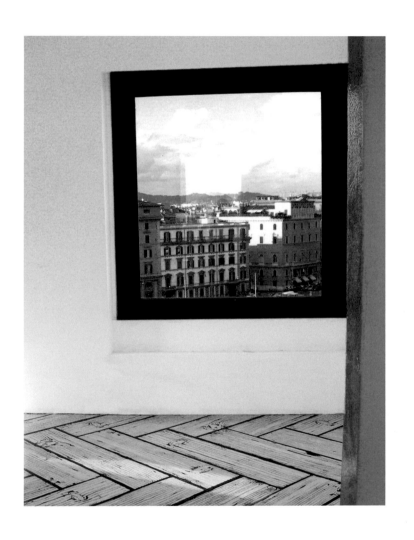

Logo no. 11 (2004) and *Floral repeat no. 10* (2004)
Collection D'Agostino, Rome
Courtesy Galleria S.A.L.E.S., Rome

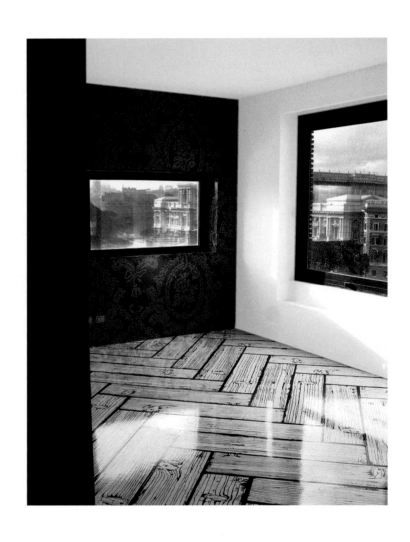

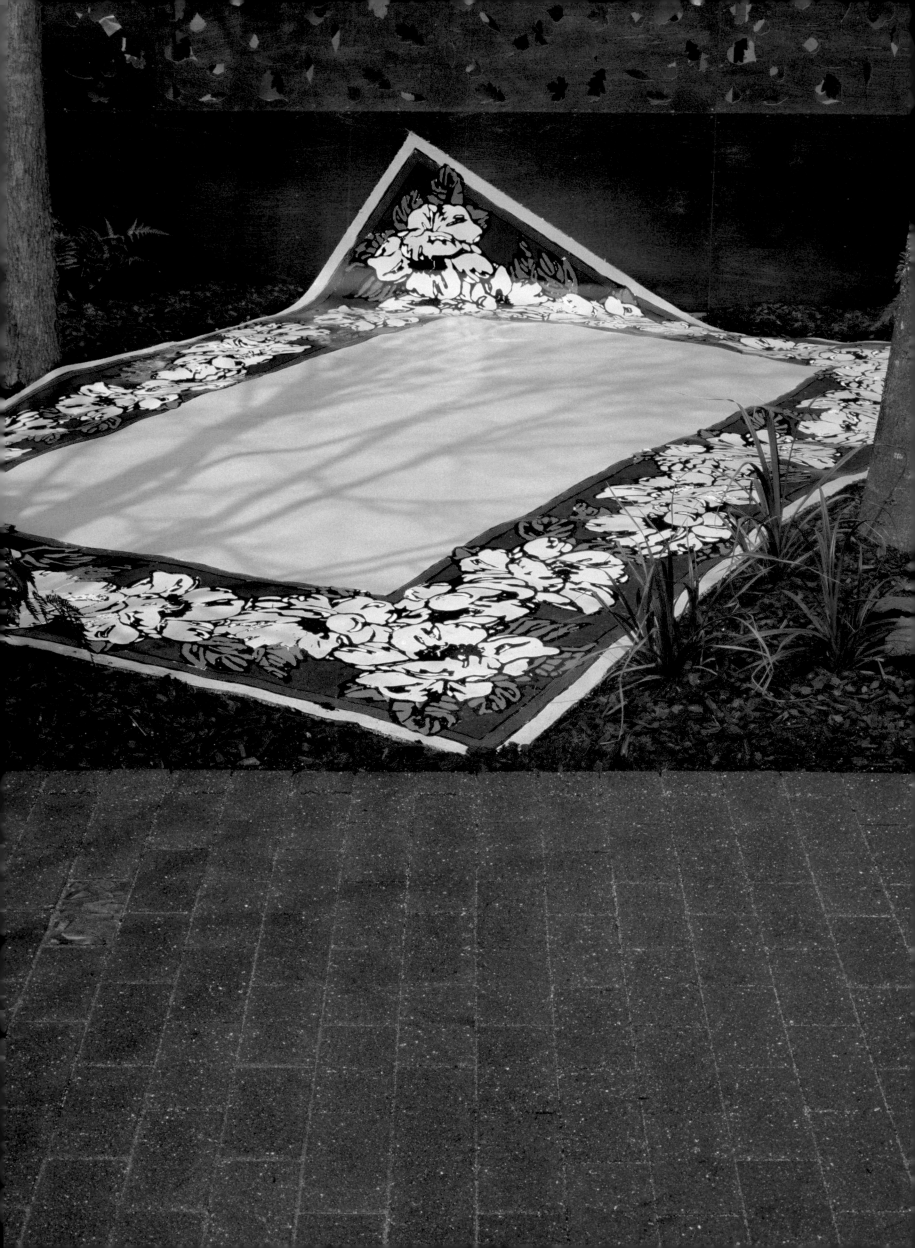

Folded floral repeat no. 5 in the UK pavilion garden
at the World Exposition, Japan, 2005

Mock Tudor painting, Sadler's Wells, London, 2005

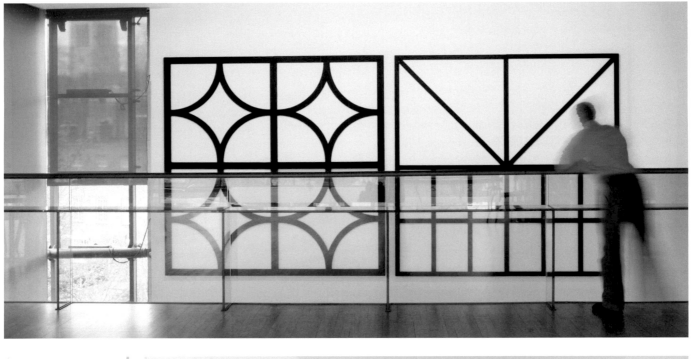

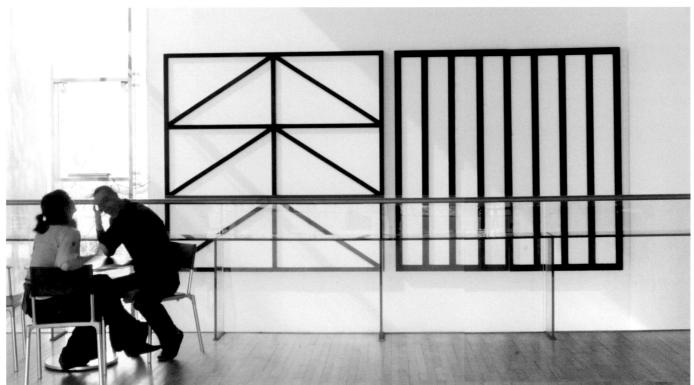

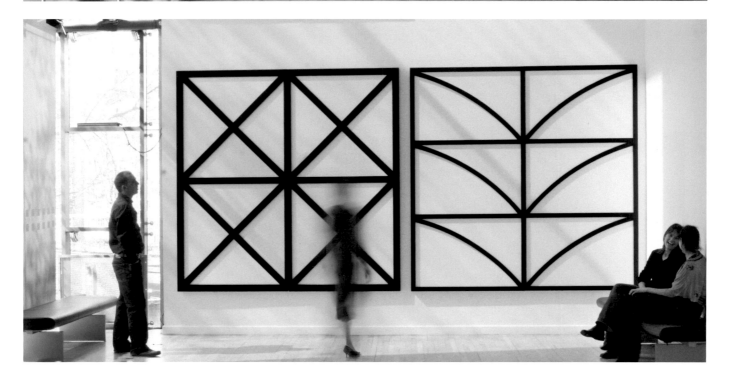

147

The Long Room, New College, Oxford

GORDON BURN: In the brick pieces, why is it important that they are concealing a real building – in other words, that there's not just a freestanding, empty house-shape or whatever? Obviously, in a gallery, you can make printed bricks on a frame in the shape of a house.

RICHARD WOODS: The original thinking behind the Oxford and Wimbledon projects was just to do a bit of urban renewal in a place that didn't really need it. That was the tiny beginnings.

Do you think some people believe that's not enough? That you should be taking a firmer position, politically or aesthetically?

I suppose I am taking a position politically, because the work is framed in that way. But all I'm trying to say is sometimes I find myself stopping and thinking, 'actually, it is just dead interesting that people make offices that look like Georgian houses'. The work I'm making doesn't have to be aggressively 'pro' or 'anti'. I've always seen it as being about asking questions rather than answering them.

I guess that's what art's about. It's about noticing things in the world in a way nobody has quite noticed them before.

More than with any of the other projects, I suppose, the Oxford and Wimbledon projects are very easy to read in terms of politics and class. But sometimes you want to stop them being read in that way, because it's prescriptive and, in the end, pretty limiting. When you start making these things they become about loads of other things – resonances, implications – you hadn't thought about before the work began.

Maybe you don't know what they're about until you see them in place. You think you know what they're going to look like and the impact they're going to have on the surroundings…

…but also I can't stop thinking of Poundbury [the mixed urban development, designed for the Prince of Wales by architect Leon Krier on the outskirts of the Dorset town of Dorchester], about the idea of an idyll. I was reading loads about Poundbury at the time, and that went into the project. Often you go into a new project with a belligerent energy and then you get through the other side and you feel completely differently about the things that gave you the energy to make the thing in the first place.

A bit like Rachel Whiteread doing the Holocaust memorial in Vienna, going into it thinking it was all about aesthetic choices, and getting drawn into local politics and ethical and political and other issues. It changes the thinking in your head by the time it's completed, I imagine.

The thing that gives you the energy to do the work, which can be a positive or negative thing, can shift, and that's what I'm trying to say about *NewBUILD* in Oxford and *RENOVATION* in Wimbledon. Somehow now I find myself looking at 20th-century, Georgian-style houses that are offices, and thinking, 'well, that's quite beautiful', whereas before I couldn't think like that. Maybe I've become a convert to the Poundbury style. Getting a taste for that postmodern architecture and perhaps seeing something half-decent in it.

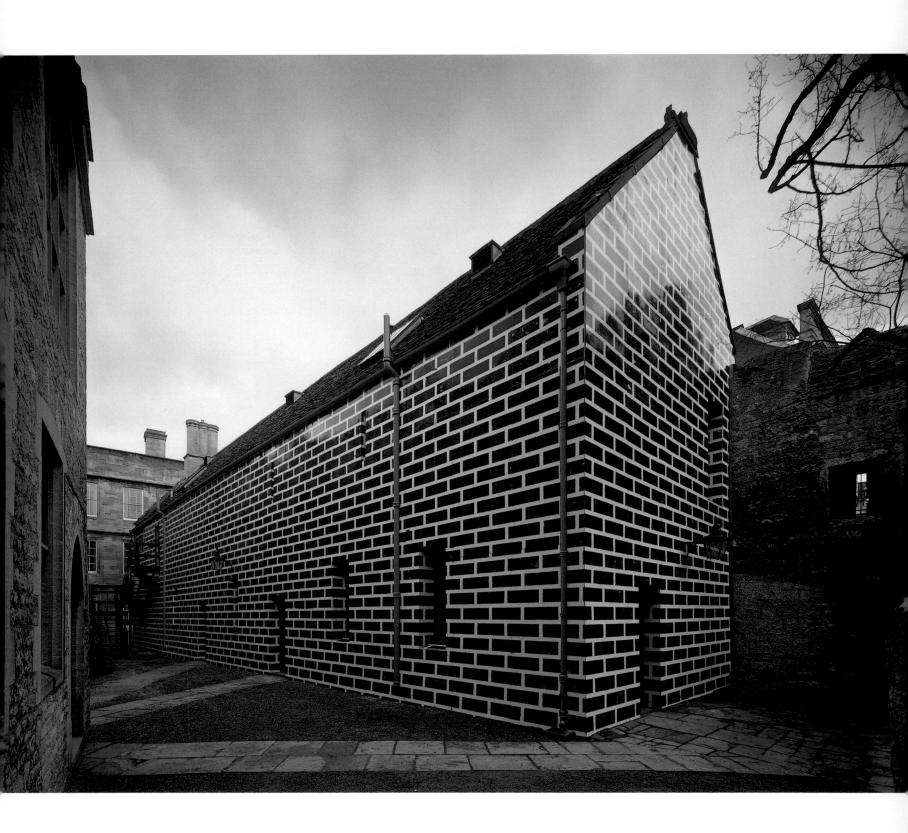

NewBUILD, New College, Oxford, 2005
Commissioned in association with the Ruskin School
of Drawing and Fine Art, University of Oxford

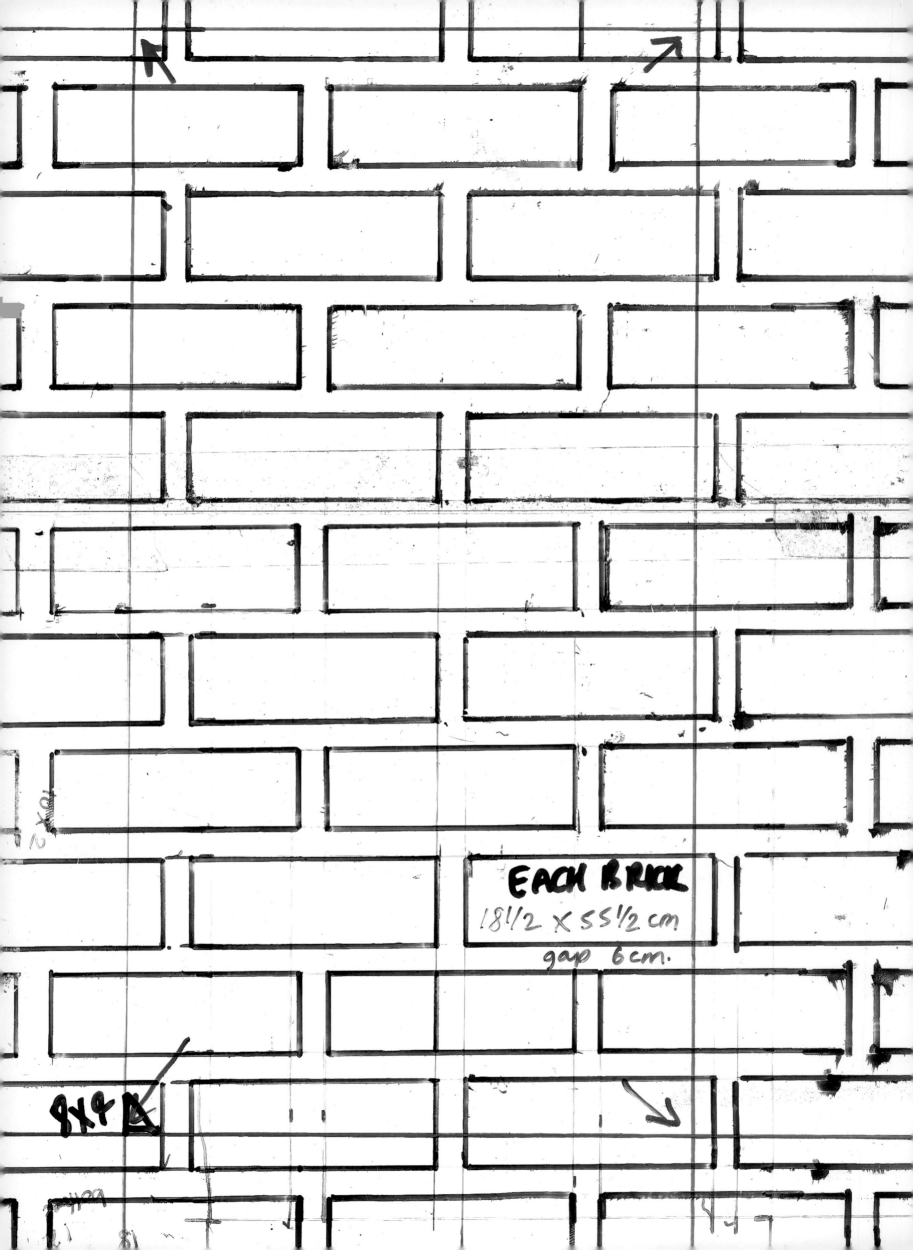

EACH BRICK
18 1/2 X 55 1/2 cm.
gap 6 cm.

9 x 9

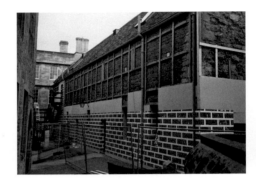

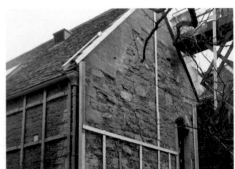

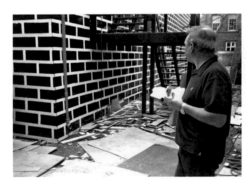
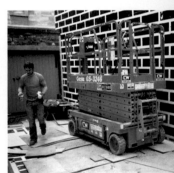
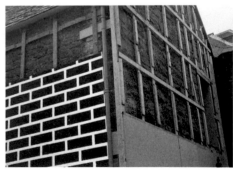

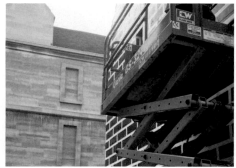
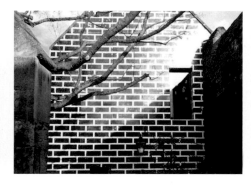
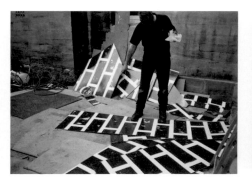

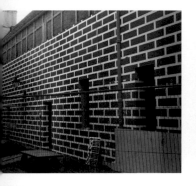
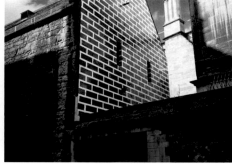
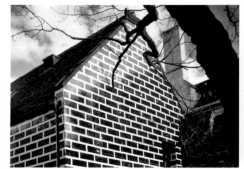

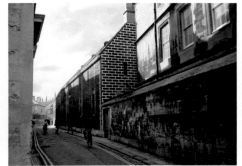
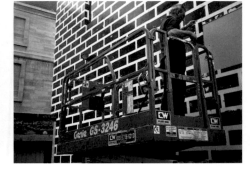
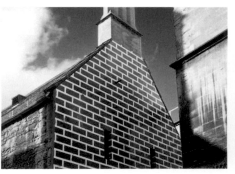

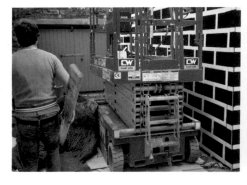
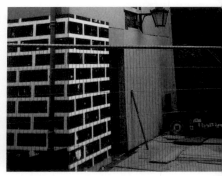

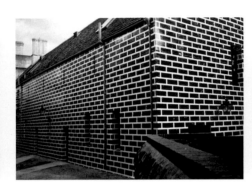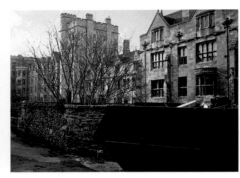
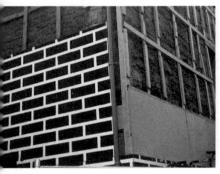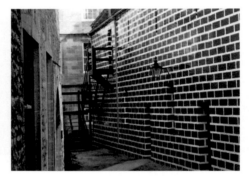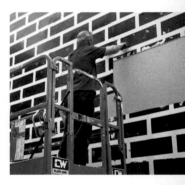
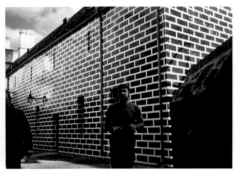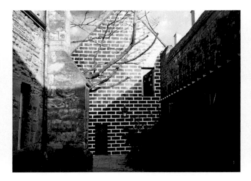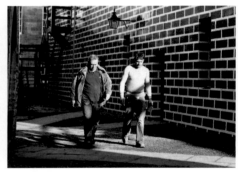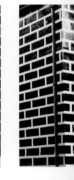
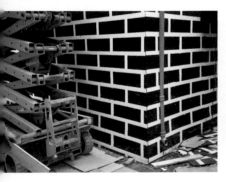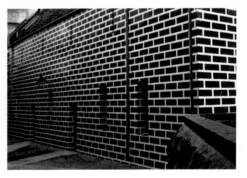

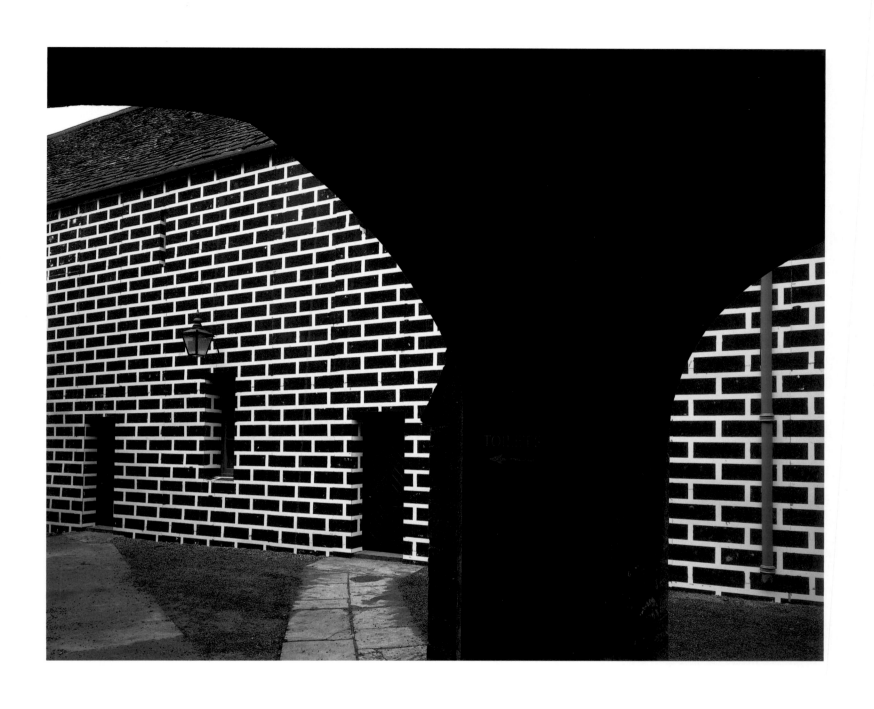

NewBUILD, New College, Oxford, 2005
Commissioned in association with the Ruskin School
of Drawing and Fine Art, University of Oxford

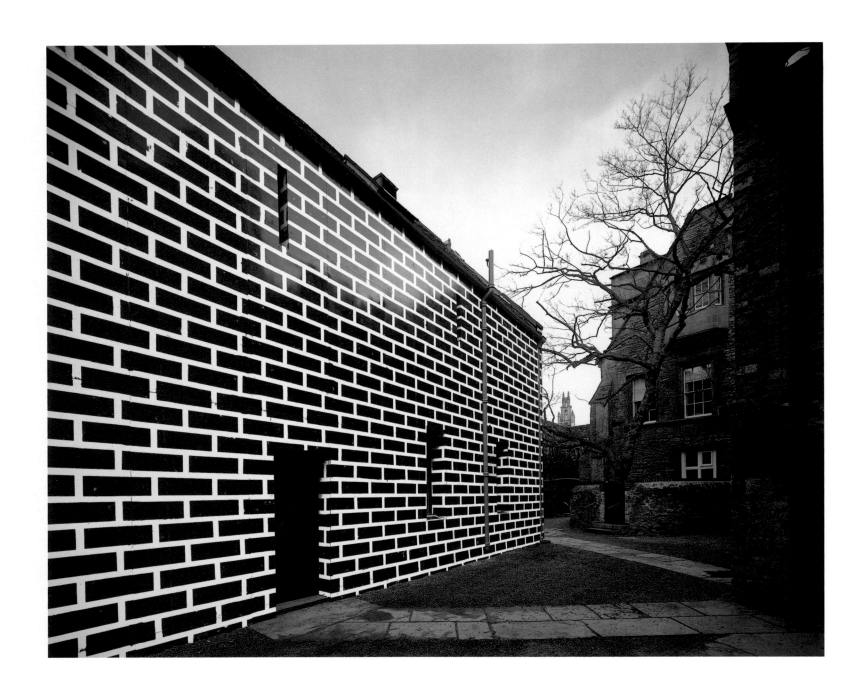

Fred + Claudia 2005

Working drawing for *Logo no. 18*

159

Logo no. 18 (2005), Collection Claudia Cargnel and Fred Bugada, Paris

Store interior commissioned by SH Architects
for Paul Smith's *Red Ear Jeans*, Tokyo, 2001

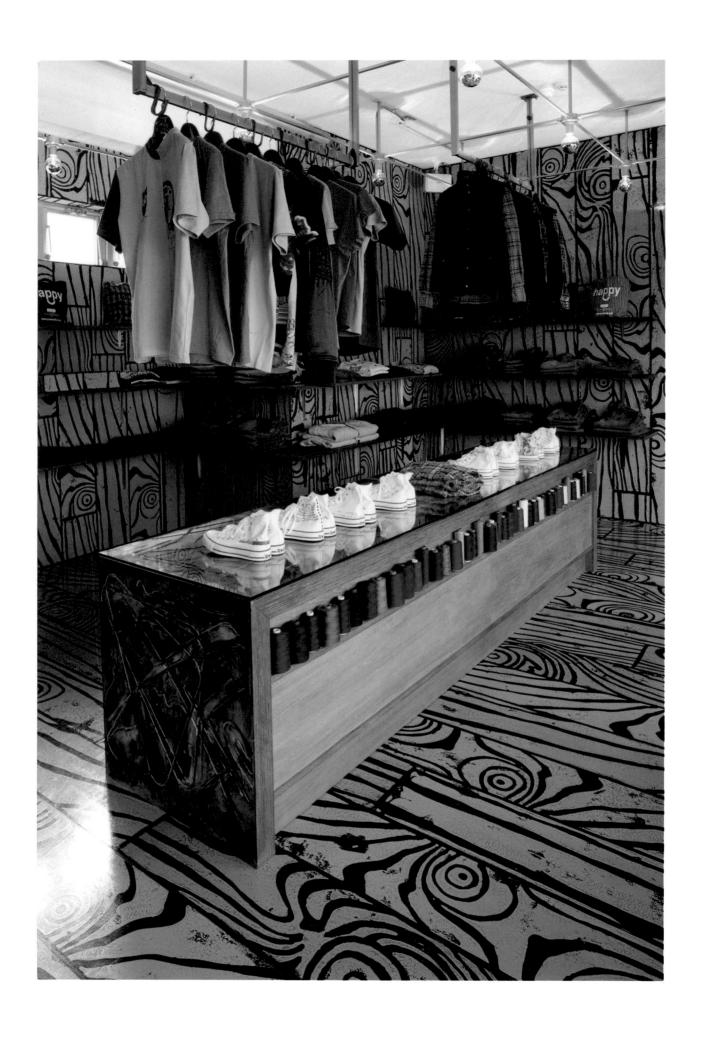

Store interior commissioned by Paul Smith
for *Happy Shop*, Tokyo, 2005

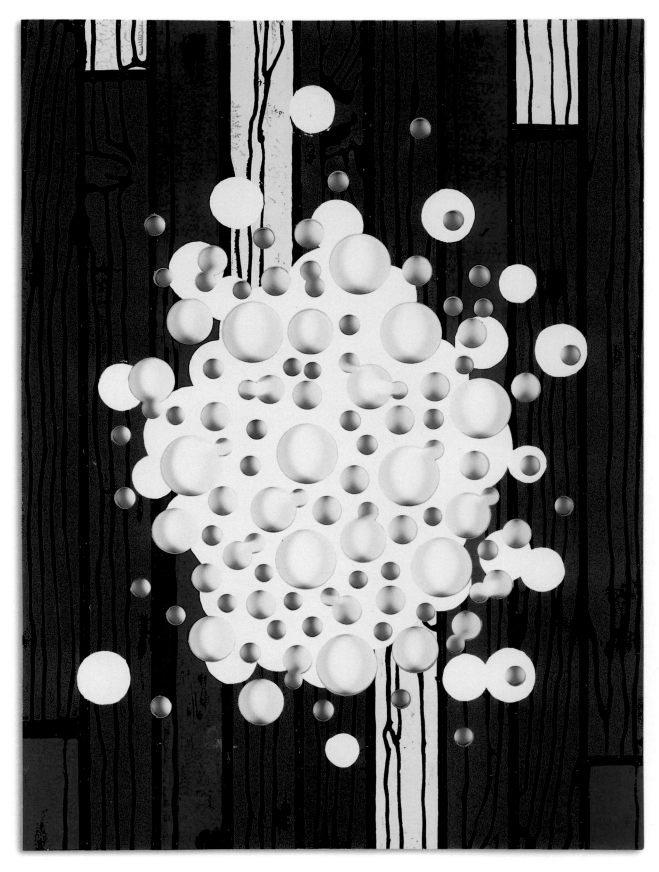

Holes and wood no. 6 (2006)
Household gloss paint on plywood
$122 \times 90\,\mathrm{cm}$
Private collection, London

Painted leaves no. 9 (2006)
Household gloss paint on plywood
122 × 90 cm

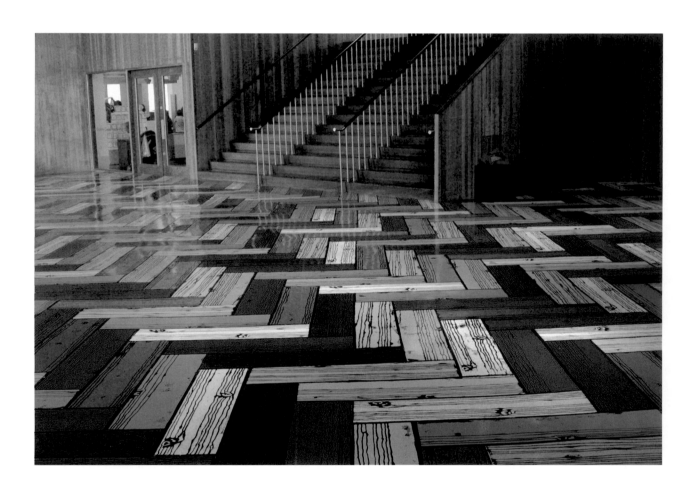

Logo no. 14, The New Art Gallery, Walsall, 2005
Commissioned in association with the Contemporary Art Society

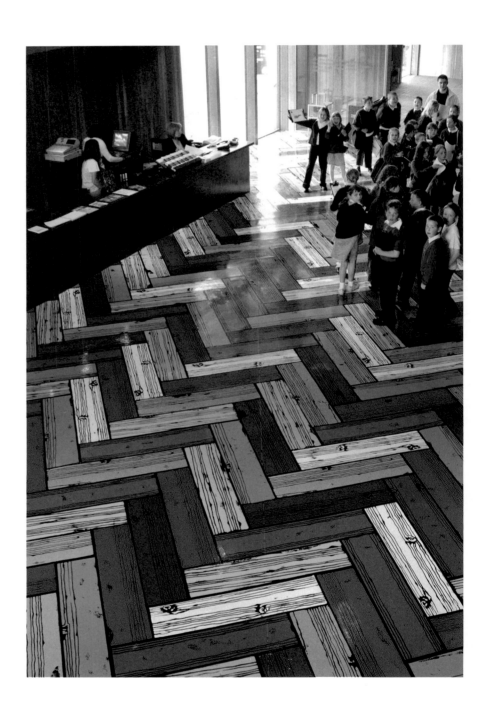

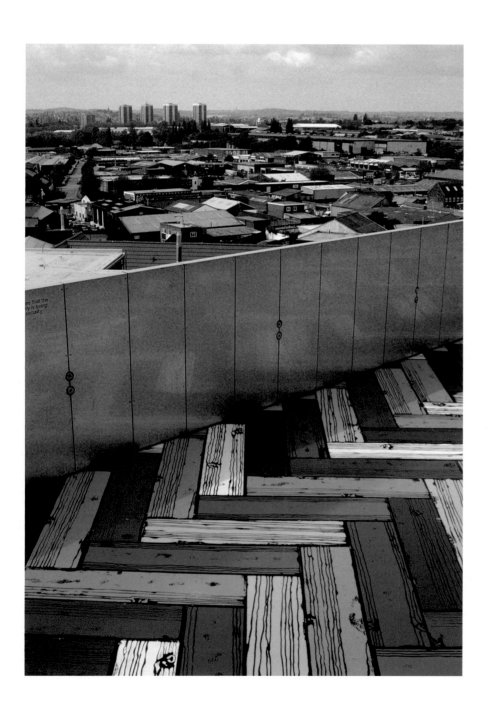

Logo no. 14, The New Art Gallery, Walsall, 2005
Commissioned in association with the Contemporary Art Society

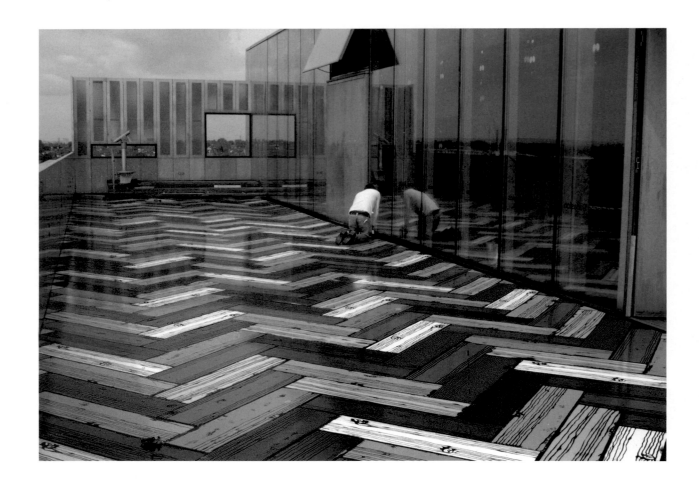

Chopped stock sculpture Lo.07 (2005)
Household gloss paint on plywood
$240 \times 5 \times 5$ cm

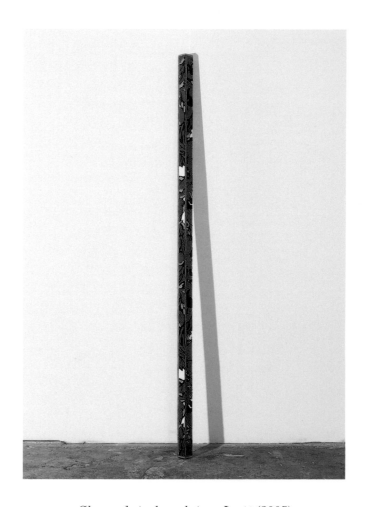

Chopped stock sculpture Lo.14 (2005)
Household gloss paint on plywood
$240 \times 5 \times 5$ cm

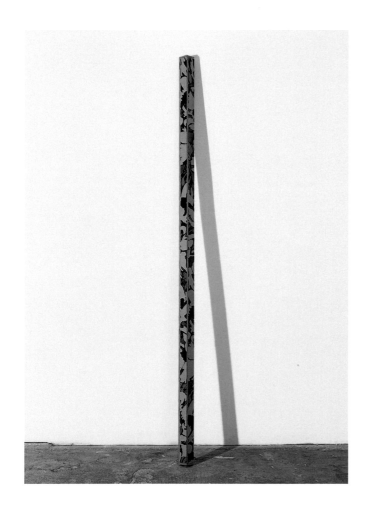

Chopped stock sculpture Lo.06 (2005)
Household gloss paint on plywood
$240 \times 5 \times 5$ cm

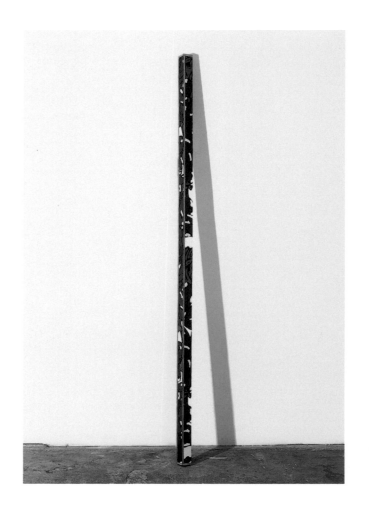

Chopped stock sculpture Lo.05 (2005)
Household gloss paint on plywood
$240 \times 5 \times 5$ cm

GORDON BURN: The comedian Norman Wisdom owned a brickworks in the Midlands in the 1960s, but the firm went bust. 'The only people who seemed to want bricks were agitators – for throwing at embassies,' he said at the time. But then 'neo-vernacular' came into its own in the property boom of the 1980s and bricks and bricklaying were back in fashion. The quantity house-builders went back to brick as a material that brought 'a breath of old England'. It became the proof of authenticity – 'Quality homes of character'.

RICHARD WOODS: That Quentin Crisp quote comes to mind: 'Why bother trying to keep up with the Joneses, when you can bring them down to your level?'

In recoil from the 'faceless' buildings of functionalist architecture, the 'retrofitters' and their supporters invest brickwork with almost human qualities. Writing about the return to brick a few years ago, the historian Raphael Samuel wrote: '[Brick] is individual and quirky where modernism is uniform, "warm" where glass and concrete are "cold". It breathes easily and naturally where breeze blocks are apt to sweat. It grows old gracefully where curtain walling stains. Brick matures and improves with the passage of the years: modernism goes to seed.' At Wimbledon you were covering up the variegated brickwork and architectural detailing of the house – the signs of its honesty and down-to-earthness – with a uniform, uninflected modernist skin.

I'm not putting forward one architectural model or canon as being philosophically superior to any other. What I do is mirror what's already there. It's always a skin. That's what I do. The printed skin is my way of making work look like my work. I love the way it's all graphic and tight from a distance, and all blobby and aggressive up close. That's my language. But I wouldn't want to get into an argument about which architectural style or period is better. I'm interested in what makes people interested in different styles, not the different styles themselves.

Was it a disappointment to you that the house was owned by Wimbledon School of Art and was no longer functioning as an ordinary domestic dwelling?

Yes. I can't help feeling this makes me a sort of fraud. I refer to the work as taking place in Merton Hall Road, and not at Wimbledon School of Art, so as to trick myself into thinking someone was living in it. But the image of the house being somewhere people live remains unhindered by this, I hope. The Oxford project took place in a civic building where the work's emphasis was directly focused on the architecture that surrounded it; you were forced to approach the work in a particular way, by taking a kind of architectural tour, and the work itself sat amongst fine, historically-sanctioned architectural examples. So *NewBUILD* became about comparing the tastes and aspirations of these buildings. In Wimbledon it was about the people who lived in the house and lived in the street. It was a much more public artwork. When I think about it retrospectively, I'm struck now by how argumentative it looks.

Many of the Thomas Bewick vignettes that you've become so fond of suggest that enclosure and emparkment, the building of walls and hedges, are acts of separation. English suburban living could be seen as this sense of separateness and isolation taken to a kind of polite and chilly extreme.

48 Merton Hall Road, Wimbledon, London

The Wimbledon house is detached. The context is the suburban road. But my hope was just to amplify what was going on underneath the wrapping. I'm not saying, 'isn't this architecture odd?', I'm talking about the motivation and thinking of the architects and builders when they decided to build in this style and in this place. I think if this is apparent in the work, then it's successful, even though no-one actually lives there.

RENOVATION will hopefully go on living in the minds of its Wimbledon neighbours who experienced it during its short life. Is that aspect of the work intrinsic to what you set out to do?

I'm a believer in a spirit living on after a project. I'm a big fan of *Lights Out for the Territory* by Iain Sinclair. I like the way the architectural ghosts are alive in this city. I live in Hackney, and I have a studio at London Bridge. This commute means I get to cycle through Liverpool Street and the City every day, and I love the relentless energy of those places: the graphics that have come and gone, the buildings that have been built and fallen down. I hope this gives my work an optimism. In the case of *RENOVATION*, in particular, I love the idea that that big graphic statement existed for a while and then disappeared, but continues to live on in the memories of the people who pass the site every day. Maybe what they remember is better than what was actually there.

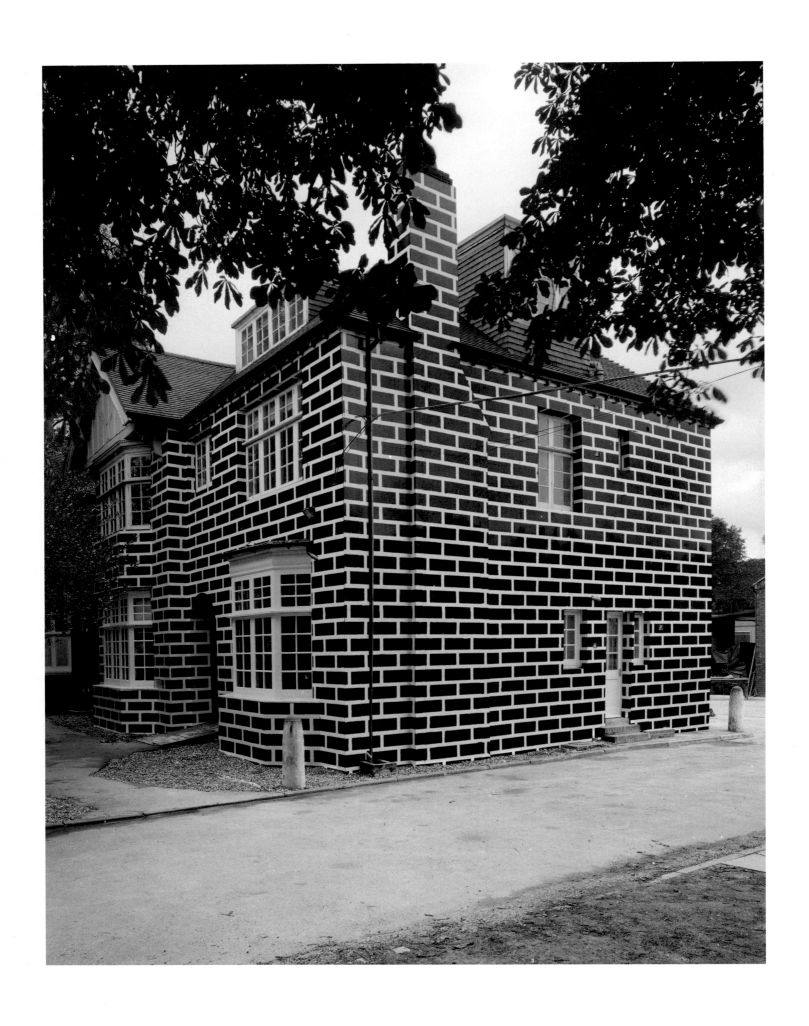

RENOVATION, 48 Merton Hall Road, Wimbledon, London, 2005
Commissioned in association with Art Works in Wimbledon and
hosted by Wimbledon School of Art

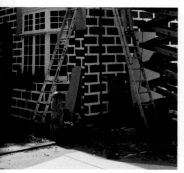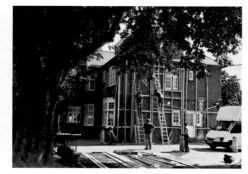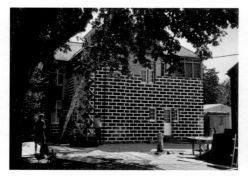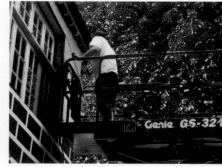
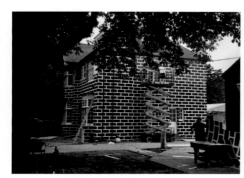
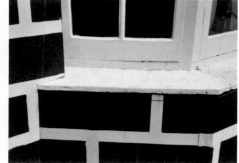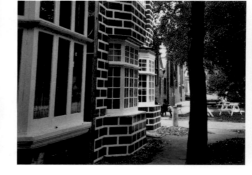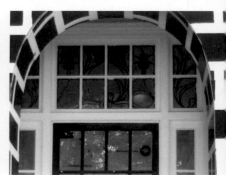

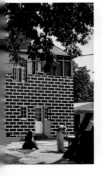
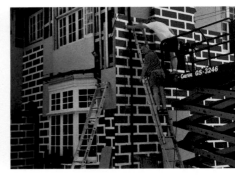

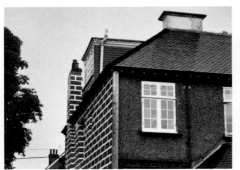

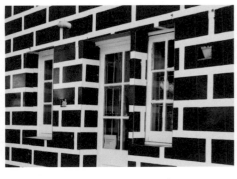
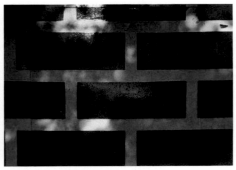
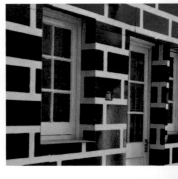

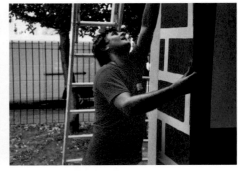

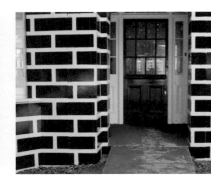

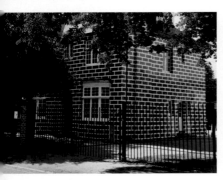
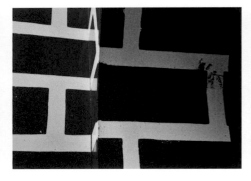
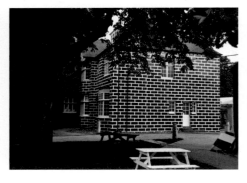

Time-lapse sequence of
RENOVATION
during construction

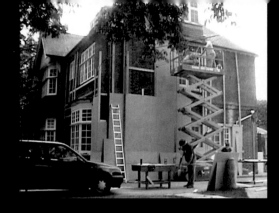
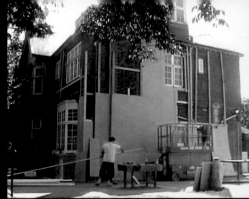
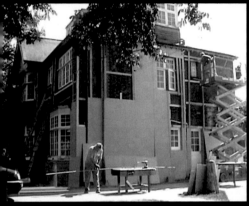
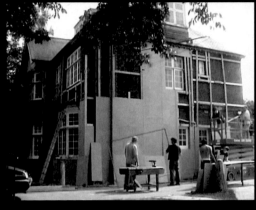
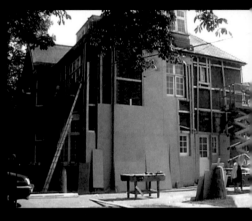
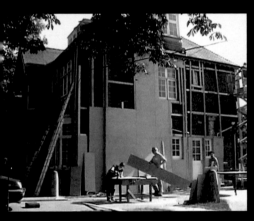
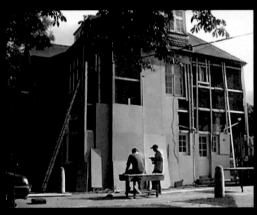
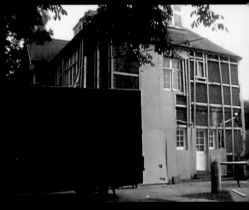
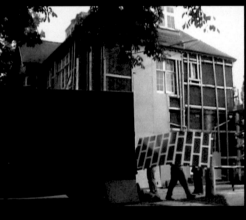
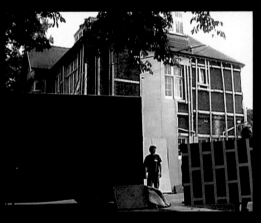
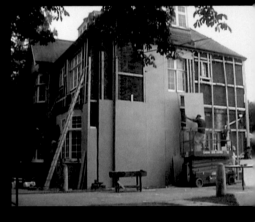
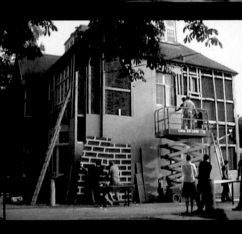
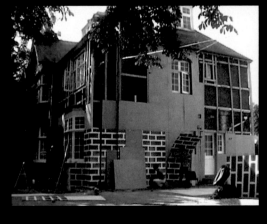
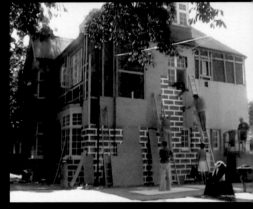

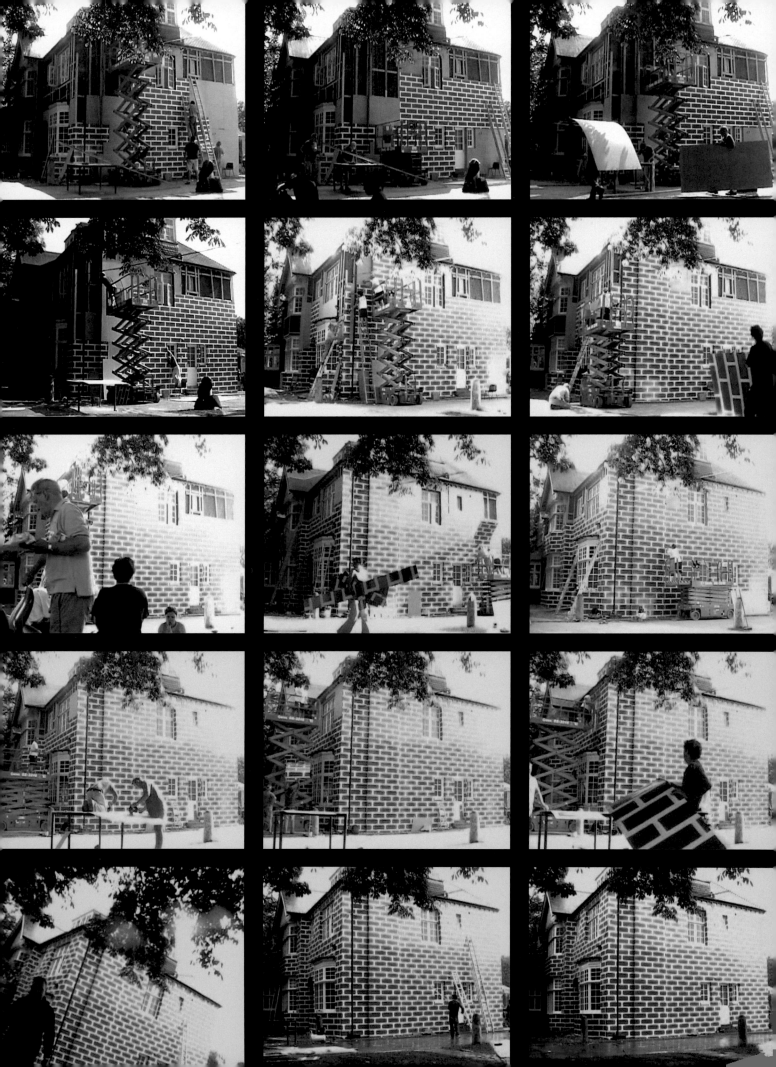

The decorative arts, Galleria Maze, Turin, 2005

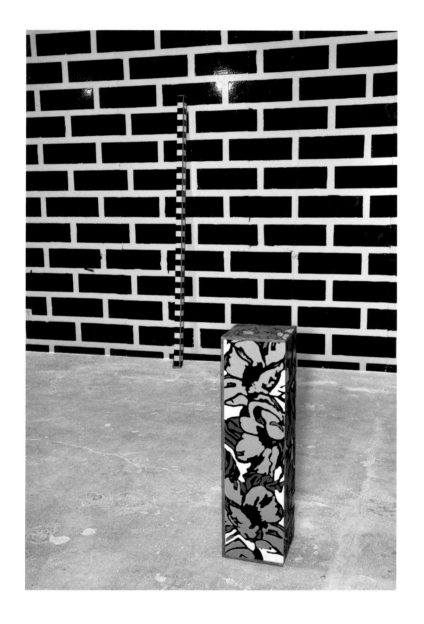
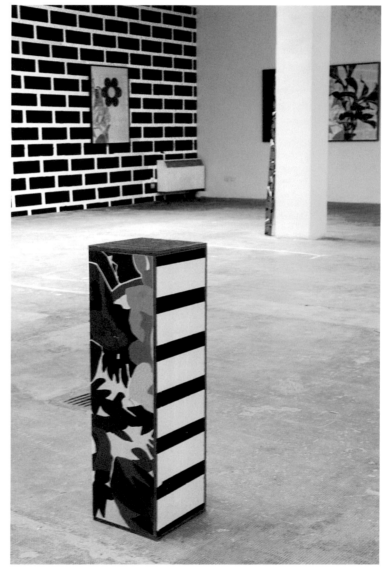

The decorative arts, Galleria Maze, Turin, 2005

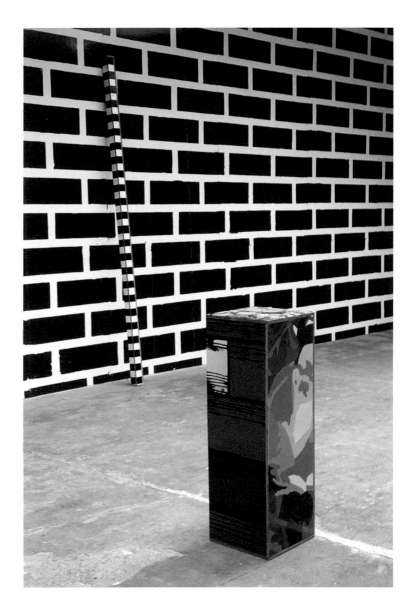

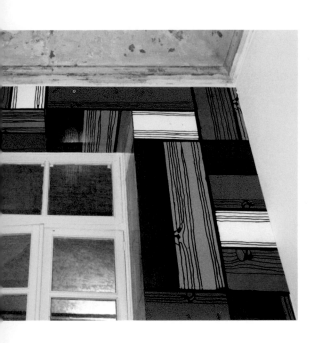

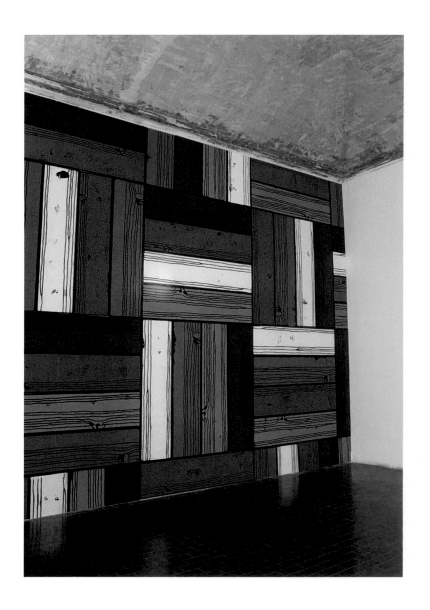

The decorative arts, Galleria Maze, Turin, 2005

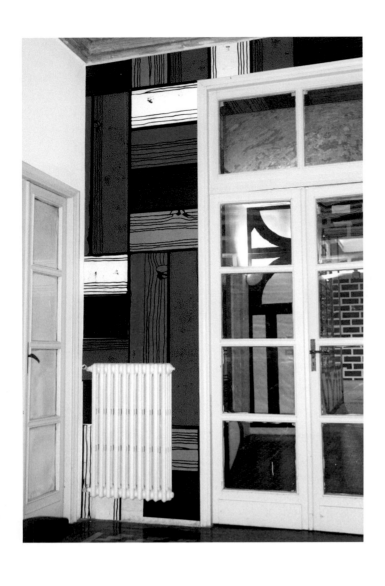

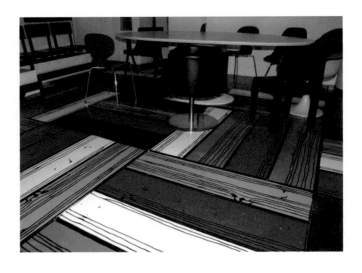

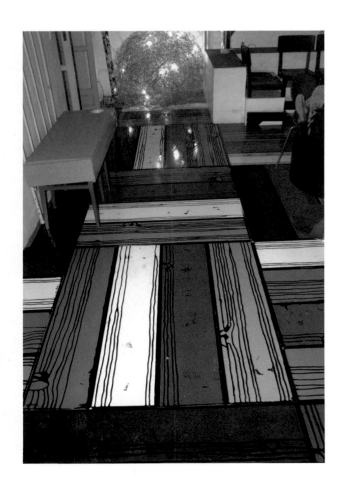

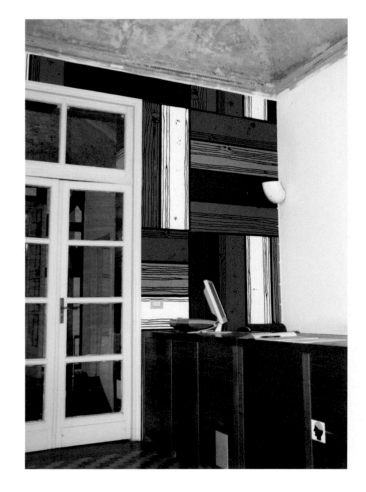

Holes and wood no. 3 (2006)
Household gloss paint on plywood
122 × 90 cm
Collection Keith Tyson, London

Holes and sculpture no. 1 (2006)
Household gloss paint on plywood
122 × 90 cm

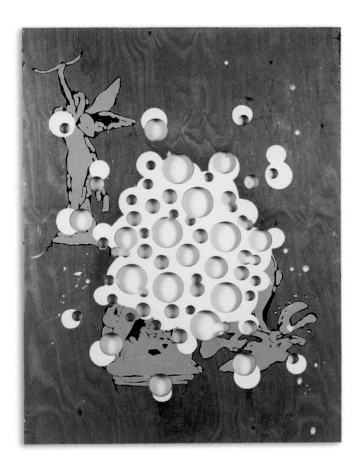

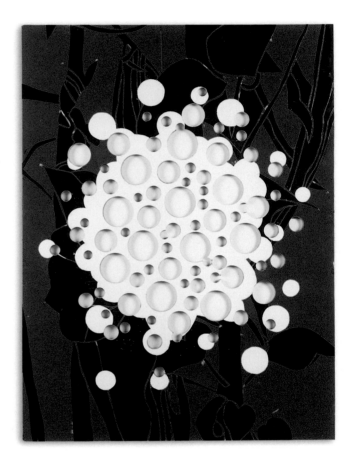

Holes and sculpture no. 2 (2006)
Household gloss paint on plywood
122 × 90 cm
Collection Keith Tyson, London

Holes and leaves no. 1 (2006)
Household gloss paint on plywood
122 × 90 cm

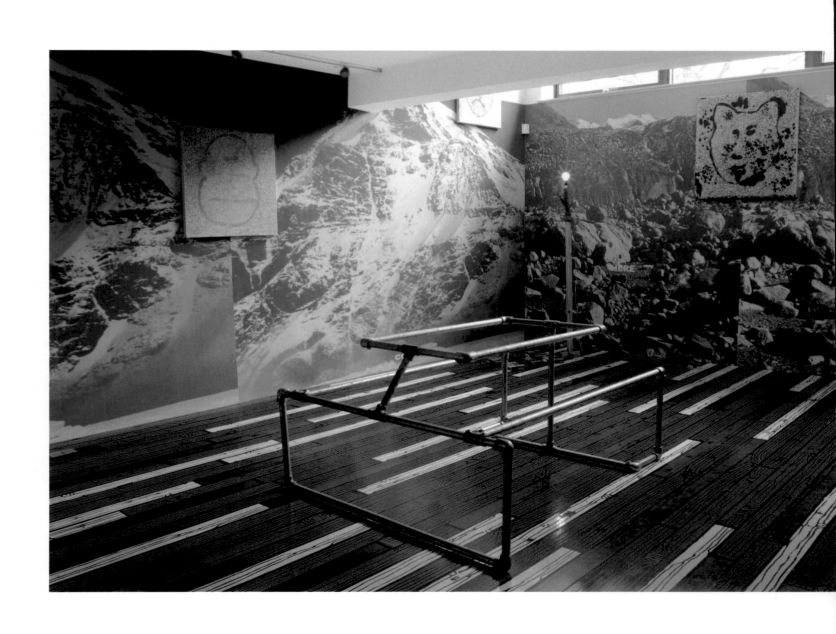

Logo no. 21 in *Picnic Area (Dumb Interior)*, Room, Bristol, 2006

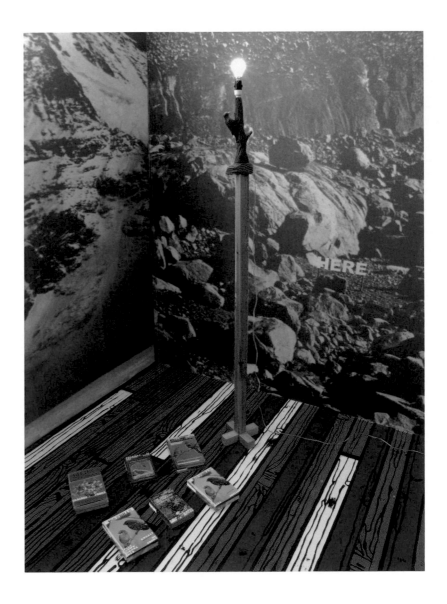

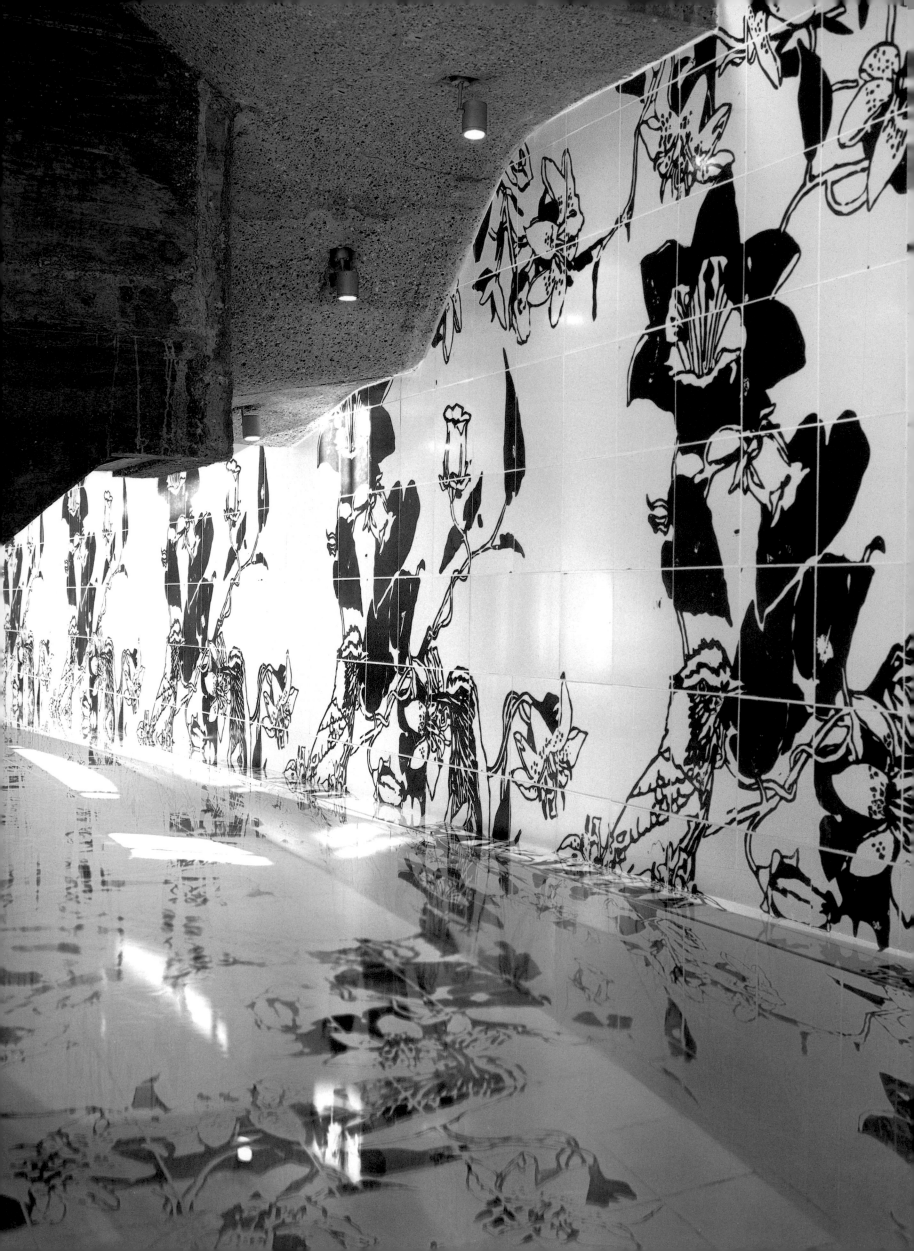

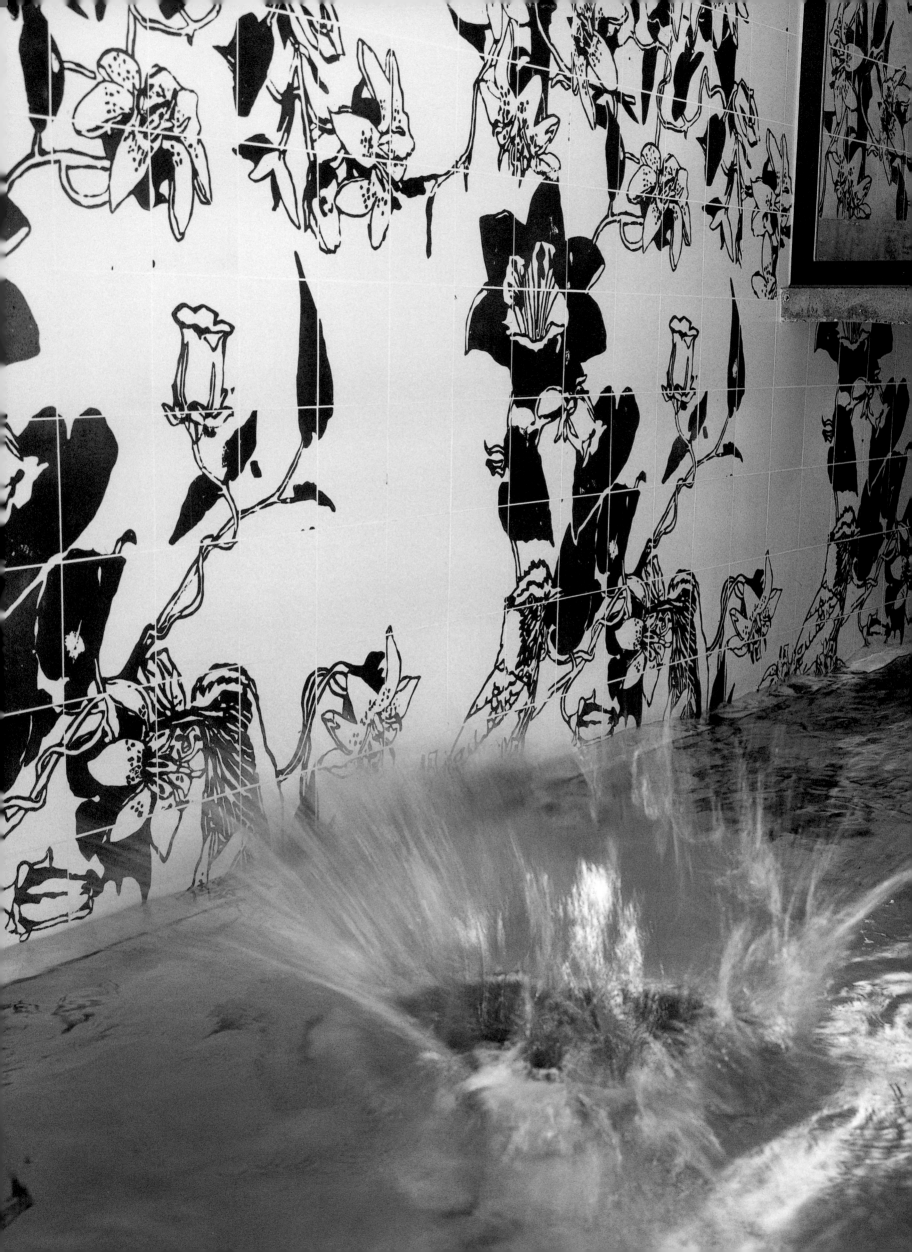

Biographies

Richard Woods

Richard Woods was born in Chester in 1966. He studied at Winchester School of Art from 1985 until 1988 and the Slade School of Fine Art, University College London between 1988 and 1990.

Woods was selected for the seventh *Barclays Young Artist Award* show at the Serpentine Gallery, London in 1991 and had his first one-person exhibitions at Hales Gallery, London in 1992 and 1994. Since then he has shown extensively elsewhere in Britain as well as in continental Europe, Japan and the United States of America, with solo exhibitions and projects at Baldacci Arte Contemporanea, Milan (1996), Cristinerose Gallery, New York (1998), Modern Art Inc, London (2000), Zwemmer Gallery, London (2000), griedervonputtkammer GmbH, Berlin (2001), Deitch Projects, New York (2002), Deitch Projects, Miami (2003), Galleria S.A.L.E.S., Rome (2003), vamiali's, Athens (2004), Kenny Schachter ROVE, London (2004), New College, Oxford (2005), The New Art Gallery, Walsall (2005), Sadler's Wells, London (2005), Art Works in Wimbledon at 48 Merton Hall Road, Wimbledon, London (2005) and Galleria Maze, Turin (2005).

Over the years the artist and his work have been the subject of numerous essays, feature articles and reviews, the most important of which include Paul Bonaventura, 'The Outside of the Envelope' and Keith Wilson, 'There was an old woman who lived by the sea…', in *Richard Woods* (London: Hales Gallery, 1994); Penelope Curtis, '18 Choppers', in *At One Remove* (Leeds: Henry Moore Institute, 1997); Susan May, 'Renovated carpet (Burgundy)', in *Here to Stay: Arts Council Collection Purchases of the 1990s* (London: Arts Council of England, 1998); Gavin Wade, 'Richard Woods', *Art/Text*, no. 70, autumn 2000; J.J. Charlesworth, 'Poor Quality Toasted Sandwich', in *Richard Forster and Richard Woods* (Newcastle upon Tyne: UNN Fine Art Press, 2001); James Hyde, 'Richard Woods', *Art in America*, July 2000; Suhail Malik, 'Potentialities not possibilities', in *OPENPLAN P3-The Marathon* (Athens: Alphadelta Gallery and Artio Gallery, 2001); Linda Yablonsky, 'Something New in the Gallery: An Electro-Pop Extravaganza', *The New York Times*, Sunday May 5 2002; Karen Rosenberg, 'Richard Woods', *Frieze*, no. 71, November/December 2002; Richard Woods, 'An installation by Richard Woods and an interview with the artist – by himself', *Modern Painters*, summer 2003; David Thorp and Sarah Glennie, 'Stopover', in *Dreams and Conflicts: The Dictatorship of the Viewer – La Biennale di Venezia. 50th International Art Exhibition* (Milan: Skira Editore, 2003), edited by Francesco Bonami and Maria Luisa Frisa; Bettina von Hase, 'The Age of Super Tudor', *Art Review*, February 2004; Gavin Wade, 'Faker', *TANK*, vol. 3, no. 8, spring 2004; Caroline Corbetta, 'Richard Woods', *L'Uomo Vogue*, no. 365, November 2005; Gill Saunders, 'Face values', in *NewBUILD – An installation by Richard Woods* (Oxford: University of Oxford and New College, 2005); Maev Kennedy, 'Risk of seeing red over Oxford facelift', *The Guardian*, Monday 21 March 2005; Jonathan Glancey, 'High Campus', *Blueprint*, July 2005; Jonathan Vickery, 'NewBUILD – Installation by Richard Woods', *Art&Architecture Journal*, no. 63; Pilar Viladas, 'Style; Tudor Revival', *The New York Times Magazine*, Sunday November 27 2005; Martin Holman, 'Woods on the Outside', in *Richard Woods RENOVATION* (London: Art Works in Wimbledon, 2005); Noha Nasser and Gavin Wade, 'Interview', in *As Big as a House… Richard Woods* (London: ARTicle Press/ixia, 2006); and Gill Saunders and Rosie Miles, 'Chapter 6: Site-Specific Print and Case Studies', in *Prints Now: Directions and Definitions* (London: V&A Publications, 2006).

Woods won a Boise Travel Scholarship in 1993 and received a commission from the Japanese couturier Rei Kawakubo to design the floor and furniture for the store interior of the Osaka branch of the fashion house COMME des GARÇONS in 2002. He has also collaborated on store interiors with the British fashion designer Paul Smith. In 2003 Woods undertook the mock Tudor refit of a private family home in upstate New York, and more recently he collaborated with the Italian architect Maria Giuseppina Grasso Cannizzo on the interiors of two further residences in Sicily. *Import/export sculpture*, Woods's impressively large crazy paving of a cloistered courtyard, formed the centrepiece of The Henry Moore Foundation Contemporary Projects's *Stopover* exhibition at the 50th International Venice Biennale of Art in 2003, and he was one of nine artists chosen to represent the United Kingdom at the 2005 World Exposition in Japan.

Marco Livingstone

Marco Livingstone has a particular interest in Pop Art and the generation of artists who established their reputations during the 1960s. His major Pop Art exhibitions include *Pop Art USA–UK* (Isetan Museum, Tokyo, 1986), *Pop Art* (Royal Academy of Arts, London, 1991 and tour), *The Pop '60s: Transatlantic Crossing* (Centro Cultural de Belém, Lisbon, 1997), *Pop Art UK: British Pop Art 1956–1972* (Palazzo Santa Margherita and Palazzina dei Giardini, Modena, 2004) and *British Pop* (Museo de Bellas Artes, Bilbao, 2005–6). In addition he has organised retrospectives of the work of Allen Jones (1979), Patrick Caulfield (1981), Peter Phillips (1982), Duane Michals (1984 and 1998), Stephen Buckley (1985), Arthur Tress (1986), David Hockney (1989, 1994 and 2002), Jim Dine (1990 and 1996), Tom Wesselmann (1993), Duane Hanson (1994 and 1995), George Segal (1997) and R.B. Kitaj (1998 and 2004), and a show pairing Roy Lichtenstein and Andy Warhol (1991).

Livingstone has published widely on late 20th-century painting, sculpture, drawing, photography and video. His books include the catalogues for all the exhibitions he has organised, *Pop Art: A Continuing History* (London: Thames and Hudson, 1990) and monographs and major exhibition catalogues on David Hockney, Jim Dine, R.B. Kitaj, Allen Jones, Tony Bevan, Tim Head, Michael Sandle, Edward and Nancy Reddin Kienholz, Clive Barker and Duane Michals. His book Hockney's *Portraits and People* (2003), co-authored with Kay Heymer, was awarded the 2004 Sir Bannister Fletcher Award for best book on the arts. His most recent book, *Patrick Caulfield: Paintings*, was published in 2005 by Lund Humphries.

Gordon Burn

Gordon Burn's first novel *Alma Cogan* (1991) won a Whitbread Award and was longlisted for the Booker Prize. His second novel *Fullalove* (1995) was also longlisted for the Booker. His most recent novel is *The North of England Home Service* (2003). Non-fiction works include *Somebody's Husband, Somebody's Son* (1984), a study of Peter Sutcliffe, the Yorkshire Ripper, which won an Edgar Allan Poe Award in 1985, and *Happy Like Murderers*, a book about the West murders in Gloucester (1999).

Burn is also the author of *Pocket Money* (1984) and *On The Way to Work* (2001), a collaboration with the artist Damien Hirst. He has written a number of monographs on Hirst, and most recently contributed to catalogues for exhibitions by Gregor Schneider (Museu Serralves, Porto, 2005) and Rachel Whiteread (Tate Modern, London, 2005–6). He is a regular contributor to the *Guardian Review*, and a collection of his writing about art will be published by Faber and Faber in 2007.

Richard Woods is published by the Ruskin School of Drawing and Fine Art, University of Oxford and Art Works in Wimbledon in association with Lund Humphries and with the support of Arts Council England, The Henry Moore Foundation, Galleria S.A.L.E.S. and the Kirsgillow Fund

Ruskin School of Drawing and Fine Art
74 High Street
Oxford OX1 4BG
T: 01865 276944
F: 01865 276949
E: info@ruskin-sch.ox.ac.uk

Art Works in Wimbledon
3 The Grange
London SW19 4PT
T: 020 8946 5206
F: 020 8946 5206
E: art_works_in_wimbledon@fsmail.net

Lund Humphries
Gower House
Croft Road
Aldershot
Hampshire GU11 3HR

and

Lund Humphries
Suite 420
101 Cherry Street
Burlington, VT 05401-4405
USA

www.lundhumphries.com

Lund Humphries is part of Ashgate Publishing

British Library Cataloguing-in-Publication Data
A catalogue record for this book is available from the British Library

Photographic credits
Fred Bugada: 159
Stefan Gant: 176–7
Jeremy Hardman Jones: 72–5
Iain Herdman: 46, 47, 79, 134–5, 164–7, 178–83, 186, 190
Sophie Hicks: 160
Martin Holman: 174–5
Andy Keate: 17–24, 29–31, 36–7, 60–1, 63, 66–9, 76–7, 90, 104–5, 110–1, 115, 122–3, 125, 127–8, 132–3, 162–3, 184–5, 188–9
Noboru Kurimura: 161
Belinda Lawley: 147
Lee Mawdsley: 144
Simon Morrissey: 186–7
Cristobel Palma: 131
Claude Picasso: 98–9
Rosie Potter: 171, 173
John Riddy: 149–51, 156–7
Jason Schmidt: 86–9
Gavin Wade: 33
Richard Woods: 40–1, 53, 56, 65, 71, 81, 85, 96–7, 153–5

Every effort has been made to contact photographic copyright holders. Any omissions are inadvertent and will be corrected in future editions if notification is given to the publishers in writing

Edited by Paul Bonaventura and Richard Woods
Designed by Fraser Muggeridge studio
Printing coordinated by Uwe Kraus
Printed in Italy

Ruskin School of Drawing and Fine Art, University of Oxford and Art Works in Wimbledon in association with Lund Humphries © 2006

Library of Congress Control Number 2006927023
ISBN 0-9538525-5-5 (978-0-9538525-5-0) Hardback
ISBN 0-9538525-6-3 (978-0-953852567) Special Edition

Richard Woods wishes to offer an extra big thanks to Jess Spanyol and Milo at Valentine Road, Keith Wilson, Keith Tyson and the triangle of power, Norberto, Massimo and Elizabeth at Galleria S.A.L.E.S., Claudia and Fred at Cosmic Galerie, Jeffrey Deitch, Dave Dorrell, Sophie Hicks, Gill Saunders, Luca, Riccardo and Manu at Galleria Maze, Detmar and Isabella Blow, Kenny Schachter, Stuart Shave, Sofia and Dimitra Vamiali in Athens, Adam Lindemann, Iain Herdman and Rita and Alex Woods for providing expertise, enthusiasm and backing in connection with the book and the projects depicted within its covers – and last, but not least the twins Lorcan and Augusta

The Ruskin School of Drawing and Fine Art and Art Works in Wimbledon would like to express their gratitude to ACAVA, especially Duncan Smith and Jon Gershon, Melanie Appleby, Elizabeth Aram, David Austen, Georgina Barney, Rod Barton, Marcus Beale, Michael Benson and his staff, Robert Brough, Ian Brown, Roger Casale, Ian Dawson, The Elephant Trust, Tom Franklin, Stefan Gant, Michael Gough, Benjamin Gurney, Robert Holmes, Ben Iliffe, Conor Kelly, Richard Kelly, Dr Elizabeth Nelson OBE, Stephen Nelson, New College, Oxford, especially Michael Burden, Derek Finlay, Caroline Thomas, Chris Conway and Joan Fraser, Maureen Pepper, Rosie Potter, Haron Ray, John Riddy, Ben Sparkes, Michael Stanley, Laurence Taylor, Tot Taylor, David Thorp, Traders Antiques, Charu Vallabhbhai, Wimbledon College, especially Father Adrian Porter SJ, Emma Wain, Nick England and the Year 12 art students, Wimbledon School of Art, especially Peter Armsworth, Jordan Baseman, Miranda Clarke, Charlotte Kelley and Anita Taylor, and Paul Wood for their assistance and support during the fabrication of *NewBUILD* and *RENOVATION* and the production of this publication

Art Works in Wimbledon

The Henry Moore
Foundation

GALLERIA S.A.L.E.S.